Wilderness to Wasteland

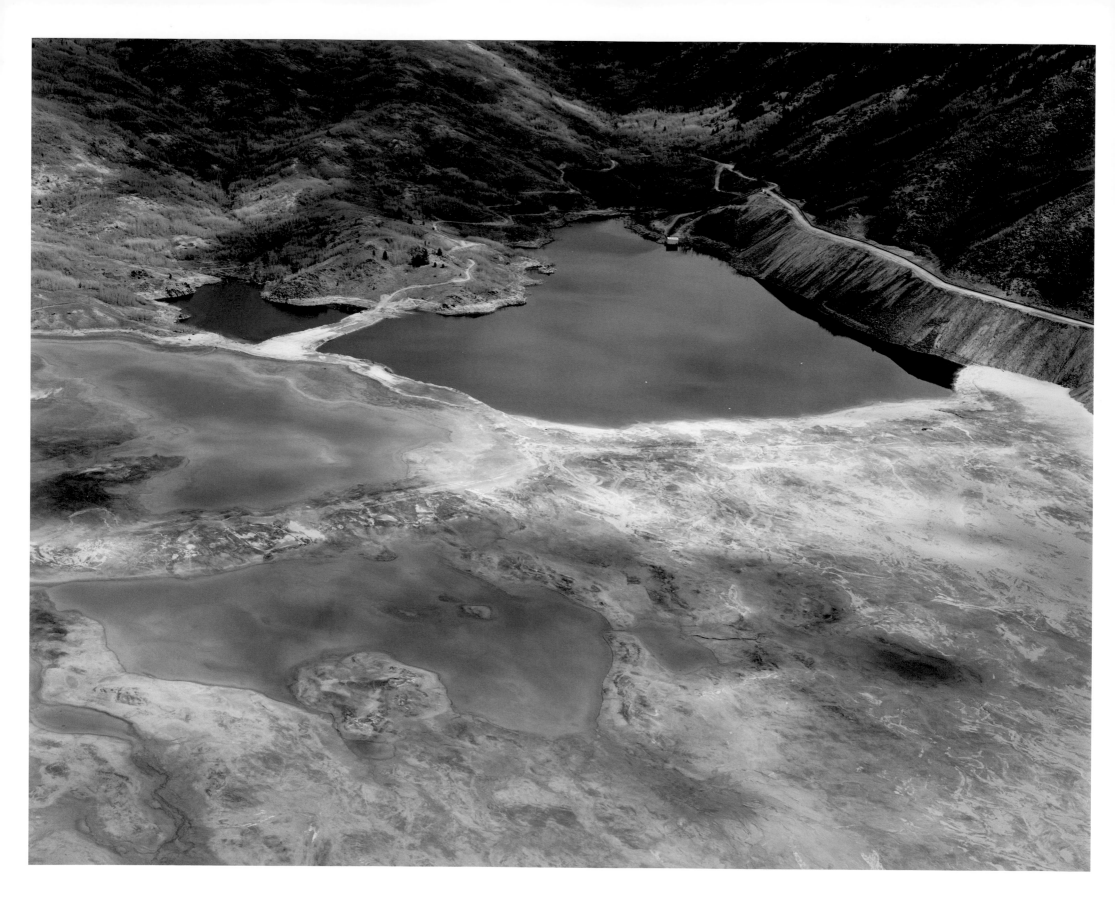

David T. Hanson

Wilderness to Wasteland

Foreword by Joyce Carol Oates

Afterword by Miles Orvell

TAVERNER PRESS

Foreword

Joyce Carol Oates

The great tradition of American landscape art of the 19th century celebrated the transcendental, the sacred and the ineffable—a conjoining of the visual and the spiritual that focuses upon the perfection of nature exclusive of humanity. These include such visions of the North American continent as the Luminist paintings of Thomas Cole and Frederic Edwin Church, notably of the Hudson River Valley; the massive landscapes of Albert Bierstadt, both of the Hudson River Valley and of the American West; and the (lesser-known) photographs of Timothy O'Sullivan of the mountainous spaces of Nevada, Arizona, Idaho, and New Mexico. In the 20th century the most acclaimed landscape photographer is Ansel Adams, whose beautifully precise, black-and-white photographs of the American West have acquired a mythic status: here is landscape not as mere scenery but as sacred vision. In Adams's great photographs of Yosemite, Glacier National Park, and the Grand Tetons, the Romantic images of the Luminist painters have been transposed into something like realism; in Adams's most famous photograph, *Moonrise, Hernandez, New Mexico*, we see earth and sky commingled into a timeless and seamless whole, irradiated by moonlight. We do not see, nor are we aware that we are not seeing, anything like a human habitation, an actual settlement called Hernandez, New Mexico, in which human beings live and toil (and may disfigure their environment). The myth is that amid the visual splendors of transcendental nature, there is no "refuse"—no devastation, no collapse, no erosion, no rot; no (seeming) effort, struggle, defeat, death. All is contained within a mystic whole that is the aesthetic creation not of nature but of the artist.

Which is to say, such transcendental visions of nature are not "natural" but "artificial"—they are distillations of what the eye sees and the brain chooses to select, to arrange formally as art, and to record. (And sell.)

It is significant that realism in all the arts was slow to evolve. The earliest drawings of presumably "primitive" humankind are fantastical figures, radically simple, mere line drawings on rock; the earliest tales are of deities, spirits, angels, and demons, but not human beings in their/our singularities. It is as if the eye did not "see" what was before it, but only what the brain selected to "see"—abstracted images of an intricate reality, a kind of Platonism of the "real." Not things but the forms of

things, distilled and idealized. It required millennia before an even partial realism could be admitted into human consciousness, in "naturalistic" 19th-century art and literature in which ordinary, not heroic or exalted, human beings are depicted in domestic or intimate scenes; as late as the early-20th century, in the esteemed prose work of Henry James, Joseph Conrad, and Virginia Woolf, among others, the human body in its physicality does not yet exist, but is coming into being in the work, shocking for its time, of James Joyce and D. H. Lawrence. In photography, idealized images remain the norm well into the midcentury, from Alfred Steiglitz's intimate nude portraits of Georgia O'Keeffe to the stylized dreamlike nudes of Edward Weston; a franker sort of realism, no less intimate, and dreamlike in its own way, is generated by the work of contemporaries Robert Mapplethorpe, Emmet Gowin, and Sally Mann in their contemplations of the human nude. (The most extreme refutation of the Romantic tradition of the nude is found in the paintings of Francis Bacon and Lucian Freud: a sort of autopsy on bodies still living, the painter's brush a scalpel.)

Wilderness to Wasteland, David T. Hanson's striking and disturbing sequence of landscape photographs, is most dramatically comprehended in the context of the history of American landscape art and of the evolution of the "real": as Hanson suggests in his title, we have here an inexorable movement, a despoliation of Eden. In a previous series, the much-acclaimed *Colstrip, Montana* (1982–85), the photographer posits tragic documents of the human despoliation of nature that refuse to be explicitly moralistic or didactic; and *Colstrip* exemplifies a contemporary genre, the ecological landscape photograph, which pictures a despoiled world from which the (human) despoilers seem to have departed. Other works done in the 1980s and '90s by David Hanson, a native of Montana, suggest his prevailing themes: *Minuteman Missile Sites; Waste Land; "The Treasure State": Montana 1889–1989; Known US Nuclear Tests 1945–1995; Targeted Terrain.*

A phantasmagoria of brilliant, haunting, at times mysterious and baffling images, *Wilderness to Wasteland* continues the photographer's lyric exploration of tragic ecoscapes. These more than eighty meticulously prepared images are a rare combination of surpassing beauty and ugliness—if by "ugliness" we mean the ruin of nature and the poisoning of humankind. (In terms of photographic

composition, textures, and colors, however, Hanson's work is disconcertingly beautiful.) For here, juxtaposed with the traditionally celebrated contours of nature—mountains, hills, streams, valleys, grasslands, deserts, "big" skies—are slag heaps and waste dumps, abandoned mines, oil rigs, tanks, power lines, deforested forests, uranium mills, every kind of erosion and toxic landfill and "Superfund site," a new term to many, perhaps, and rather an innocuous phrase to describe those poisoned places where hazardous waste has been knowingly, illegally dumped, contaminating water, soil, air, affecting ecosystems and people. According to the Environmental Protection Agency, there are approximately 1,322 Superfund sites in the US.

The photographs in *Wilderness to Wasteland* pass in fluid sequence of the "real" laced with the "surreal." How appropriate it is that Hanson begins with a study of Atomic City, Idaho, which documents a former nuclear boomtown now abandoned; the series includes "Atomic City, Ida"— a ghost town post office that resembles a flat façade with nothing behind it. No patrons, no mail to be delivered. When human habitations are introduced to these desolate scenes, the effect is jarring and unsettling. Farm houses, trailer homes—and where are their residents? As in the classic photographs of Ansel Adams there are no human figures visible. Ironic to learn from Hanson's commentary that the mining site near Butte, Montana, once proudly proclaimed as "the richest hill on earth"—the title of the second series of photographs in the volume—has been redefined as "the largest hazardous waste site in the United States." Ironic too to learn that one of the open-pit mines appearing in a later section and resembling a mandala from above, has become "the world's largest toxic pond," which would cost an estimated $1 billion to clean up, were such a cleanup even possible.

Walt Whitman, whose great subject was America, the spiritual essence of America, would have wept at these incursions into nature even as (one supposes) he would have honored David Hanson's brilliance and audacity in transforming such incursions into works of art. Consider the central section of the volume, "Wilderness to Wasteland." Here is the very poetry of despoliation— a beauty of symmetry of power lines, raw new construction, hive-like housing for an incoming and anonymous workforce. It is rare, and dramatic, to encounter in Hanson's work so specific a sign as

"Brown's Mobile Home Park." More common are desolate roads and lanes leading nowhere. (That is, to a shut-down mine in Rich Hill, Arizona.) Temporary-looking settlements (for laborers) amid devastated earth. An abandoned silo—an artifact of an agrarian era now past. A small graveyard, that looks as if it has been abandoned (in Childress County, Texas). In a desert, the aftermath of ravaging human activity—off-road vehicles, cycles that have scarred the delicate ecosystem of the desert. Against a chain-link fence, gorgeous pink azaleas: but this is a fence that surrounds the federal prison at Marianna, Florida.

Hanson's aerial views exude a mythic air. Suddenly we are aloft, we are looking down, dispassionately, unjudging, not altogether sure what we are seeing: hazardous waste remains, dried and discolored toxic ponds, scattered houses? "Superfund sites" in (lyrically named) Rancho Cordova, California; Perdido, Alabama; Leadville, Colorado; Times Beach, Missouri; New Brighton, Minnesota; The Dalles, Oregon. A harsh beauty to the "waste ponds" of the Rocky Mountain Arsenal site, as to the "Yankee Doodle tailings pond," Montana Resources' open-pit copper mine at Silver Bow Creek/ Butte Area Superfund site. Exquisite-looking ponds and streams—containing what toxins?

Any landscape of Hanson's at which we look, however initially attractive, will soon yield its terrible secret—one need only look more closely. In the final section, "Twilight in the Wilderness," we move from pastel skies and romantic reflections in placid-seeming bodies of water—"Providence Harbor at Sunset," "Moonrise over Narragansett Bay," "Twilight along Long Island Sound," "Dusk on the Prairie"—such beautiful titles!—to a realization that these are documents recording the presence of Texaco, Allied Chemical, Exxon, Standard Oil, the Millstone Nuclear Power Plant. We find ourselves in a world of dazzling nocturnal scenes that are in fact industrial hells. Lights are blurred as if undersea—or vision has become distorted. A cobalt-blue sky, eroded grassless earth. White and red striped smokestacks, perversely graceful; gigantic ghostly white tanks shimmering in reflecting water; an eerie equipoise in compositions in which industrial sites are reflected in (polluted, poisoned) waters. Gradually, human artifacts appear: a pickup truck, isolated vehicles in a parking lot amid a ghastly light.

The photographs of *Wilderness to Wasteland* constitute, in Hanson's words, an "oblique" look at this aspect of American industrial history, and reflect upon the quasi-utopian dreams they may have once embodied; in another set of heartrending photographs, one could imagine the human wreckage that is the consequence of industrial pillage and pollution. It is a perversity of art that, as art, what we see is likely to be apprehended in purely, or primarily, aesthetic terms. The less explicit, the less didactic, the less polemic—the more such art is likely to strike the eye memorably, and to linger in the mind like a visual riddle. David Hanson's work is a heroic synthesis of two impulses: the wish to record, to educate, and to protest; and the wish to find an arresting sort of beauty in even these debased images. For *Wilderness to Wasteland* is far from photojournalism, and carries with it no evident imperative, no accusations or angry despair. How far we have come from the romanticized wilderness of the 19th century, and from the stylized photographs of Ansel Adams! David Hanson is a worthy successor to such visionaries, in these portraits of cultural anomie and loss, the Luminist images of our time.

In but few years the impenetrable forests will have fallen. The noise of civilization and of industry will break the silence of the Saginaw. . . . It is this consciousness of destruction, this arrière-pensée of quick and inevitable change that gives, we feel, so peculiar a character and such a touching beauty to the solitudes of America. One sees them with a melancholy pleasure; one is in some sort of a hurry to admire them. Thoughts of the savage, natural grandeur that is going to come to an end become mingled with splendid anticipations of the triumphant march of civilization.

—Alexis de Tocqueville, *Journey to America*, 1831–32

Melancholy Pleasures: Late Twentieth-Century Landscapes

David T. Hanson

As it happens, I began my survey of the contemporary American landscape exactly 150 years after Alexis de Tocqueville's historic journey. In the intervening years, our civilization has created levels of riches, technology, and abundance that far exceed Tocqueville's wildest dreams. But we have also developed a capacity and tolerance for destruction and loss—culminating in a reduced and poisoned landscape—which he could never have imagined. Tocqueville's impenetrable forests have fallen and "the solitudes of America" and its "savage, natural grandeur" have long since "come to an end." The "touching beauty" he chronicled seems today an almost impossibly romantic notion. Nevertheless, many of us have complex feelings about the "triumphant march of civilization," which has brought us—by logical steps—to the modern landscape.

In the late 1970s, after I had spent a number of years primarily photographing wilderness areas in Montana and throughout the West, my photographic work became increasingly focused on the relationship humans have with their environment. My interest in our transformed landscape culminated in 1982, when I began an extended study of Colstrip, Montana, the site of one of the largest coal strip mines in North America as well as the coal-fired power plant and modern-day factory town that it surrounds. Over the course of three years, I photographed many aspects of the Colstrip operation, including a series of aerial views of the site.

While I was working on my Colstrip series, my parents gave me a book of paintings and sketches by Karl Bodmer, made between 1832 and 1834, as he traveled up the Missouri River to its source. I was born and raised in Montana, and Bodmer's picturesque views of my native region gave

me a sense of what this landscape had looked like 150 years before. During this same time, I came across the writings of Alexis de Tocqueville on his journeys in America, which had also been made in the early 1830s. As I thought about Tocqueville and Bodmer, I conceived of a project that would begin to describe how much this territory had changed in the last 150 years.

Consequently, I widened my scope to include all of Montana and the High Plains, eventually encompassing the entire country in an investigation of the American industrial and military landscape at the end of the 20th century. After the series *Colstrip, Montana* (1982–85), I created *Minuteman Missile Sites* (1984–85), aerial views of nuclear missile silos throughout Montana and the High Plains; *Waste Land* (1985–86), an investigation of hazardous waste sites throughout the United States; and *"The Treasure State": Montana 1889–1989* (1991–93), which examines industrial sites across Montana and their impact on imperiled species. These four bodies of work reveal an entire pattern of terrain transformed by humans to serve their needs.

• • •

I recently went back over my early work and discovered several series of photographs that have never been exhibited or published. In fact, most had not even been printed. These pictures are mainly ground-based images taken during the early to mid 1980s as I pursued my primary interest in aerial views of the late 20th-century American landscape. Originally created as four distinct series, these photographs form the natural "chapters" of this larger body of work, sequenced with consideration to pictorial logic and thematic development. In what follows, I trace their *chronological* development.

The earliest series, *Twilight in the Wilderness* (1982–83), is a sequence of photographs taken at night of industrial sites for energy production. I had been working on my extended series *Colstrip, Montana*. Early on, as I was photographing the dominant power plant and its surrounding industrial site at Colstrip, I made a few pictures at twilight and at night. Intrigued by these images, I decided to pursue the idea when I returned to Rhode Island, where I was in graduate school. I subsequently photographed other industrial sites involved in power production near places where I had lived in Montana, New England, and California. These pictures, taken at night using color film, available light,

and extended exposures, were directly related to themes I was exploring at Colstrip. I conceived these works as "Luminist landscapes of the late-20th century"; I saw them as reflections on the tradition of 19th-century Luminist landscape painting and the early American landscape that they celebrated, and I titled my works after seminal Luminist paintings. These photographs underscore the fact that we can no longer claim that "We still live in Eden" (as Thomas Cole wrote in his "Essay on American Scenery" in 1836). Rather, they document how radically the American landscape has been altered in the past 150 years. Landscape as Eros has been transformed into landscape as Thanatos.

Wilderness to Wasteland (1985–86) is a larger group of pictures, which I made as I was traveling throughout the United States on a Guggenheim Fellowship photographing hazardous waste sites from the air. Several years ago, as I printed the ground views and aerial views from my Guggenheim year, I realized that these two very different perspectives on the landscape complemented each other in fascinating ways, just as my aerial views and ground views of Colstrip had done. *Wilderness to Wasteland* begins with ground-based photographs of the towns and countryside that I drove through as I traveled to forty-five states in twelve months, and it concludes with previously unprinted aerial views of some of the Superfund sites that I had selected from over 400,000 hazardous waste sites throughout the United States. The series is wide-ranging in both subject and geography: Alabama farmland, real estate development in the Los Angeles basin, a Florida prison, oil fields in Texas, petrochemical plants in Georgia, abandoned mines throughout the West, chemical weapons complexes and their disposal sites in Colorado and Utah, aerospace industries in California and Arizona, Wyoming's abandoned Lucky Mac uranium mine, and the toxic Yankee Doodle tailings pond in Butte, Montana. Juxtaposing photographs of the vernacular landscape with those of Superfund sites, this series places those toxic sites within the context of their social environments in a wide-ranging meditation on the American landscape at the end of the 20th century.

Even as I was working on *Wilderness to Wasteland*, I continued to desire to focus on specific places in my native region. And so I began *The Richest Hill on Earth* (1985–87), examining the extensive copper mines, housing and ethnic enclaves, and surrounding wasteland of Butte, Montana. A

historic marker at a turnout on Interstate 15 overlooking Butte proudly proclaims: "The greatest mining camp on earth, built on the richest hill in the world. That hill which has produced over two billion dollars worth of gold, silver, copper and zinc is literally honeycombed with drifts, winzes and stopes that extend beneath the city. There are over 3,000 miles of workings, and shafts reach a depth of 4,000 feet. . . . Butte has a most cosmopolitan population derived from the four corners of the world. She was a bold, unashamed, rootin', tootin', hell-roarin' camp in days gone by and still drinks her liquor straight." The photographs in the series were taken just after the Atlantic Richfield Company (having purchased the Anaconda Copper Mining Company only a few years earlier) permanently closed what remained of the Butte mines following a century of large-scale industrialized mining of copper, silver, gold, and other metals. The resulting loss of jobs and income was devastating to the Butte community, which had been heavily dependent on the mines. At the beginning of the 20th century this legendary mining town had been one of the most robust cities in the country—the "Pittsburgh of the West"—but it is now a part of the largest Superfund complex in the United States. At its center is the Berkeley Pit, a former open-pit copper mine that, since mining operations ceased in 1983, has slowly filled with more than 40 billion gallons of acidic, metals-laden contaminated water. The carcasses of snow geese and other migratory birds are frequently found floating in what is now the country's biggest man-made toxic lake. Reclamation in Butte will cost at least $1 billion but will not address the town's most serious environmental problems—including an extensive bedrock aquifer system that is permanently contaminated—which have been determined to be unsolvable or economically infeasible. Environmental engineers have estimated that, were it possible to fully reclaim the Butte site to its original condition, it would cost far more than all the mining revenues the "richest hill on earth" generated during its 140 years of production.

Finally, in December 1986, I created *Atomic City* (1986), a small series documenting the former nuclear boomtown, Atomic City, Idaho, located at the edge of the National Reactor Testing Station, an 890-square-mile nuclear complex constructed in the remote high desert of southeastern Idaho. This now nearly abandoned city is adjacent to the site of the Experimental Breeder Reactor-1, which

became the world's first electricity-generating nuclear power plant on December 20, 1951, when it produced enough electricity to illuminate a string of four 200-watt lightbulbs. EBR-1 later suffered the world's first partial meltdown, due to operator error. It was decommissioned in 1964, and in 1966 it was declared a National Historic Landmark. In 1961 another reactor at the site, SL-1, suffered a fatal nuclear reactor accident—the only one in US history—in which three workers were killed. Their bodies were so highly contaminated with radiation that they were buried in lead coffins sealed in concrete. Over fifty nuclear reactors were built on this desert plain, more than in any other place on earth. Only three are now in service, yet the complex is still one of the most contaminated sites in the United States and will likely remain so for centuries. My photographs, made on the thirty-fifth anniversary of the completion of the world's first nuclear power plant, constitute an oblique look at this historic place and reflect on the utopian dreams and visions of empire that it embodied.

Even as these photographs are an investigation into our contemporary American landscape and the ways we live now, they are also an exploration of the problems involved in *representing* the landscape of the late-20th century, of mapping our social reality. The ground views and the aerial photographs represent two very different approaches to photographic description and are radically divergent views of the American landscape. In 1986, when my series *Colstrip, Montana* was exhibited at The Museum of Modern Art in New York, John Szarkowski, then the museum's Director of the Department of Photography, wrote: "Hanson offers us, however, not one set of facts but two, one describing Colstrip from the ground, a place informed by the circumstantial, indeterminate particularity of temporary places; the other, made from the air, showing the terrible beauty of an unfamiliar and inhuman landscape. The two views challenge each other and the habit of mind that allows us to equate a sharp photograph with the truth."

As I was creating these photographs, I saw them as monuments for the end of the 20th century. In examining how dramatically the American landscape has been transformed in the past 150 years, they begin to reveal the new landscape that we have created and now inhabit. In many ways our contemporary landscape seems to fulfill—and go beyond—the prophetic words of

Tocqueville written during his travels in America in 1831–32. My photographs of utilitarian landscapes reflect on both the melancholy pleasure that Tocqueville experienced and the "triumphant march of civilization" that he anticipated. The images are a testament to how much our landscape has changed and how much has been lost. Displaying the dystopian side of progress, they form an extended investigation into nature and culture, the real and ideal, order and entropy.

These late 20th-century landscapes begin to trace the geography of the mental landscape of our time. Like the ancient megaliths of Stonehenge and the lines of Nazca, these sites may be seen as monuments to the dominant myths and obsessions of our culture. Indeed, it seems likely that the most enduring monuments that Western civilization will leave for future generations will not be Stonehenge, the Pyramids of Giza, or the cathedral of Chartres, but rather the hazardous remains of our industry and technology. Landscapes of failed desire, these sites become both arena and metaphor for the most constructive and destructive aspects of the American spirit. The photographs become, finally, meditations on a ravaged landscape.

Atomic City 1986

1 View toward East Butte, Atomic City, Idaho

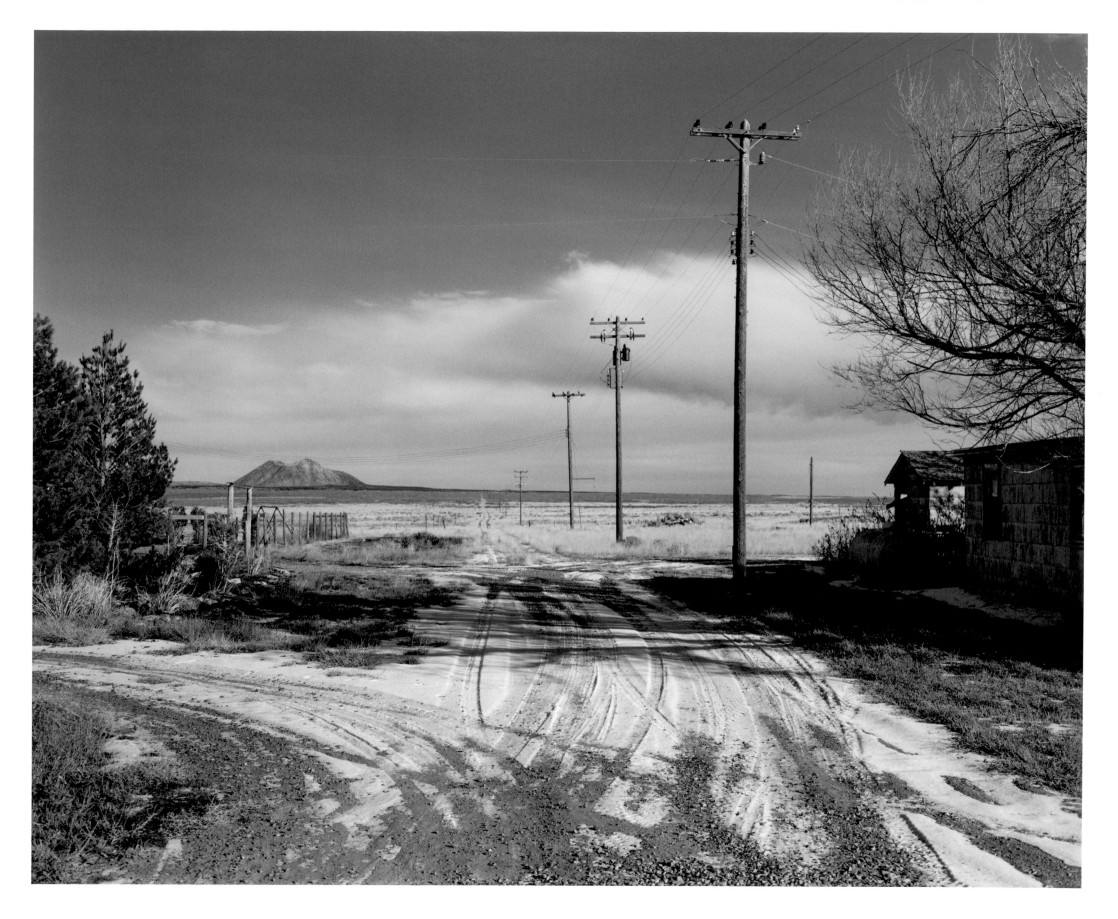

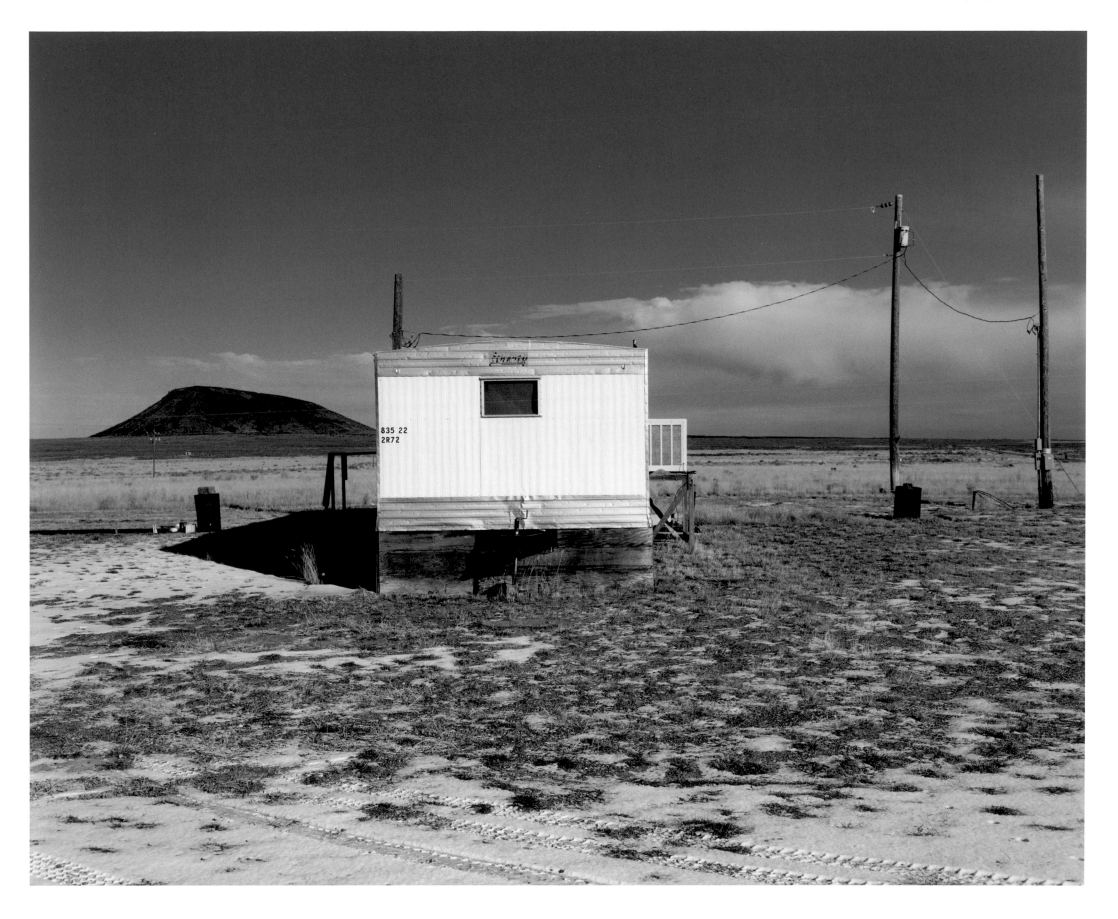

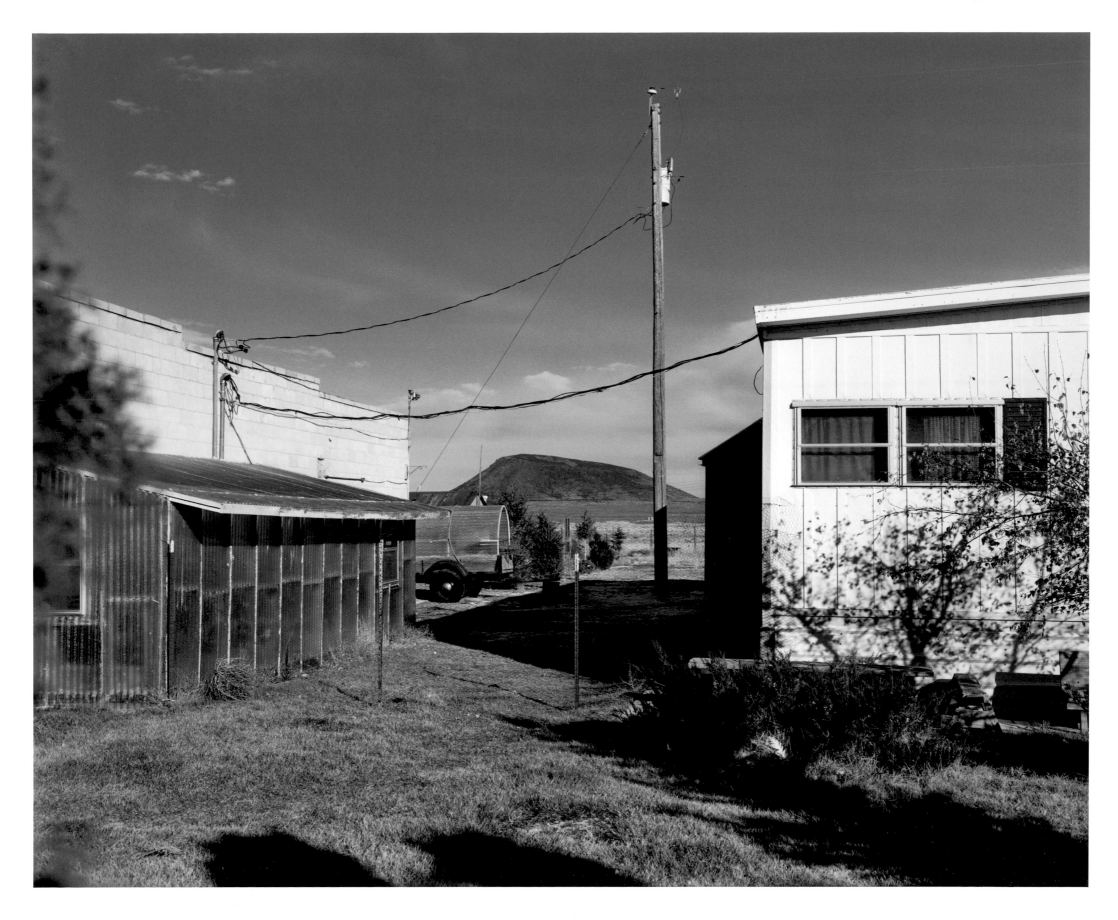

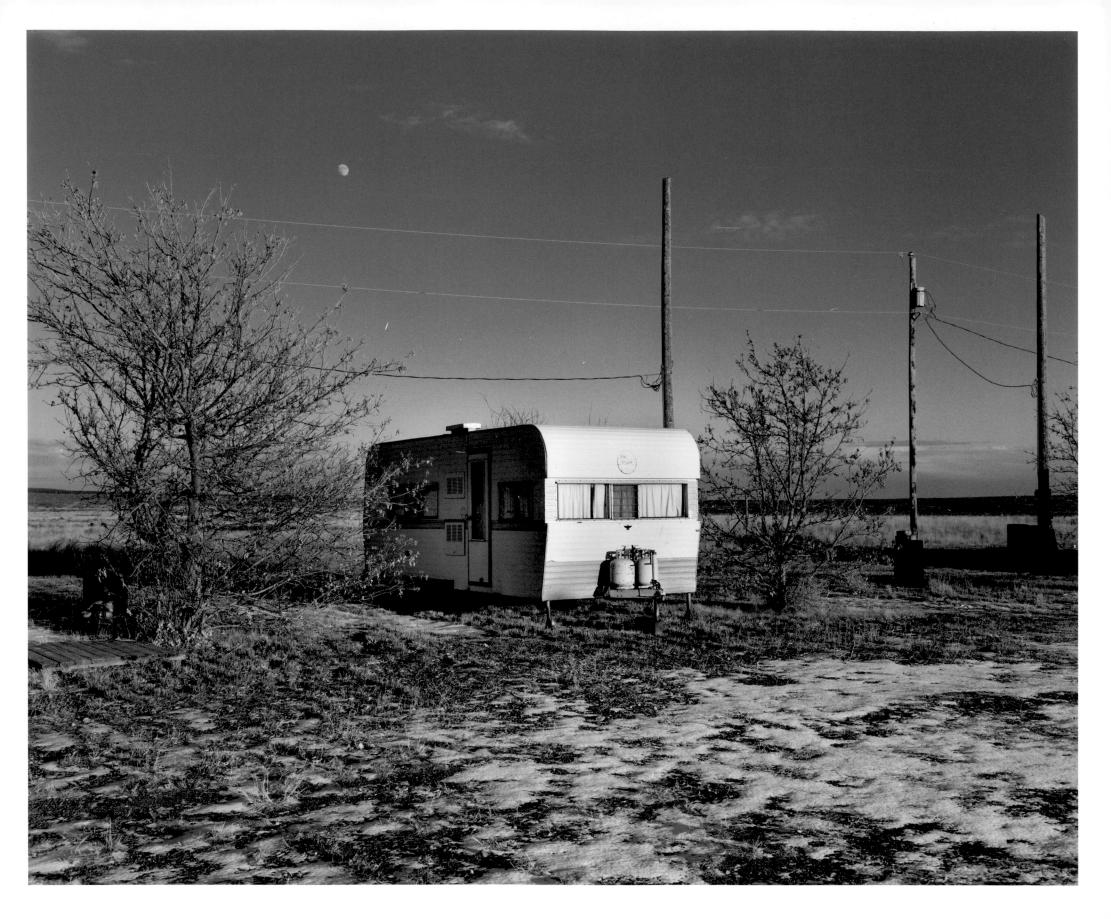

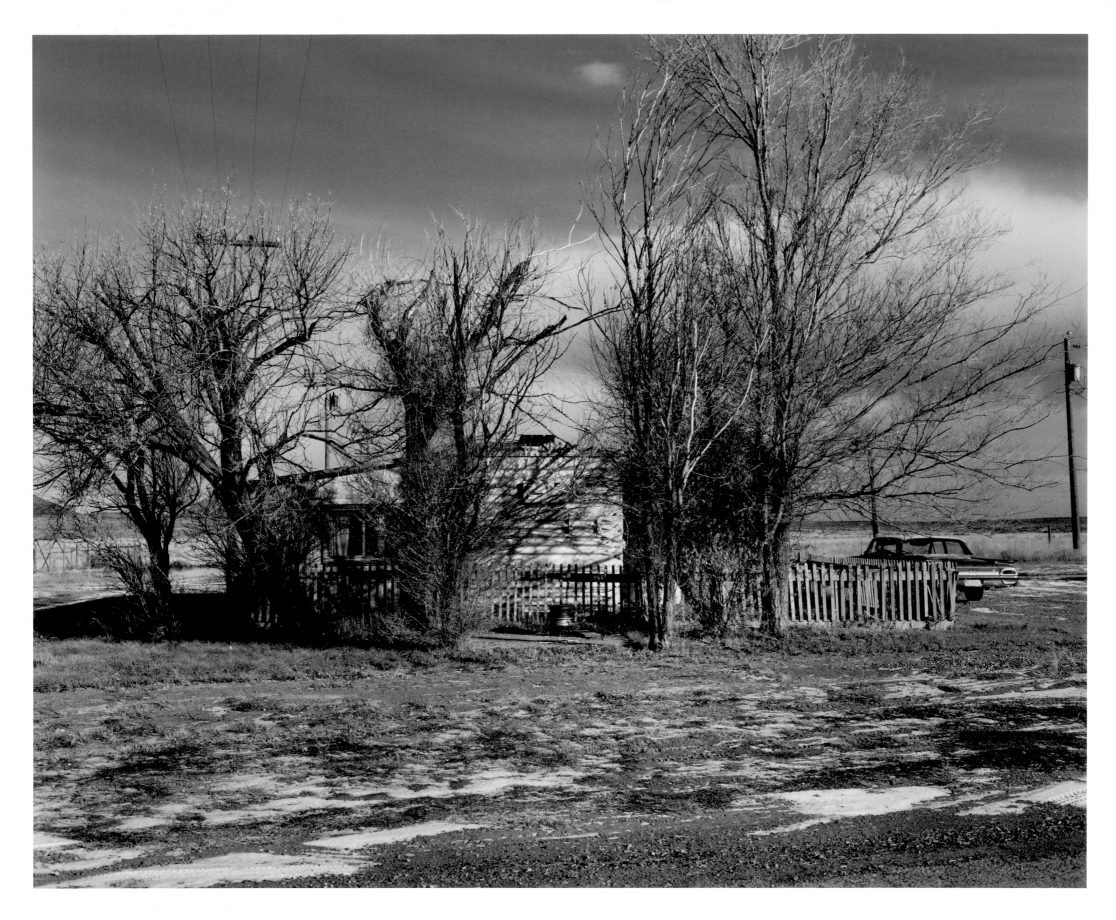

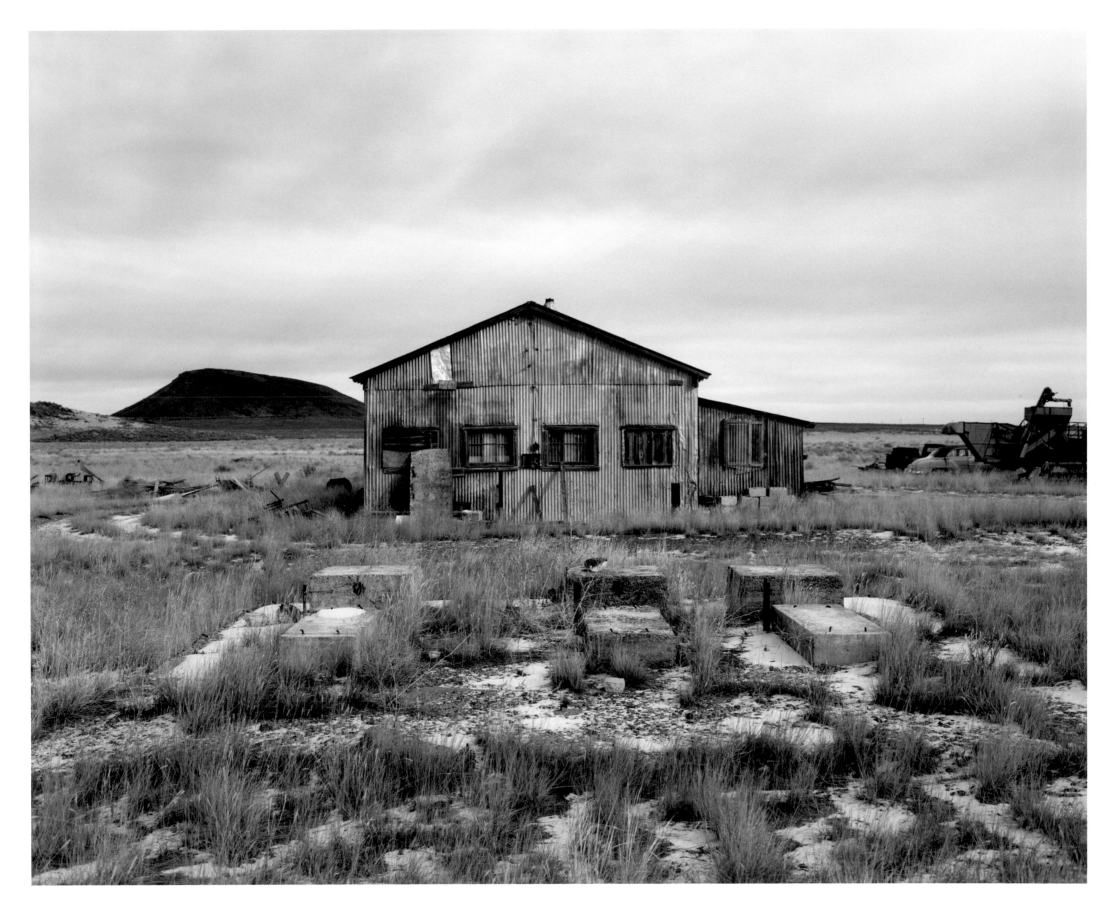

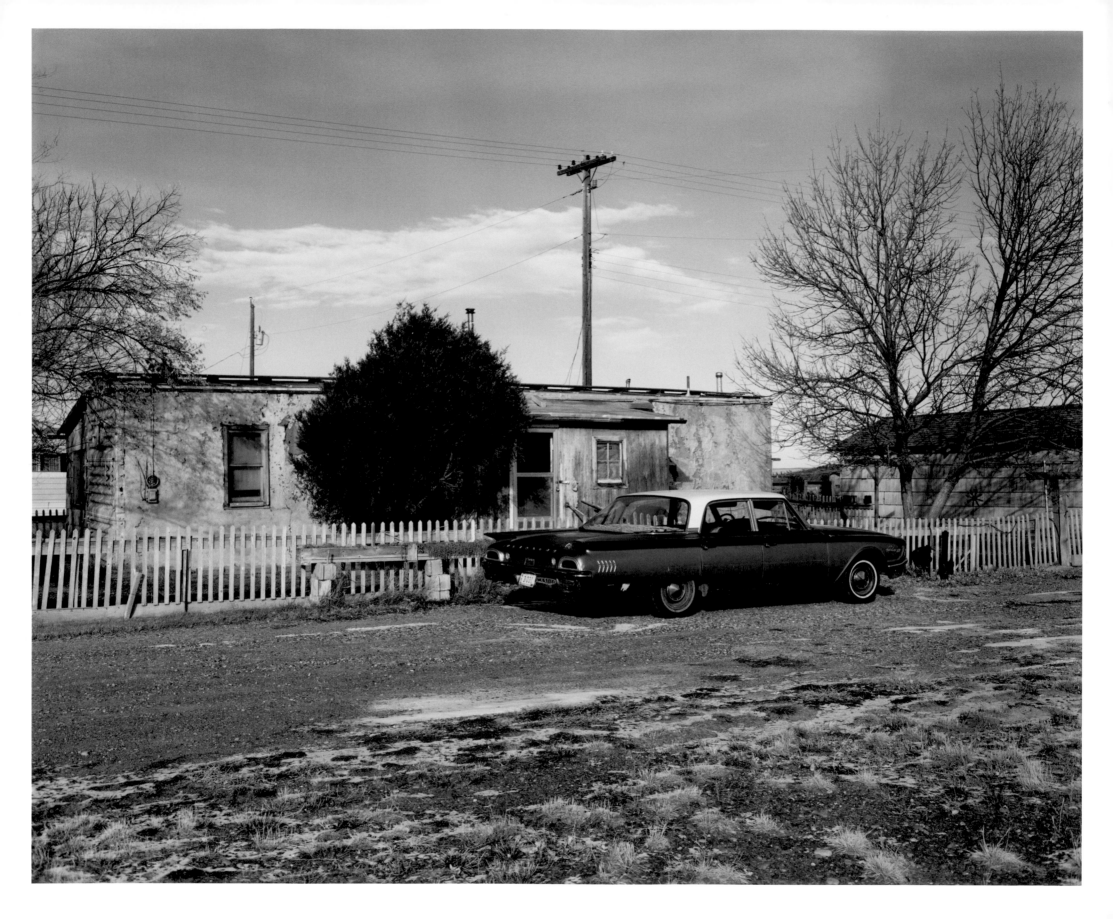

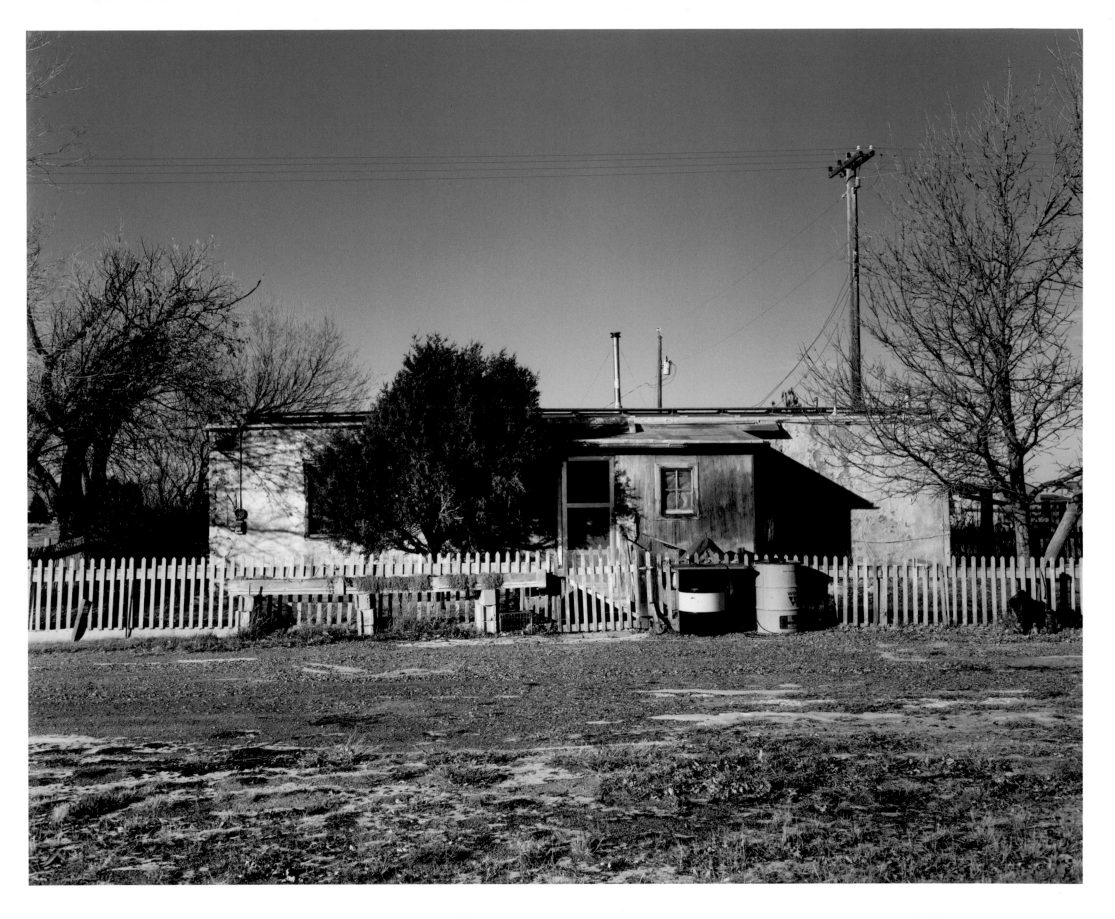

9 Fackrell's Texaco Store & Bar, Atomic City, Idaho

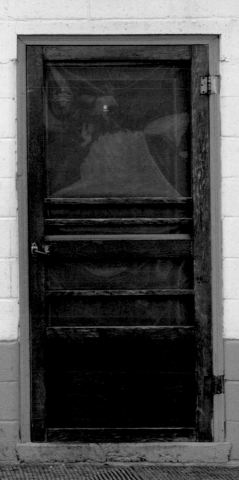

FACKRELL'S SERVICE
STORE · POST OFFICE

UNITED STATES POST OFFICE
ATOMIC CITY, IDA.
ZIP CODE 83215

O FACKRELL

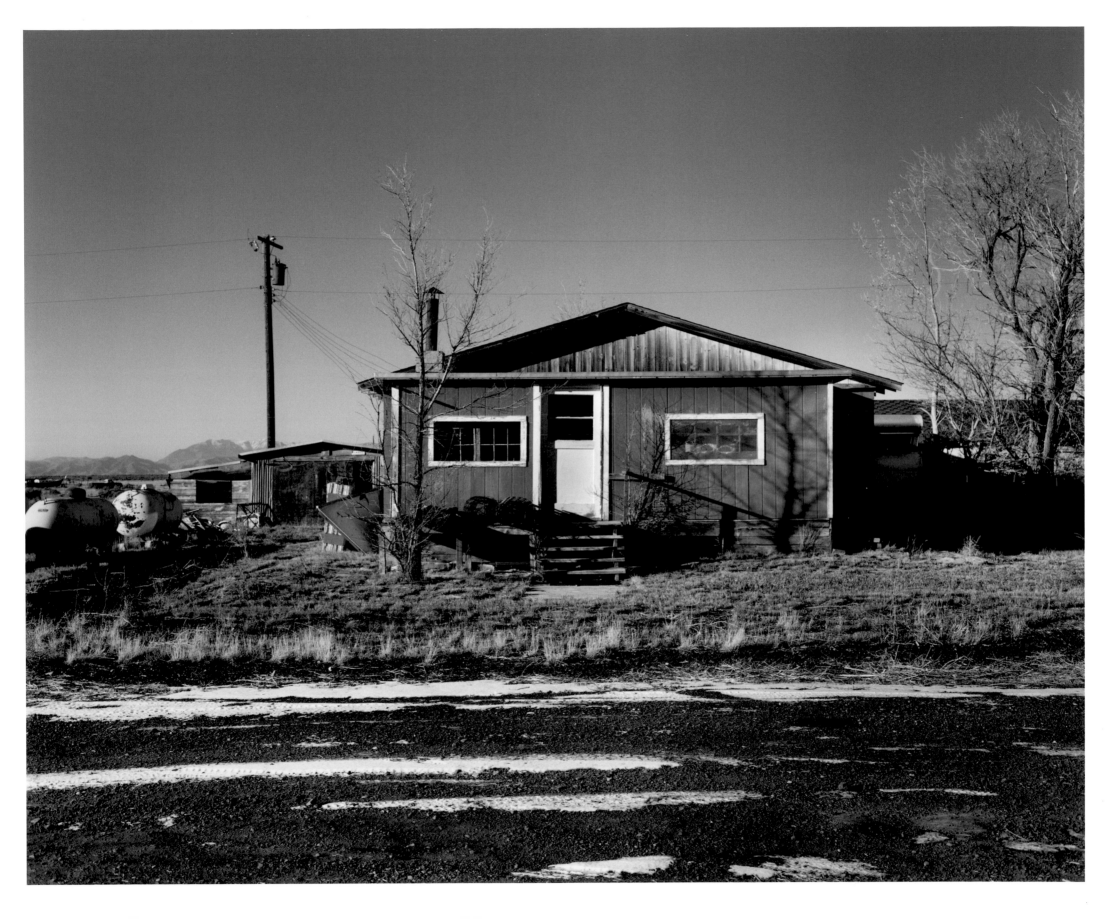

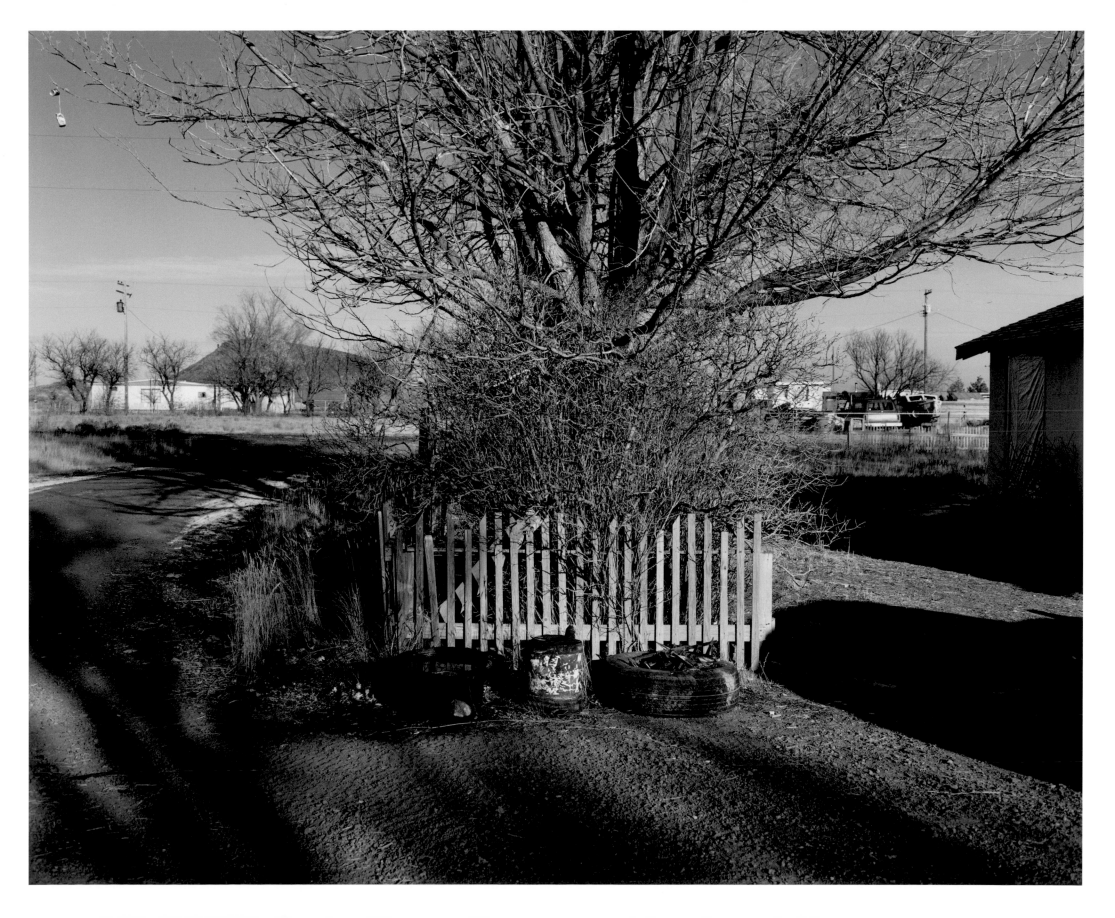

Looking north toward the Sawtooth Mountains, Atomic City, Idaho

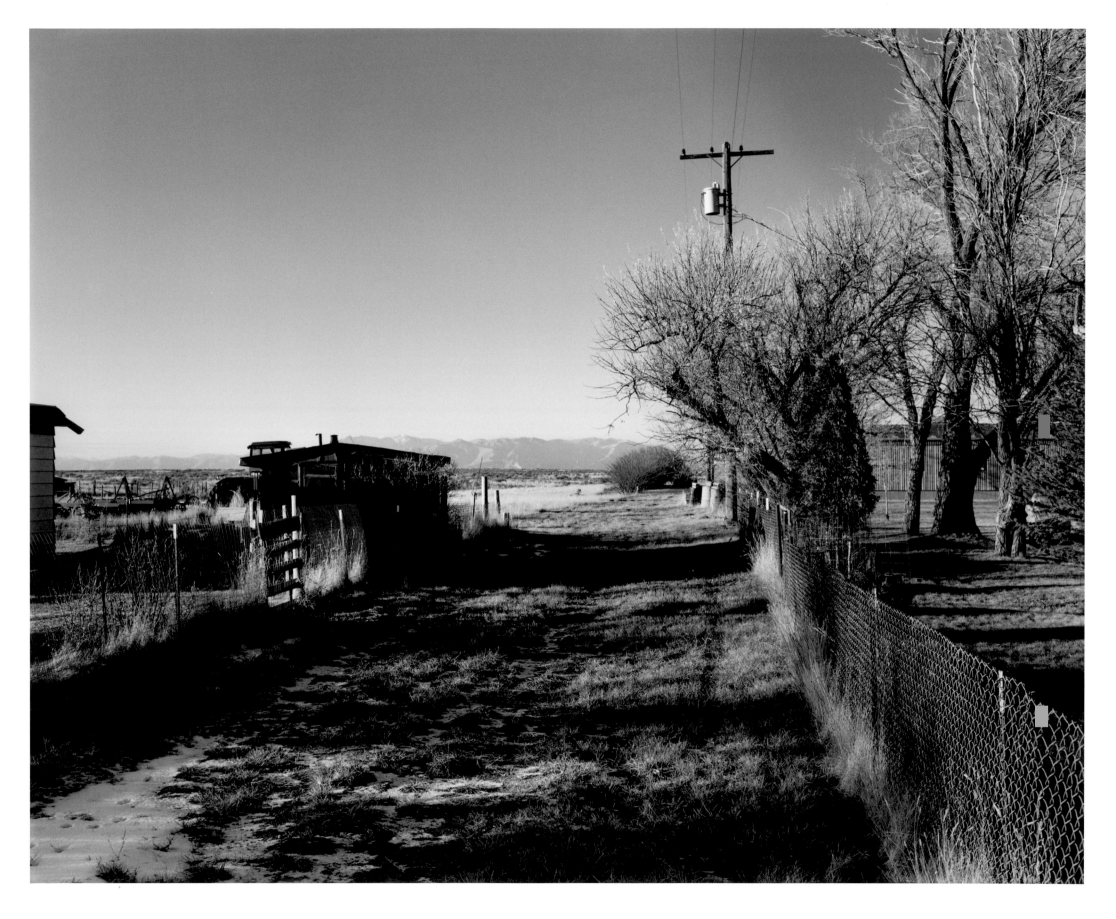

The Richest Hill on Earth 1985–87

13 Mt. Con Mine waste pile and remains of Corktown, Butte, Montana

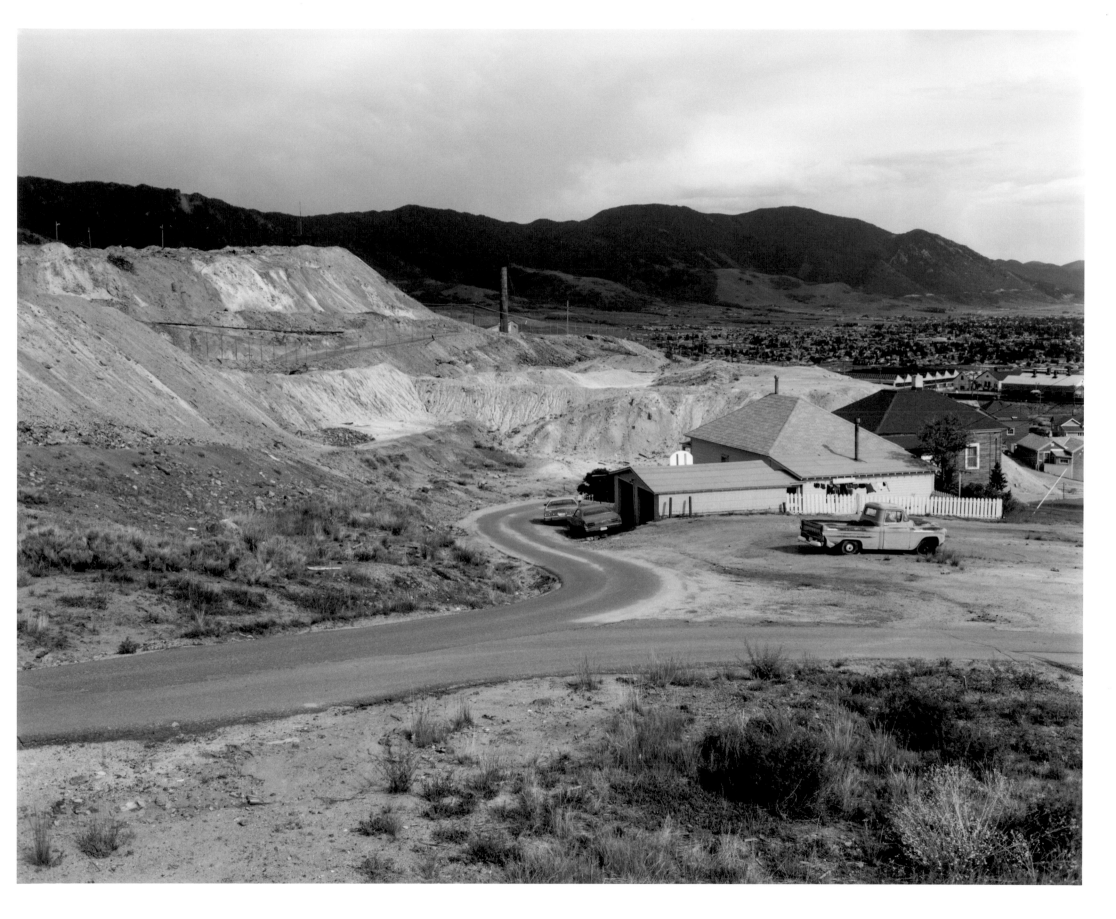

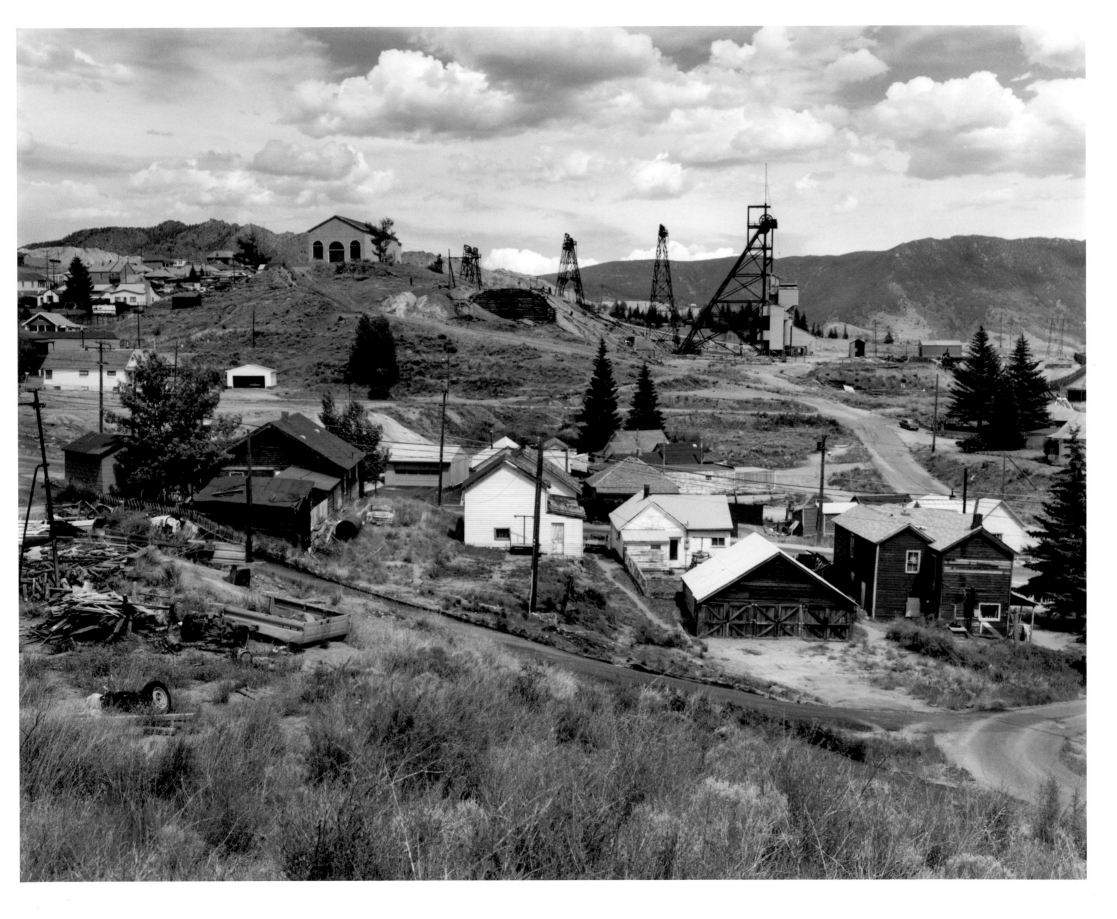

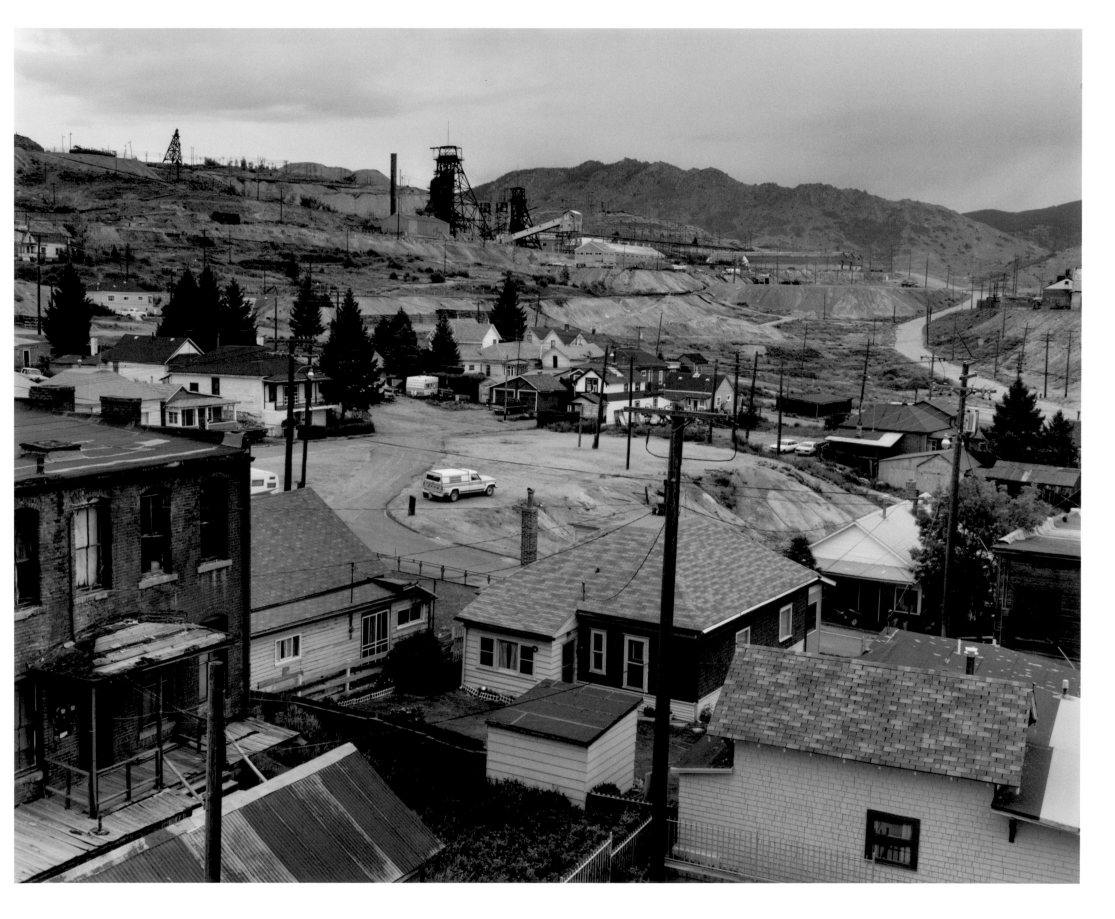

Steward Mine, Original Mine and Dublin Gulch, Butte, Montana

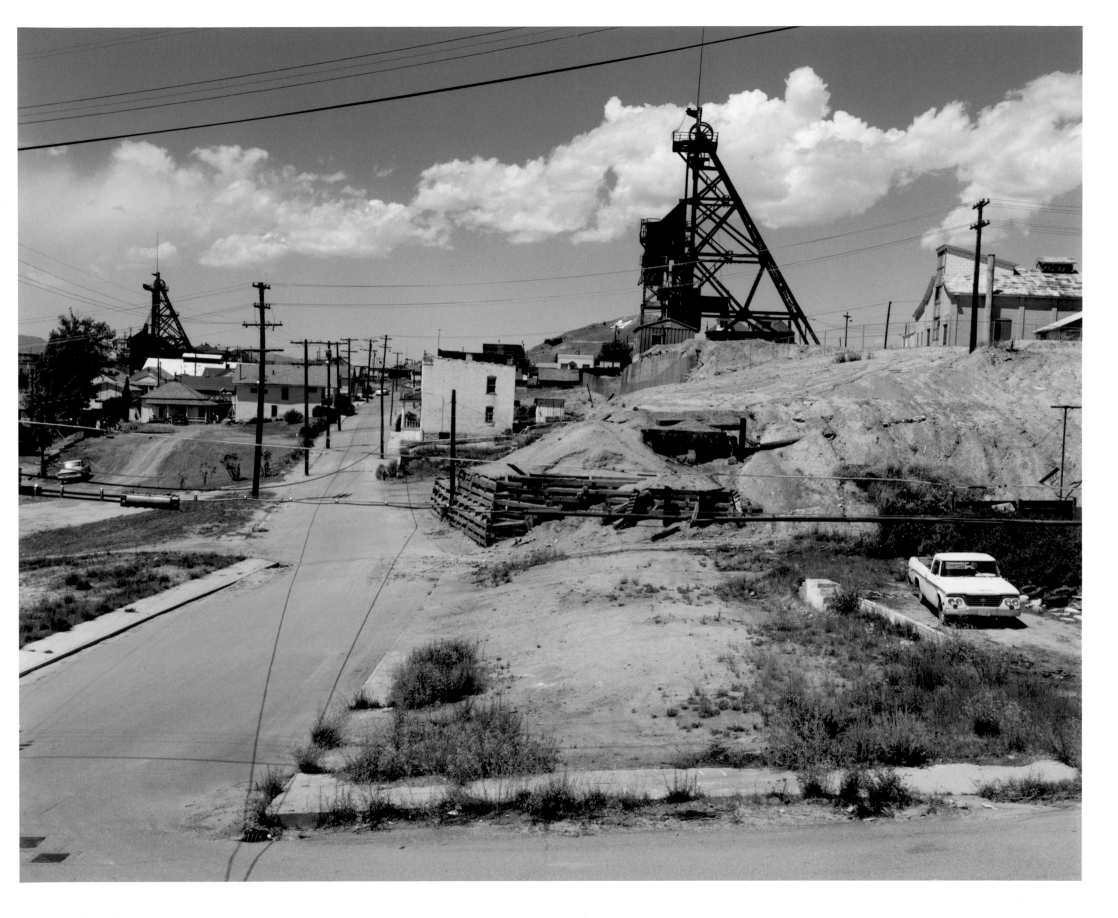

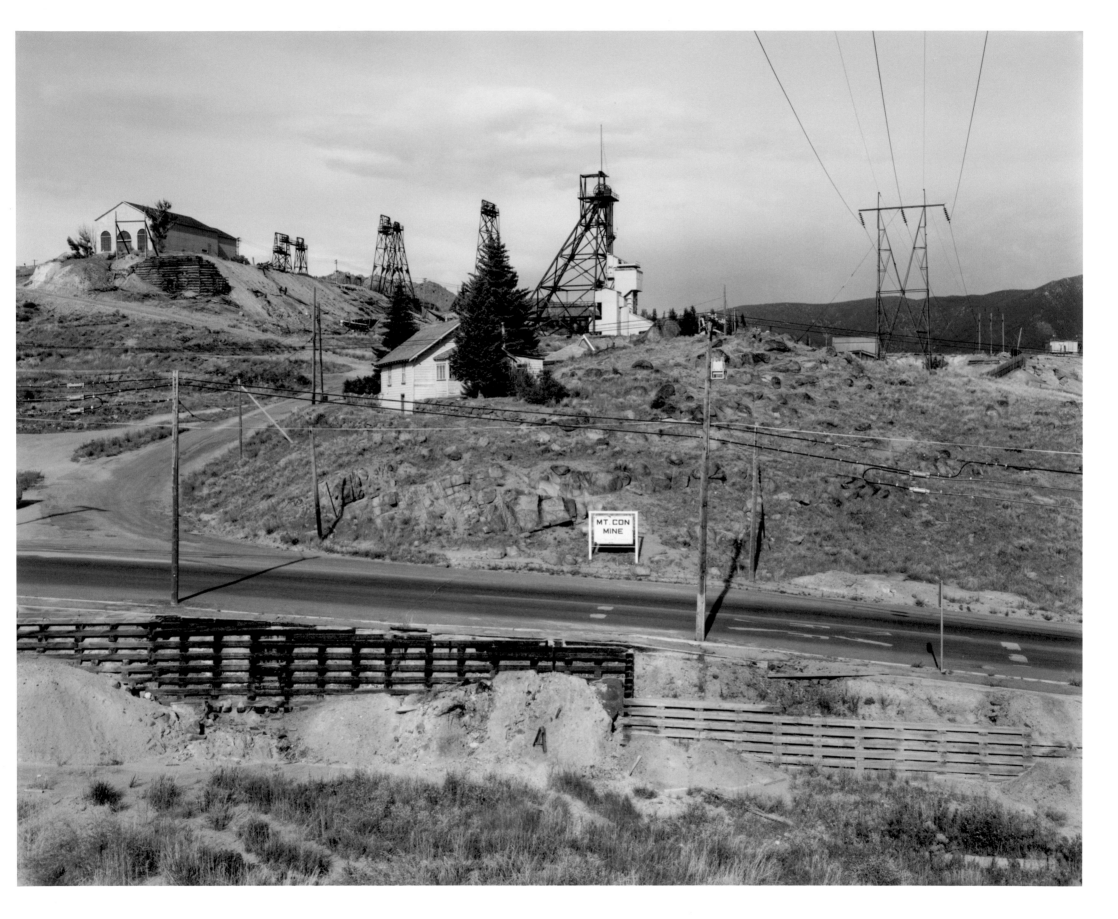

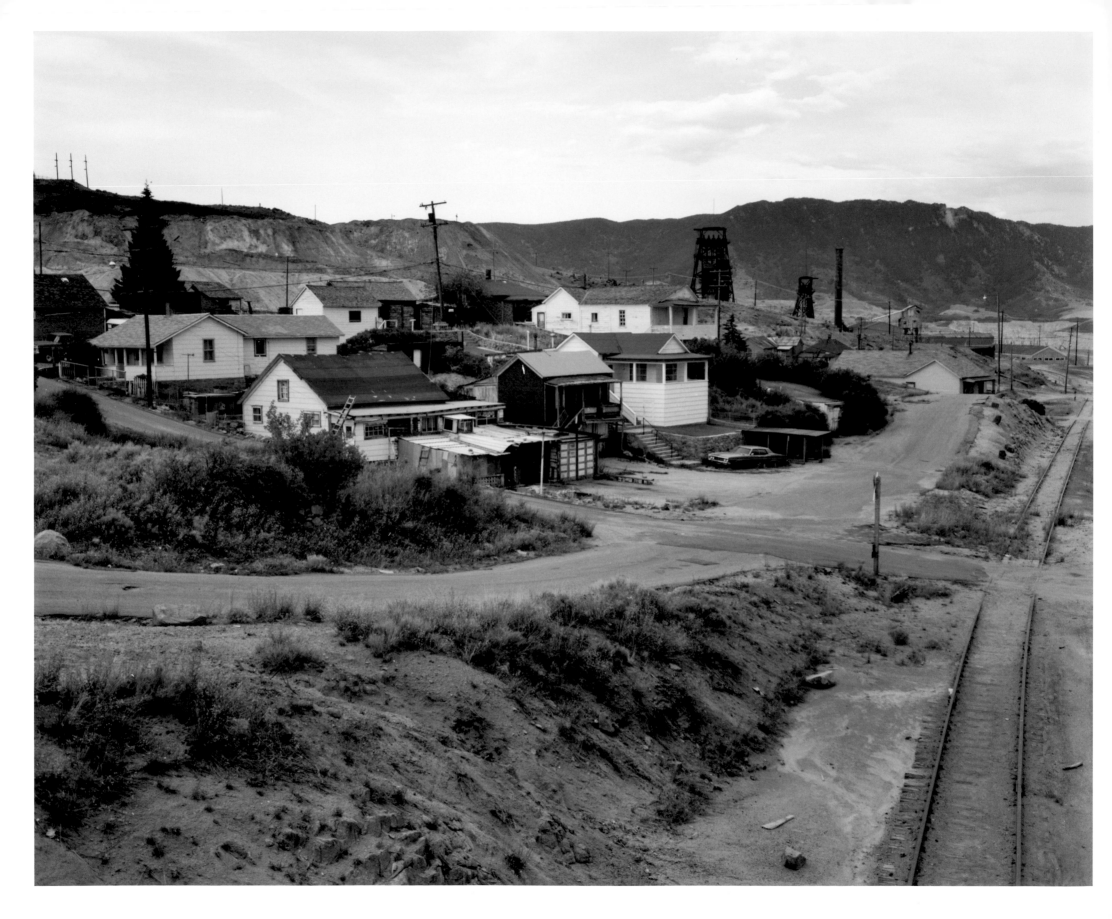

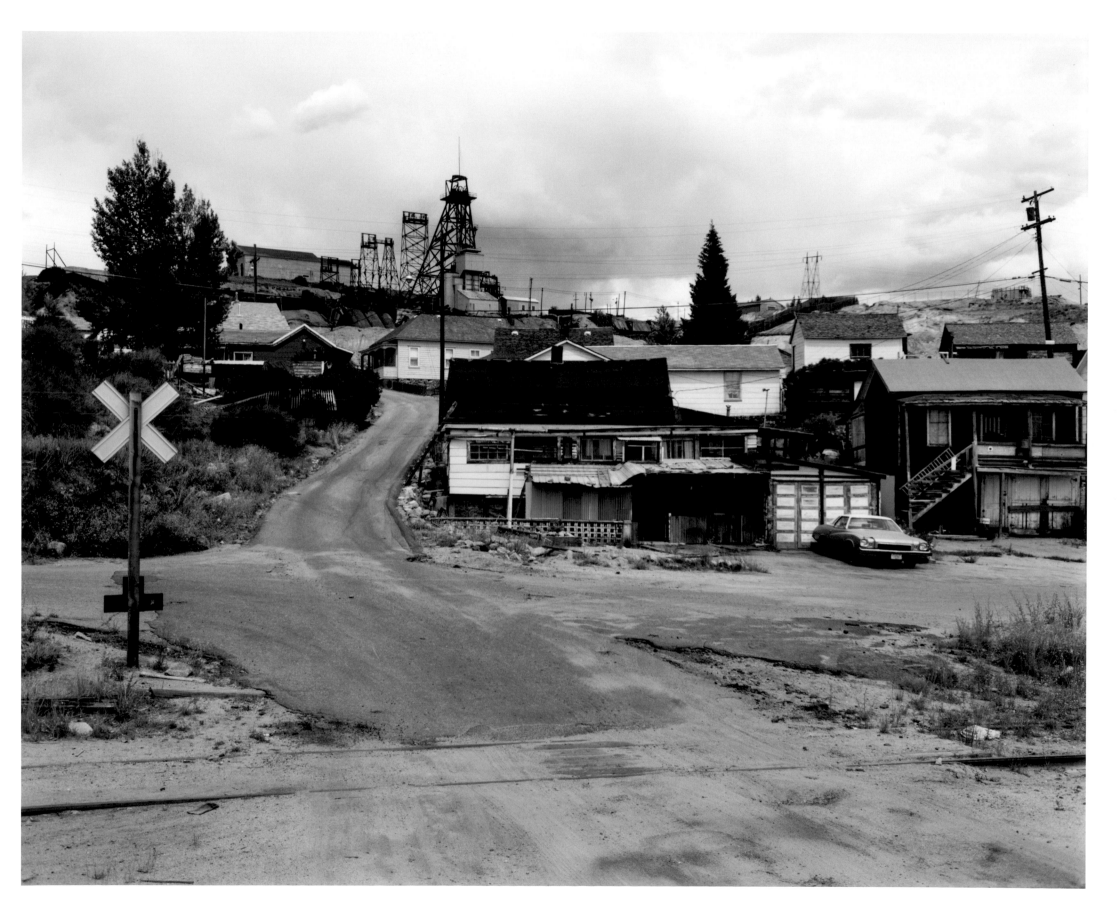

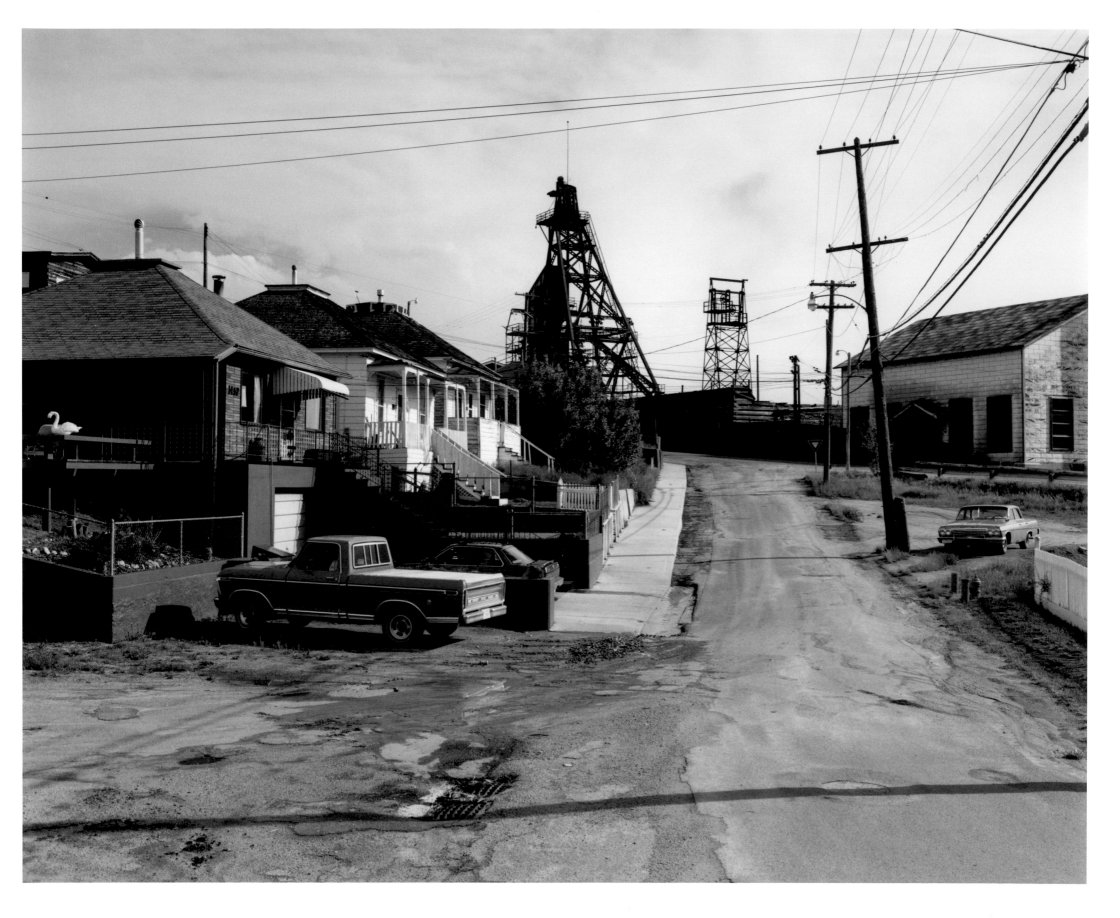

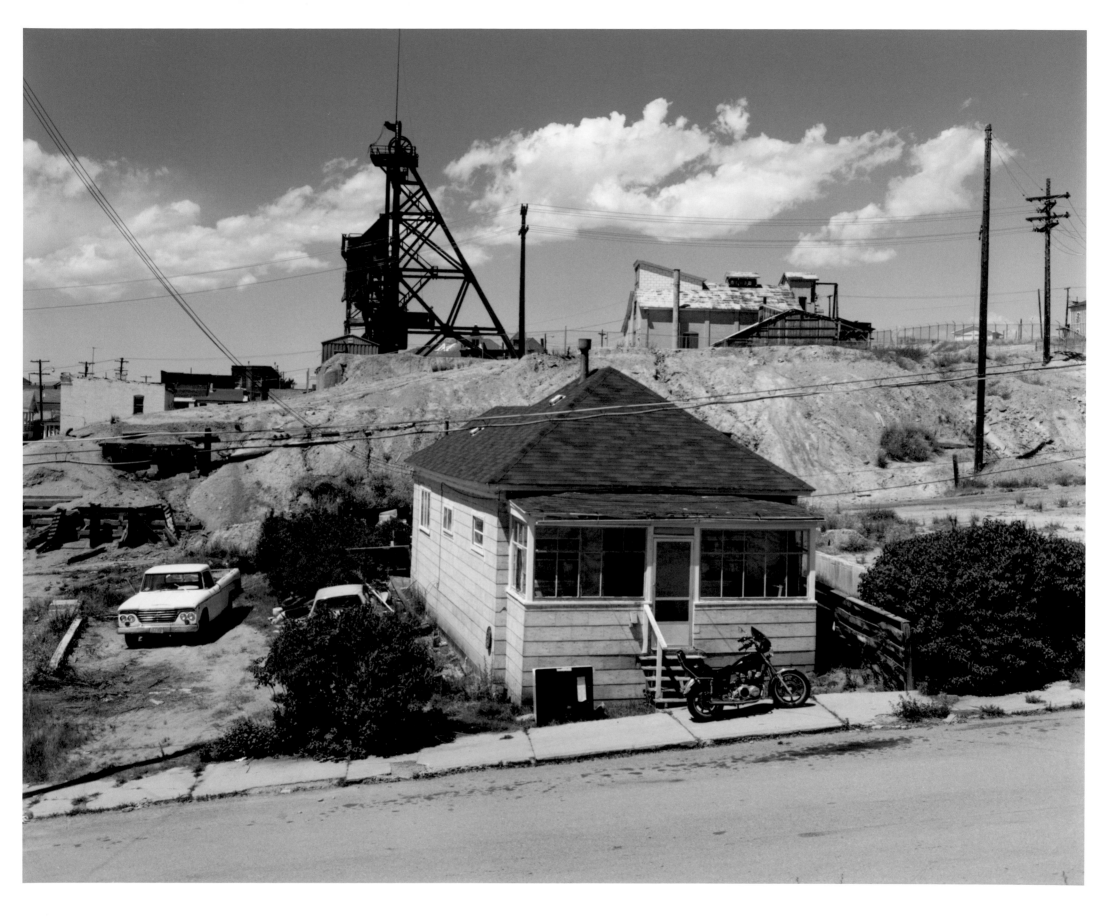

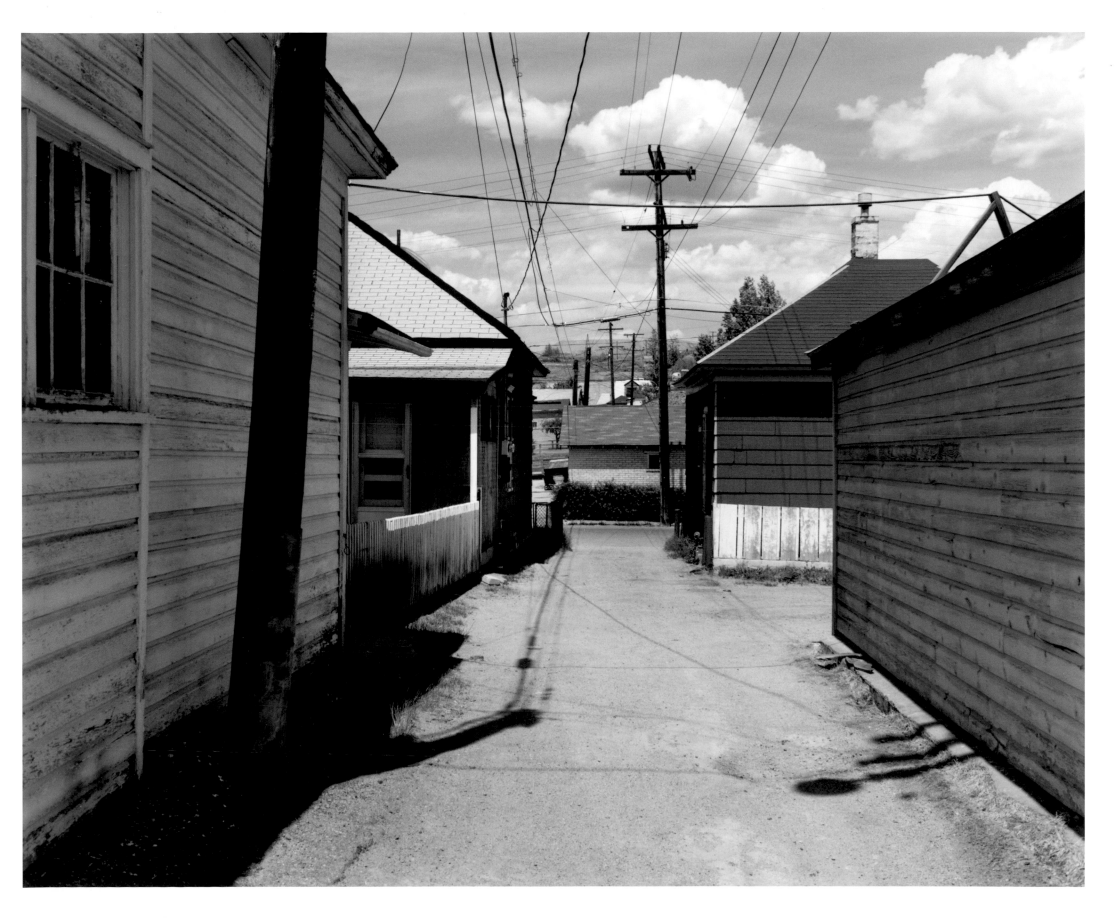

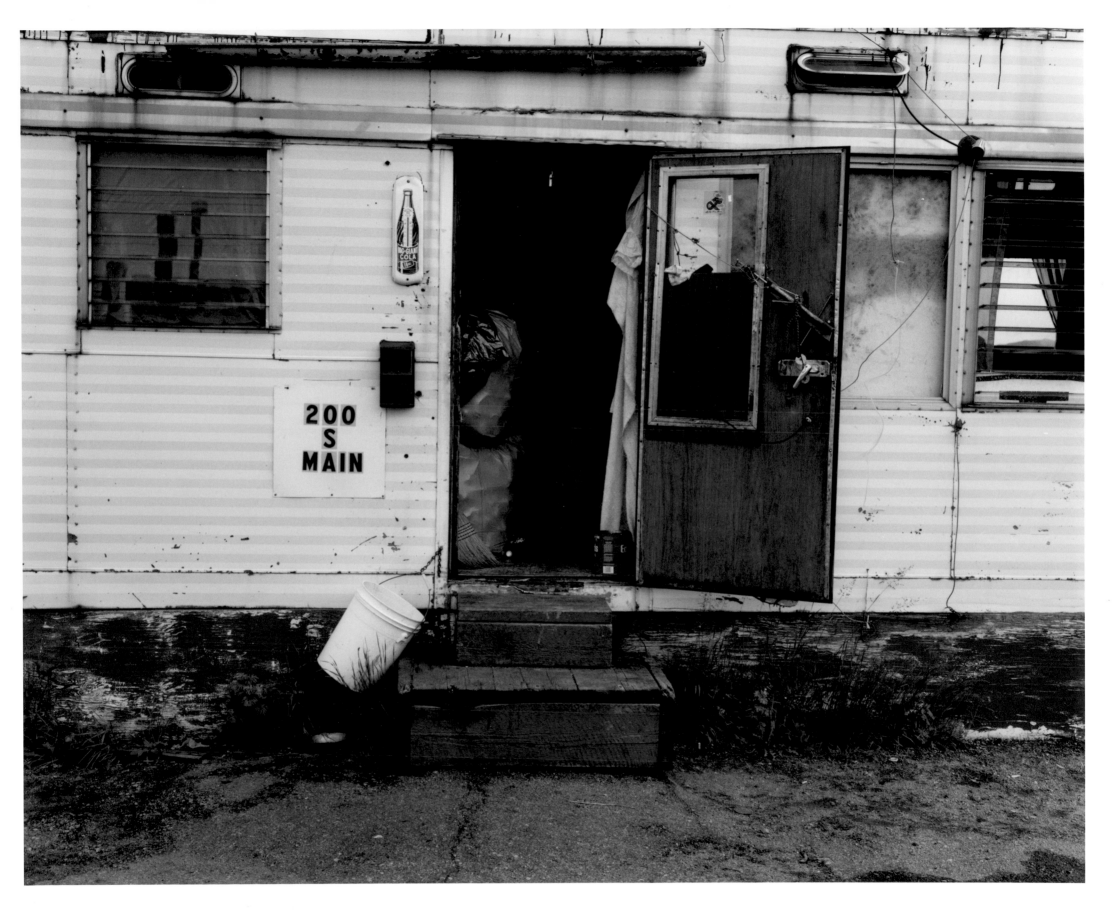

U.S. Property, confiscated home, Butte, Montana

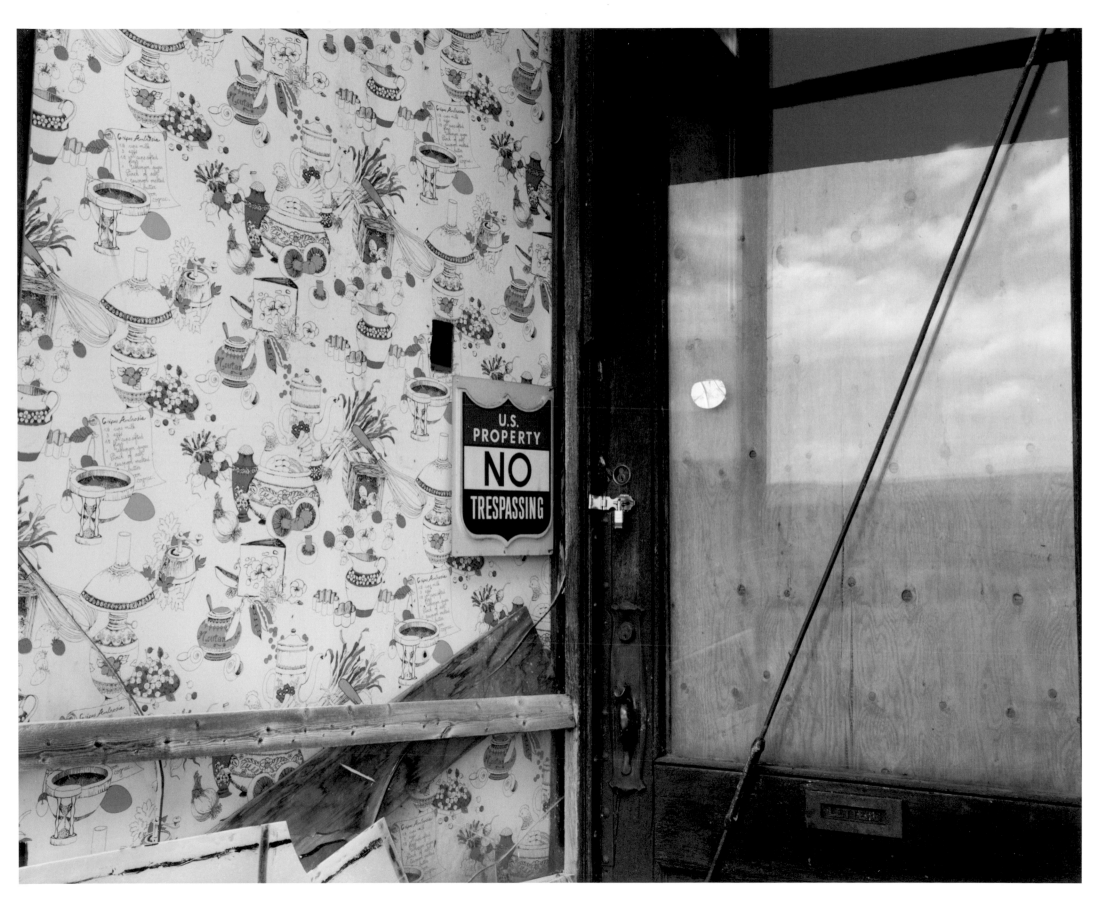

Butte, Anaconda and Pacific Railway yard along Silver Bow Creek, Butte, Montana

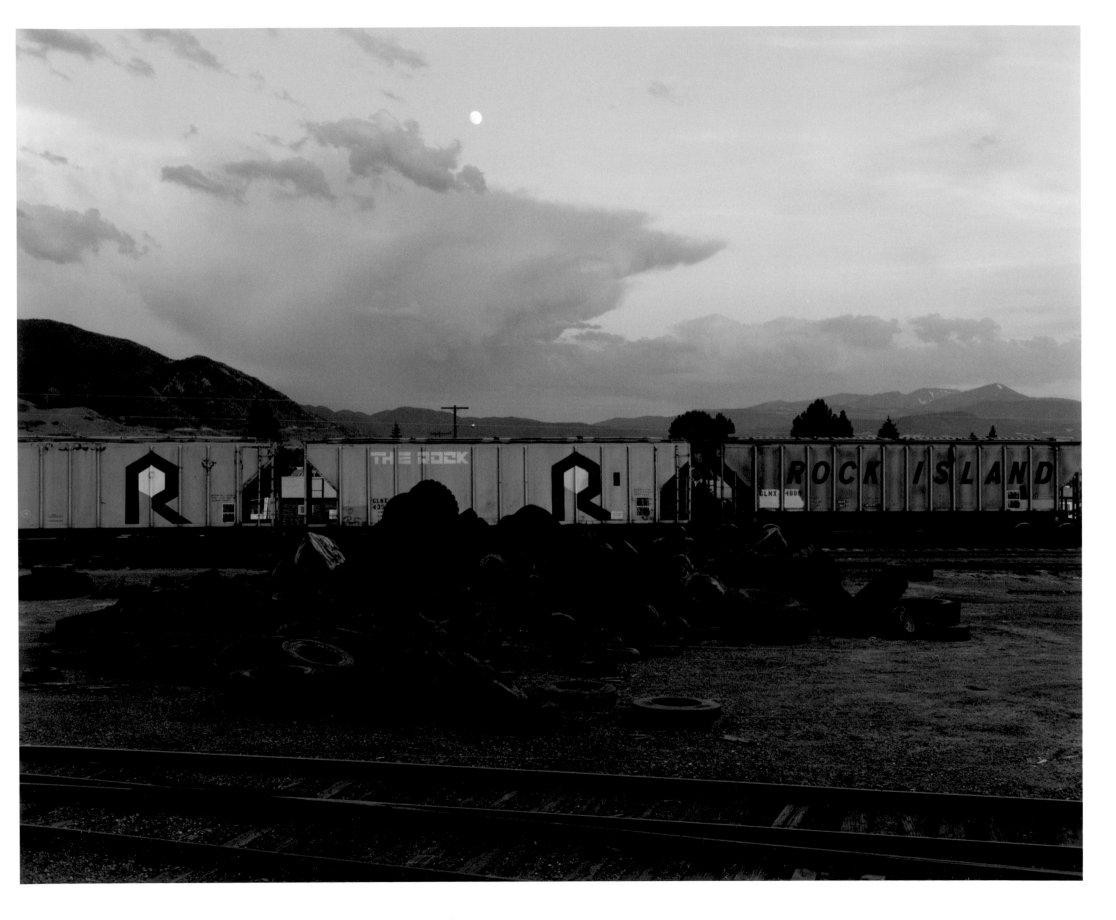

Slag and mine waste along Silver Bow Creek, Butte, Montana

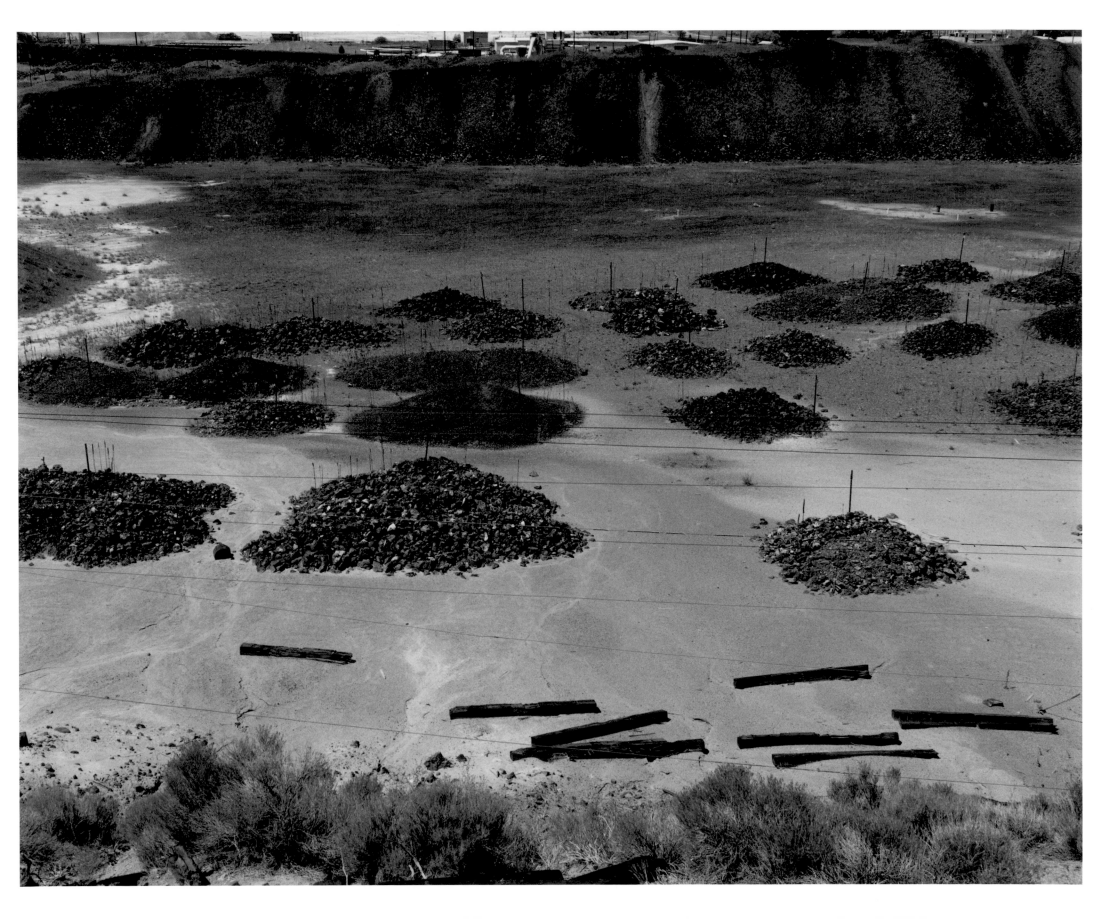

Slag and mine waste along Silver Bow Creek, Butte, Montana

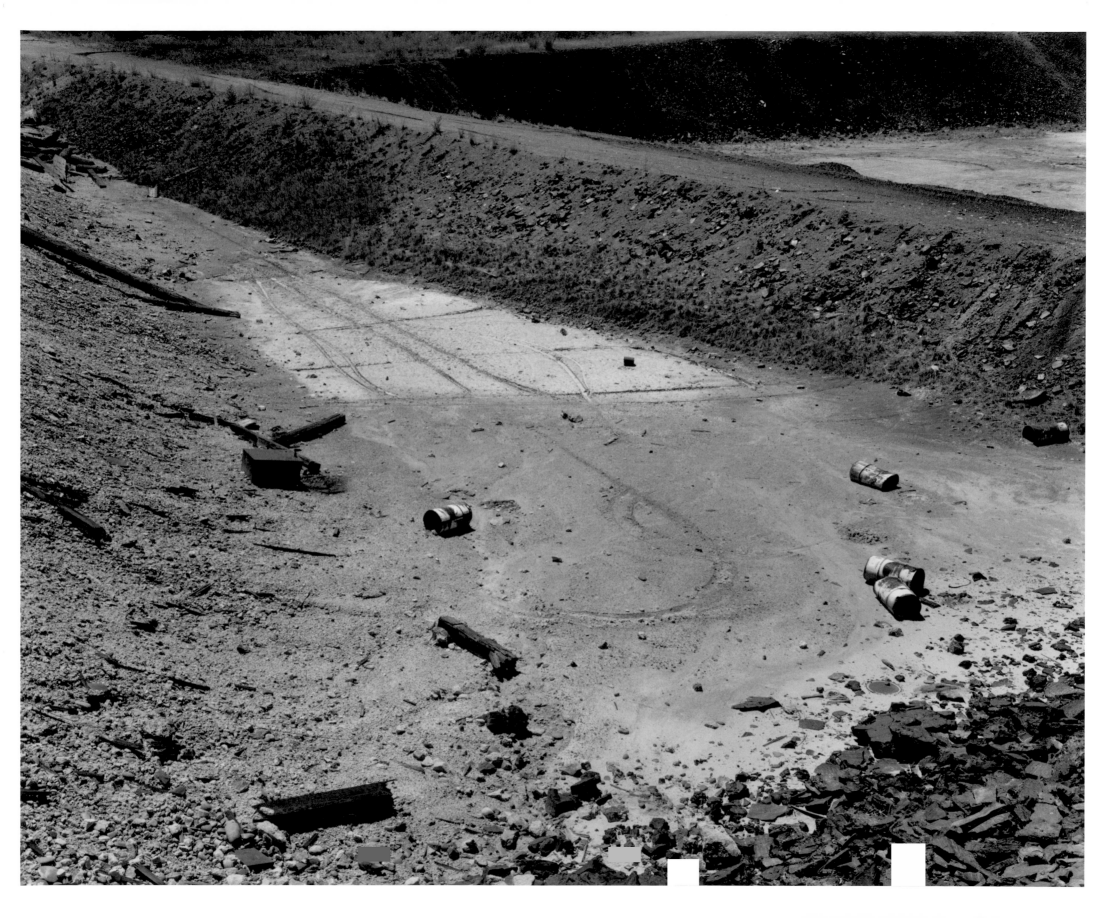

Silver Bow Creek polluted by mine waste, Butte, Montana

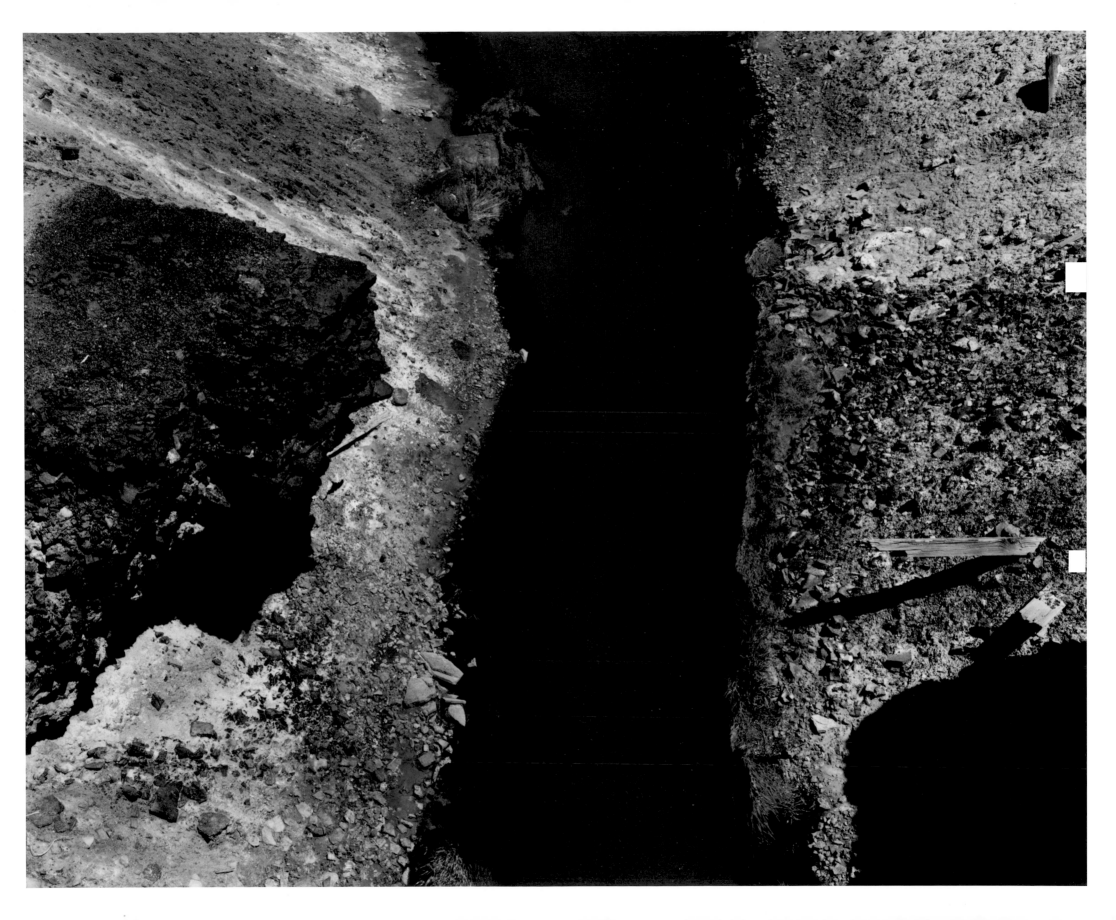

Wilderness to Wasteland 1985–86

Forest fire recovery area and the Upper Gallatin River, Gallatin County, Montana

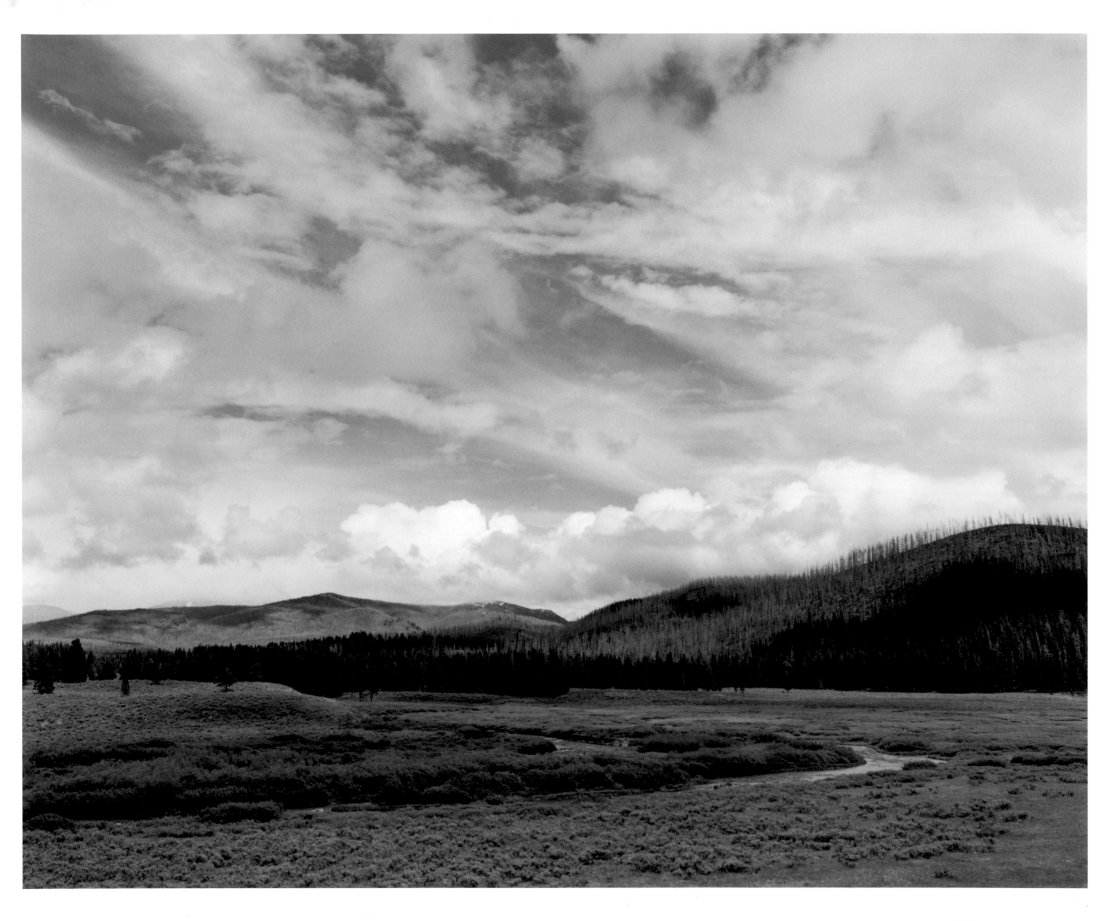

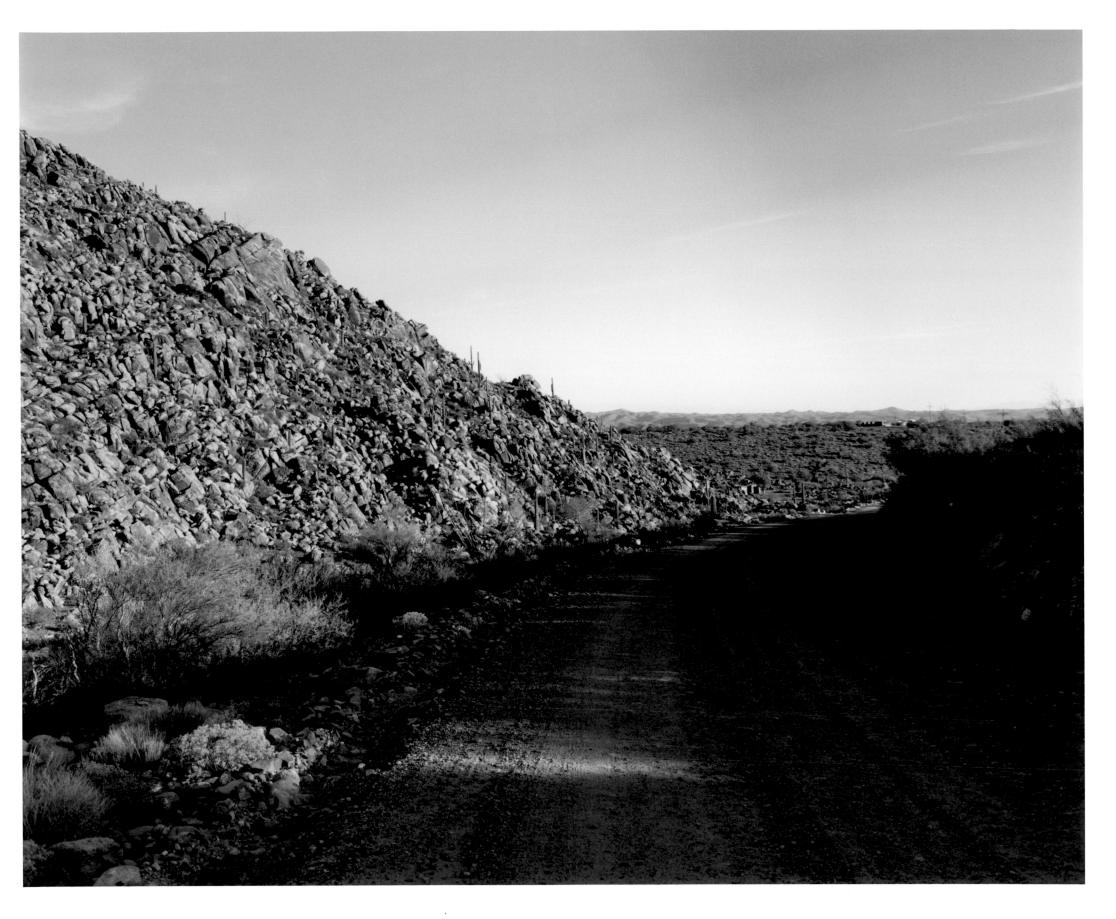

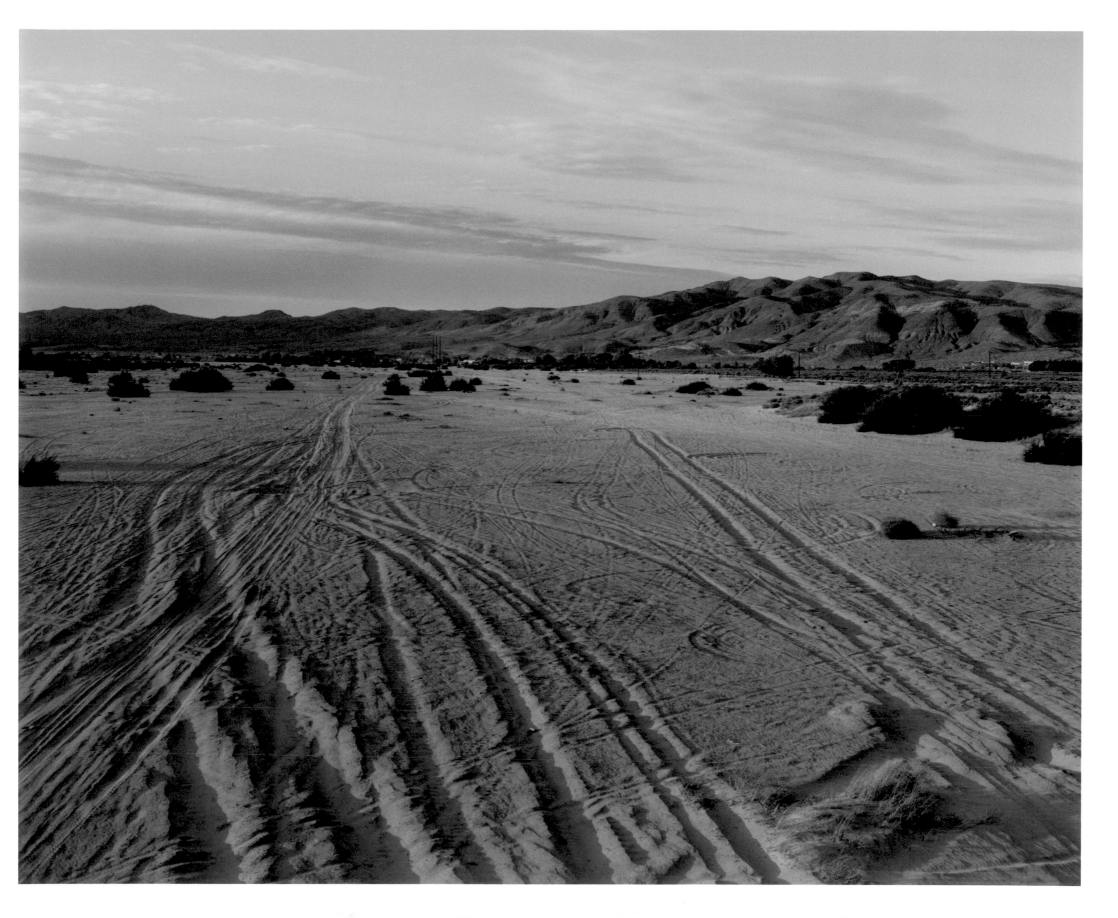

New housing development, Rancho Cucamonga, California

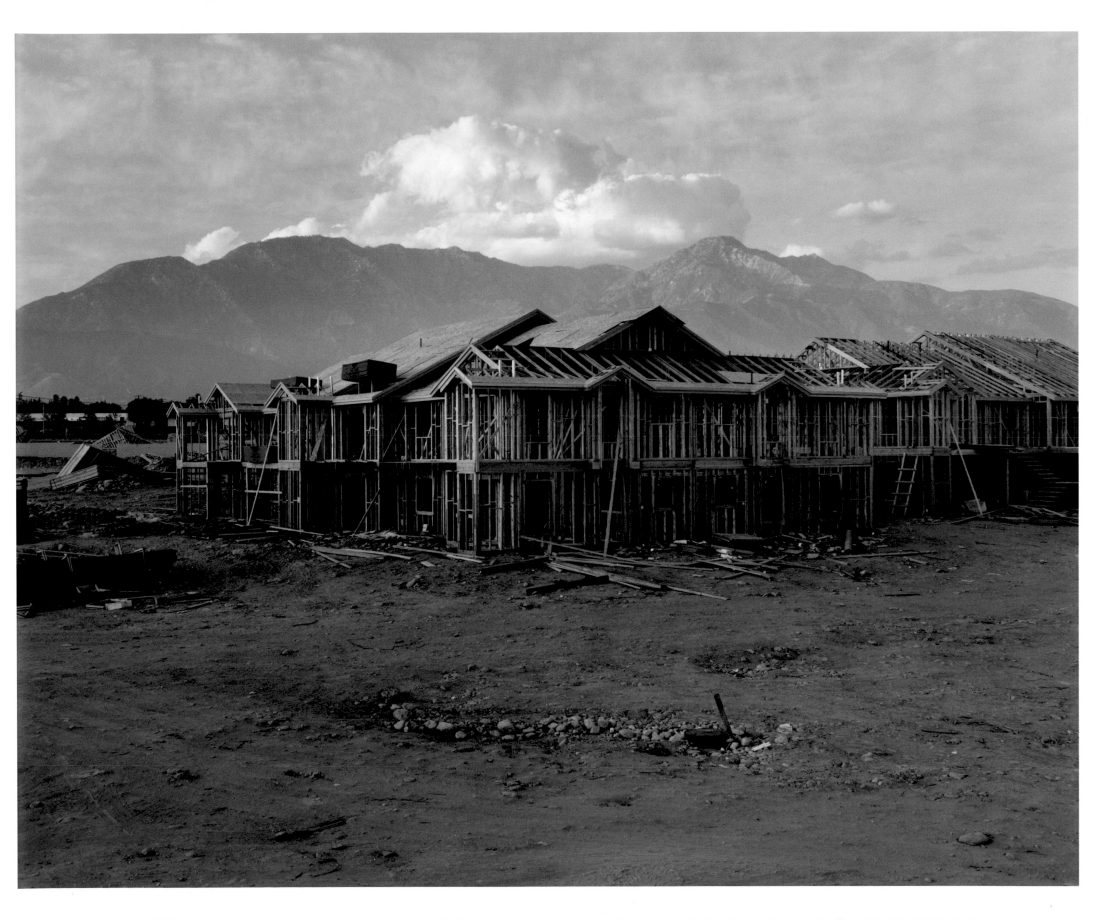

Interstate 15 near Barstow, California

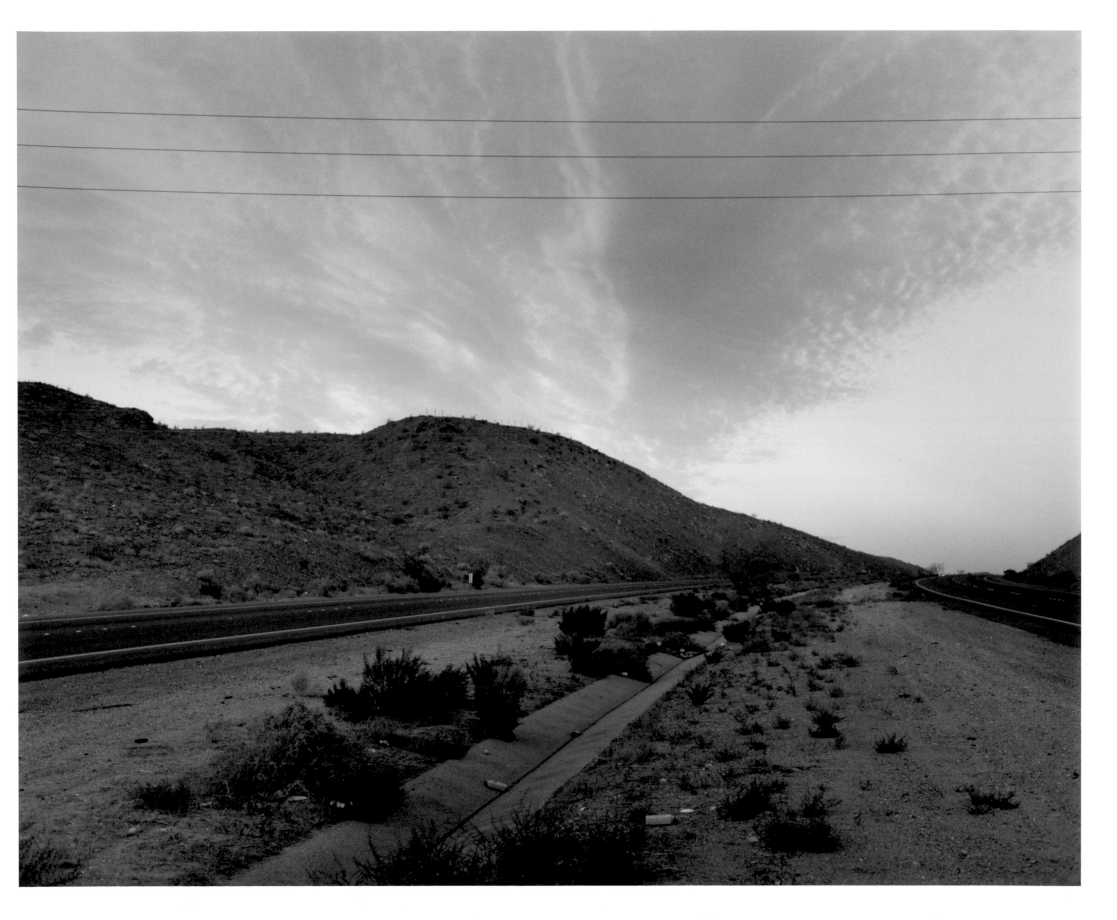

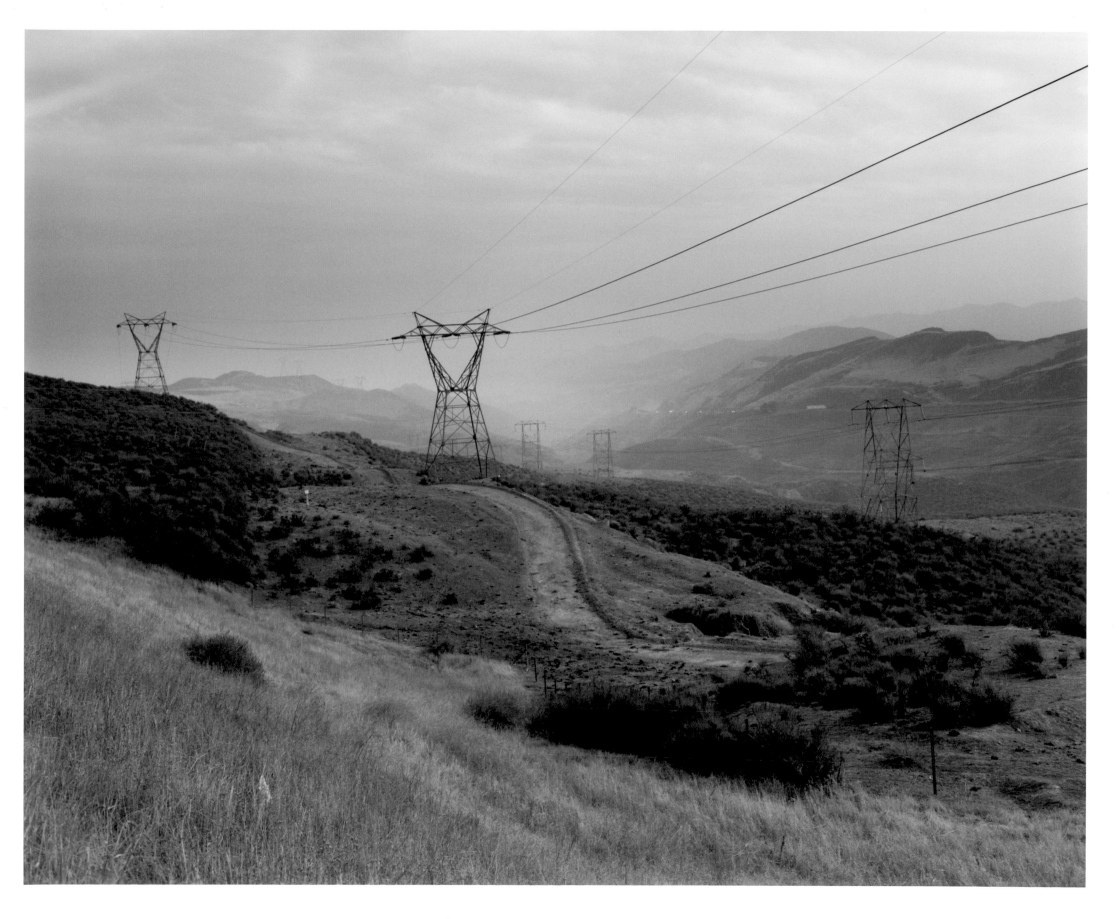

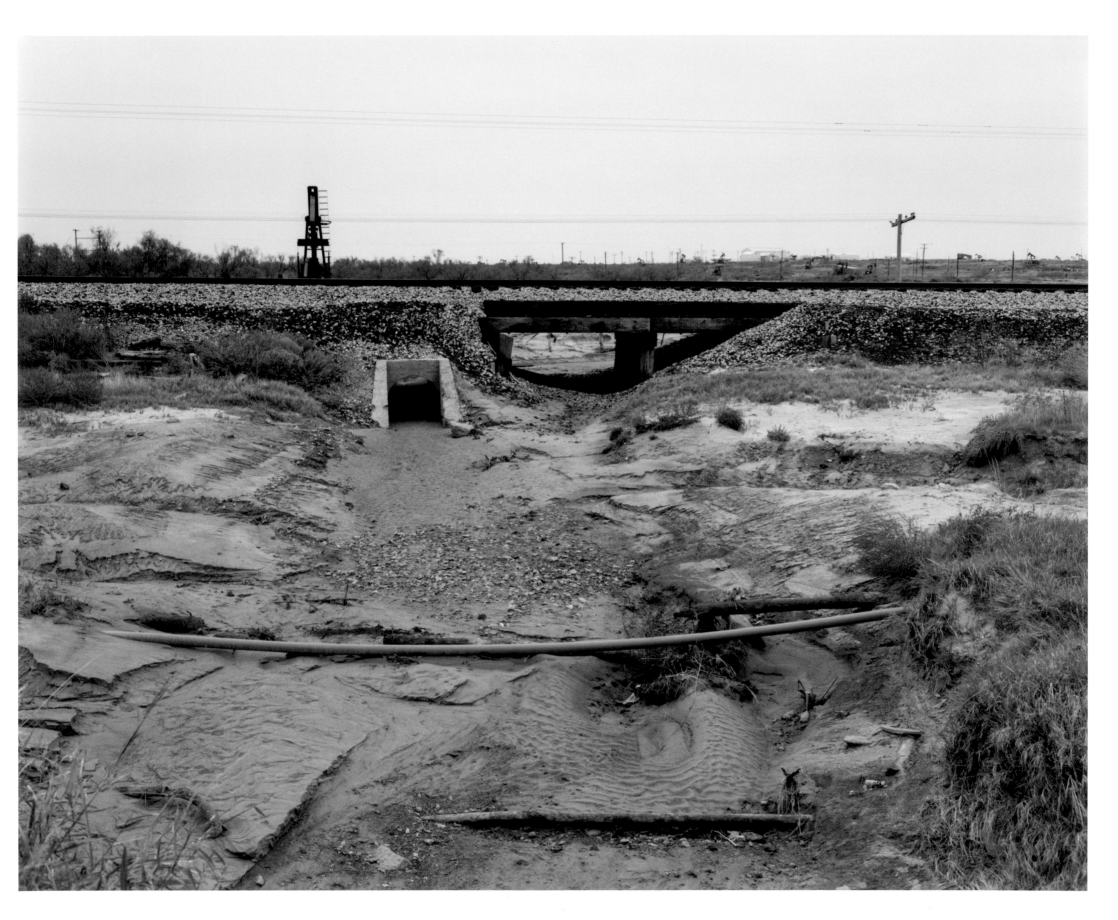

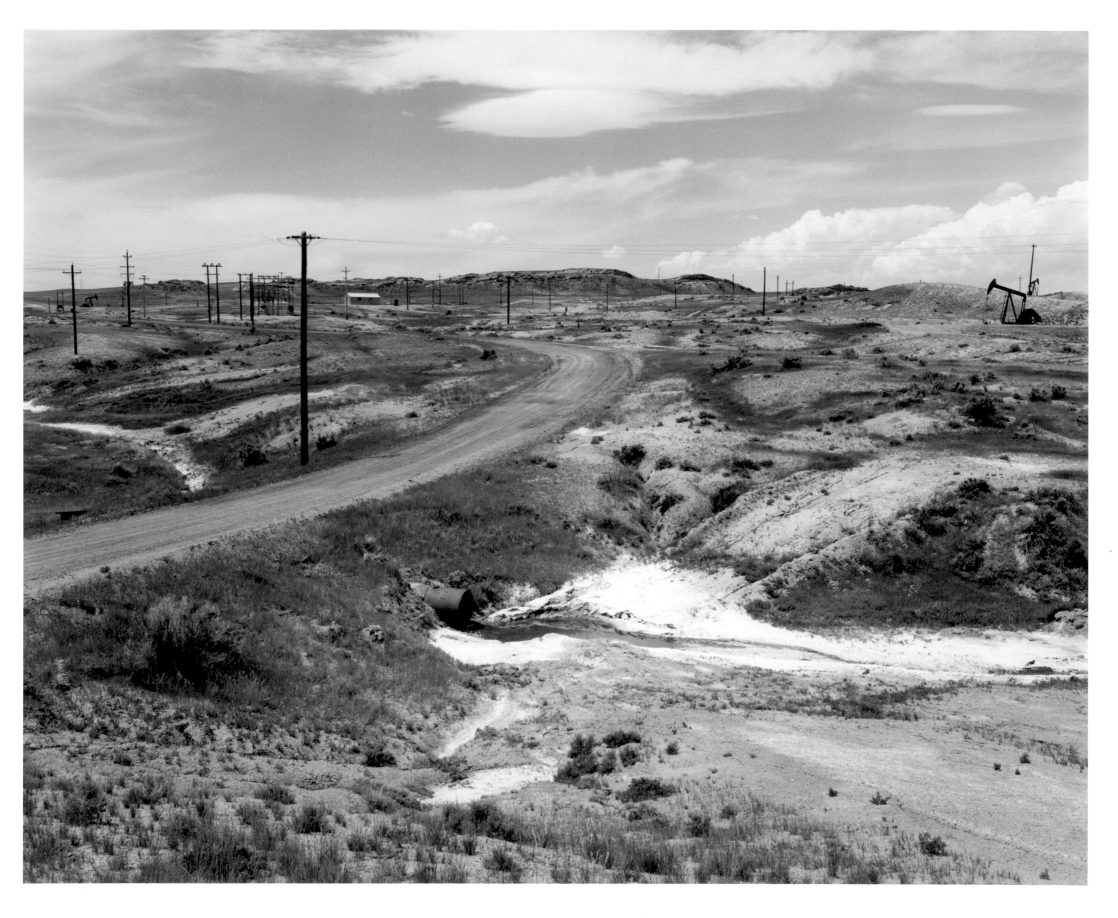

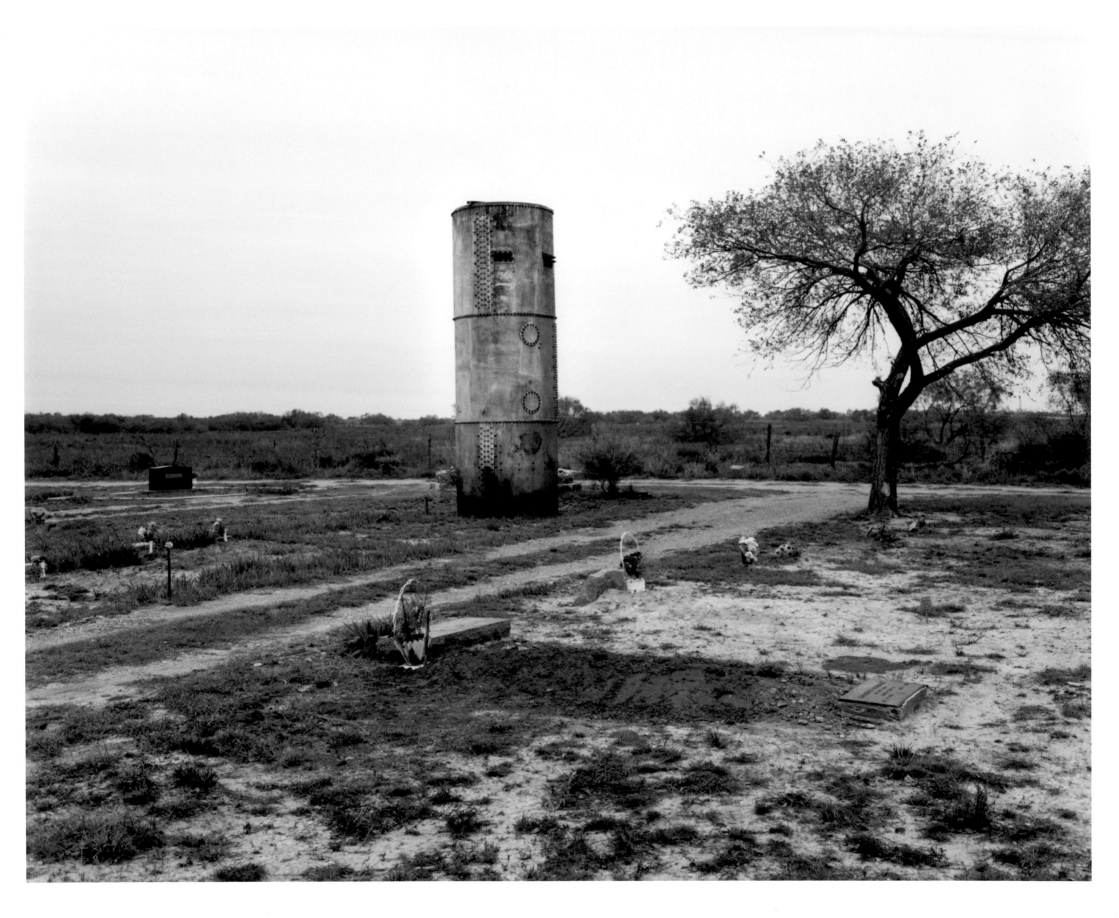

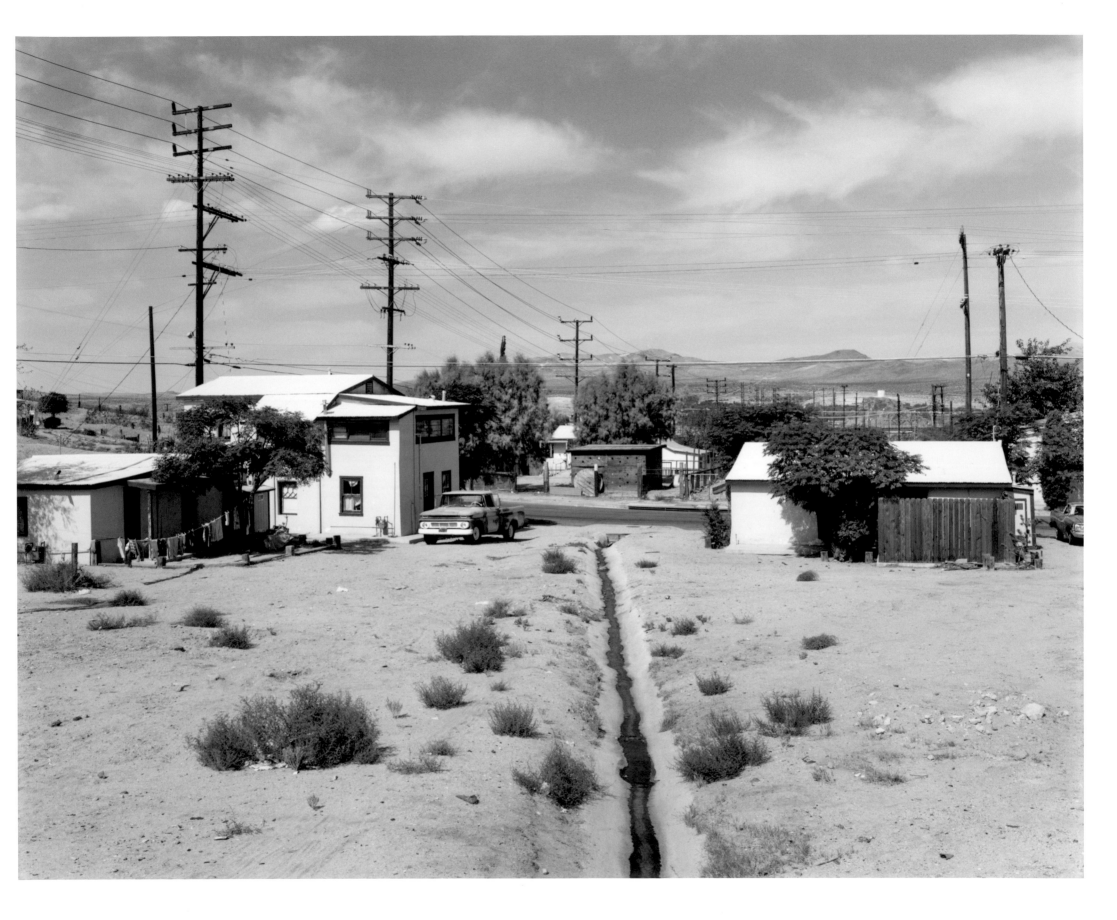

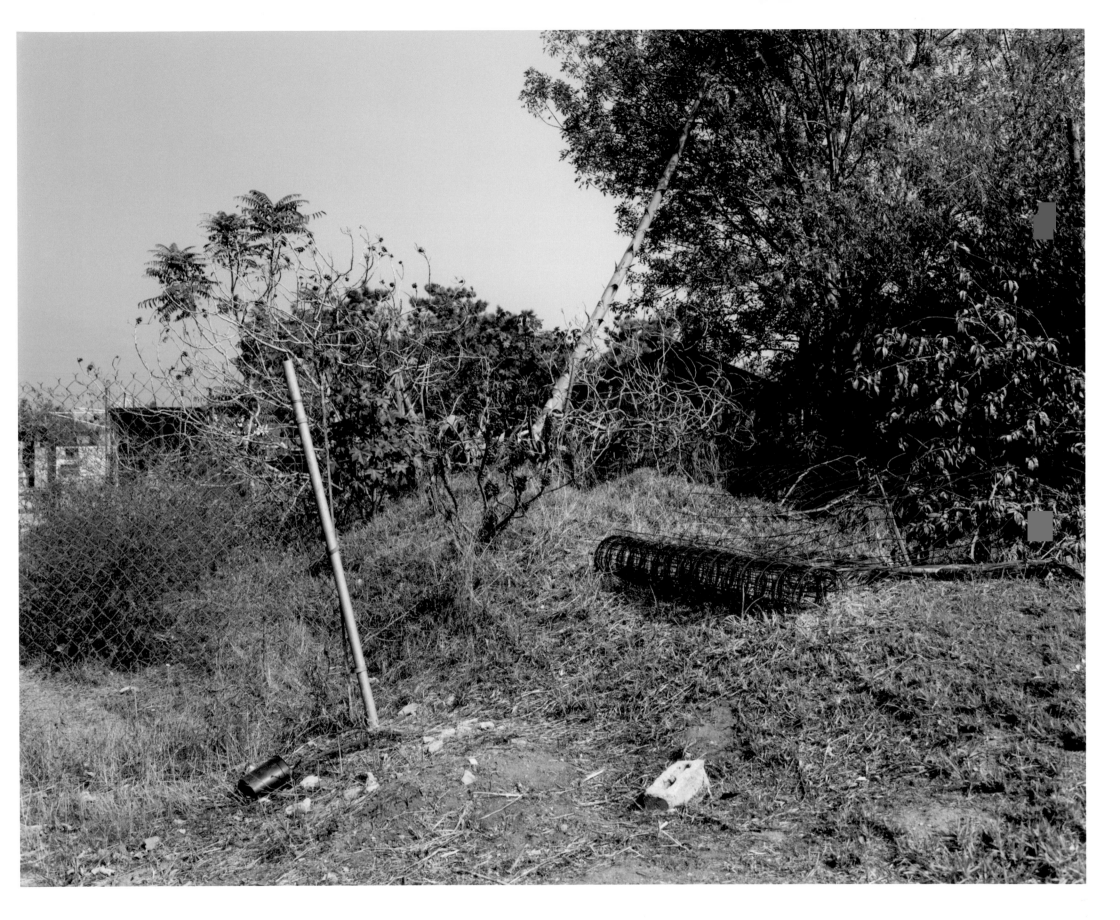

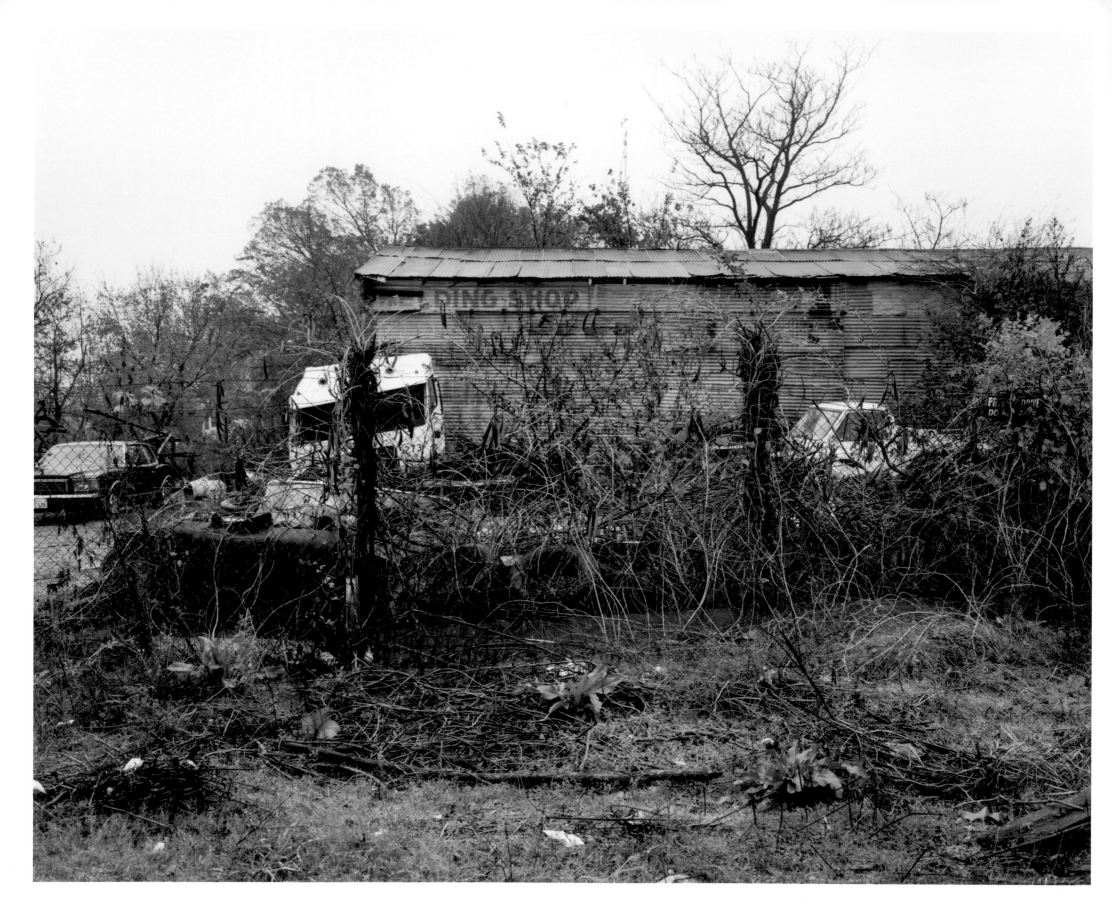

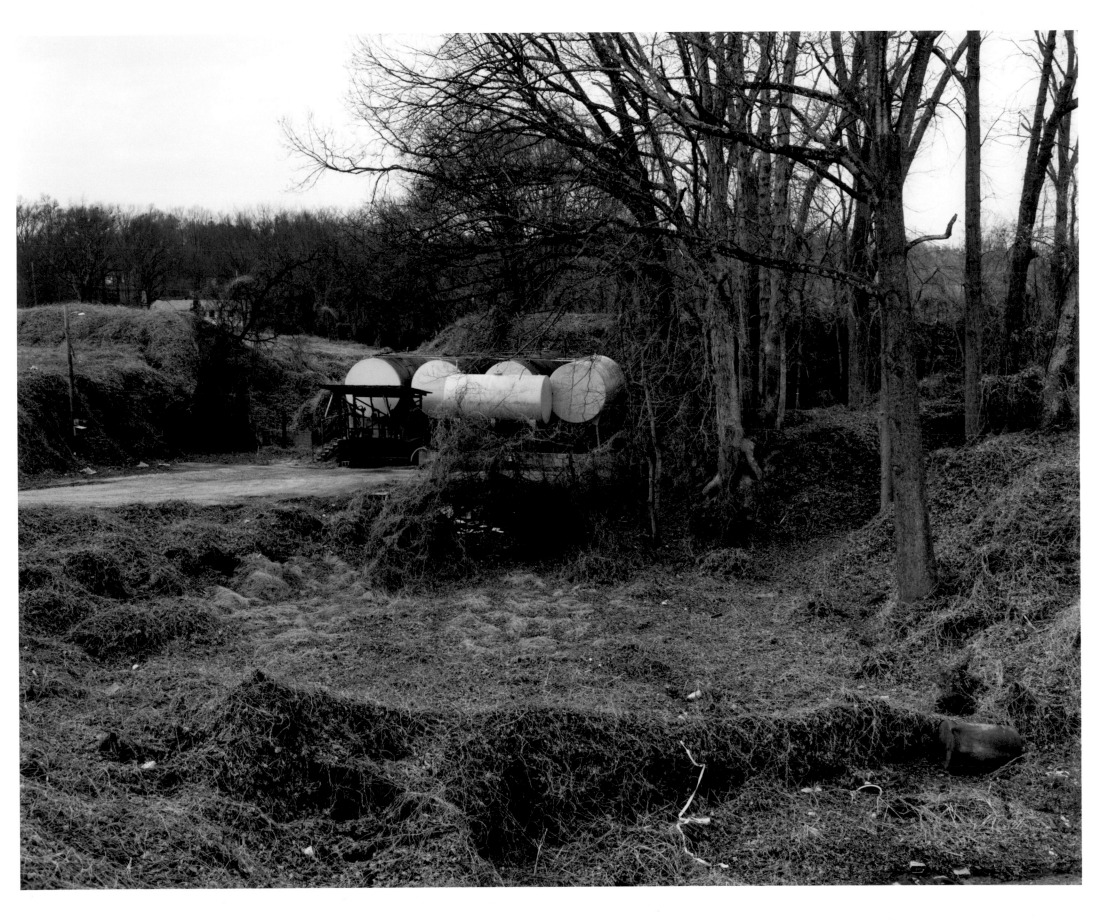

Next to Florida State Highway 84, Everglades, Collier County, Florida

43 Ft. Worth-Dallas Club, next to the Pantex nuclear weapons plant, Carson County, Texas

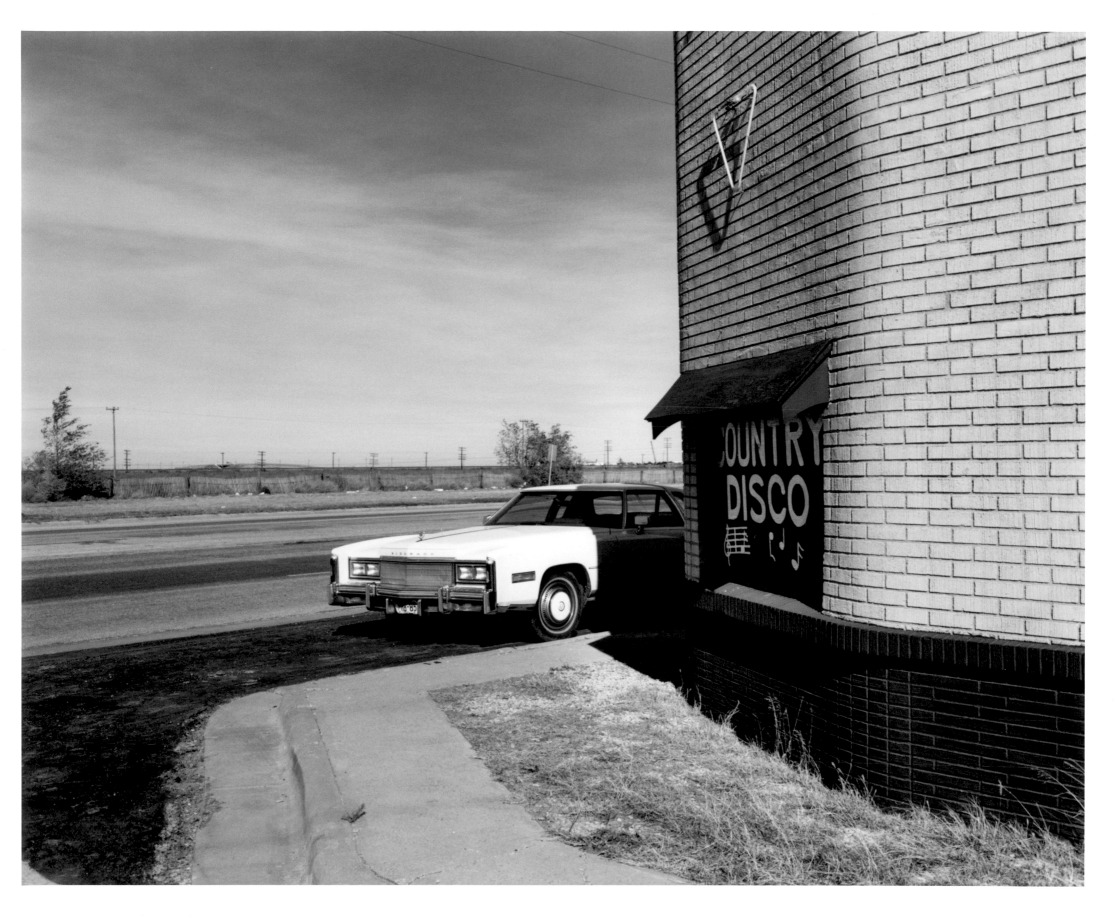

44 Baker, California

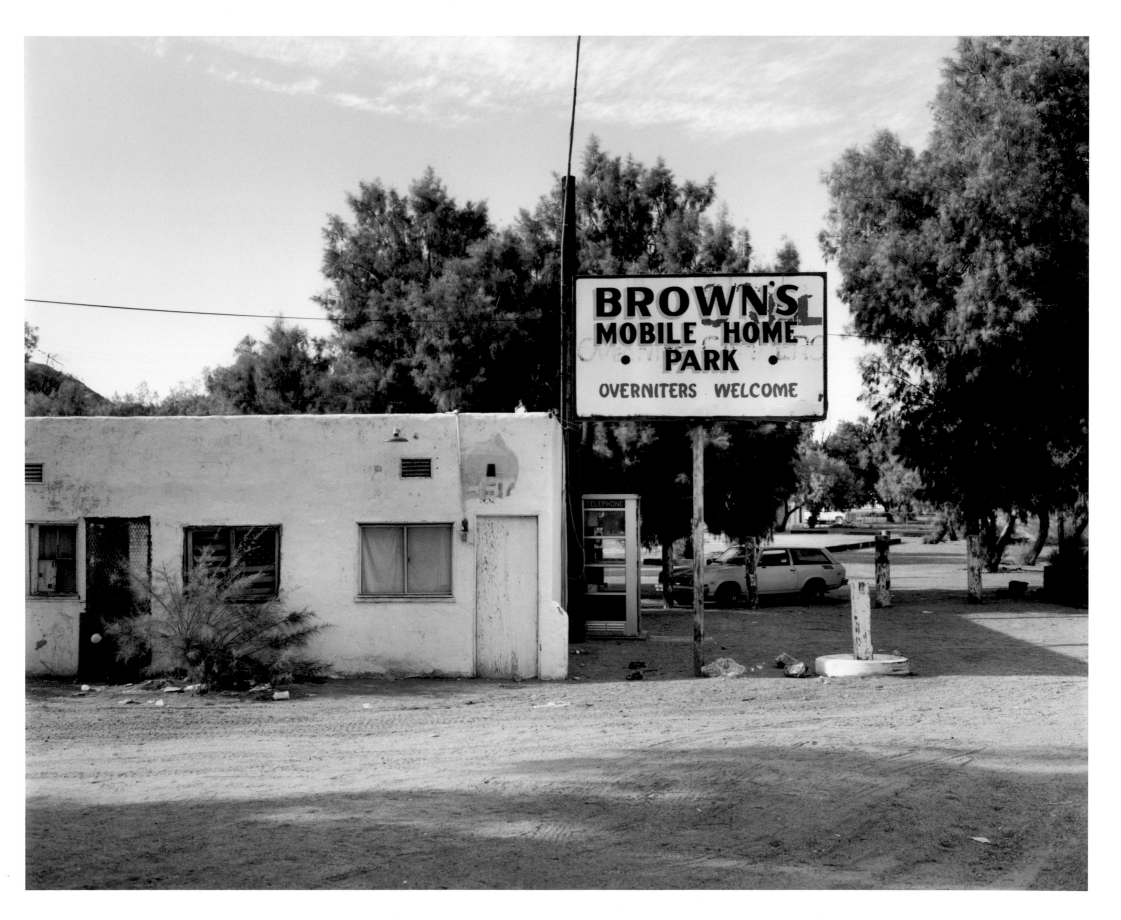

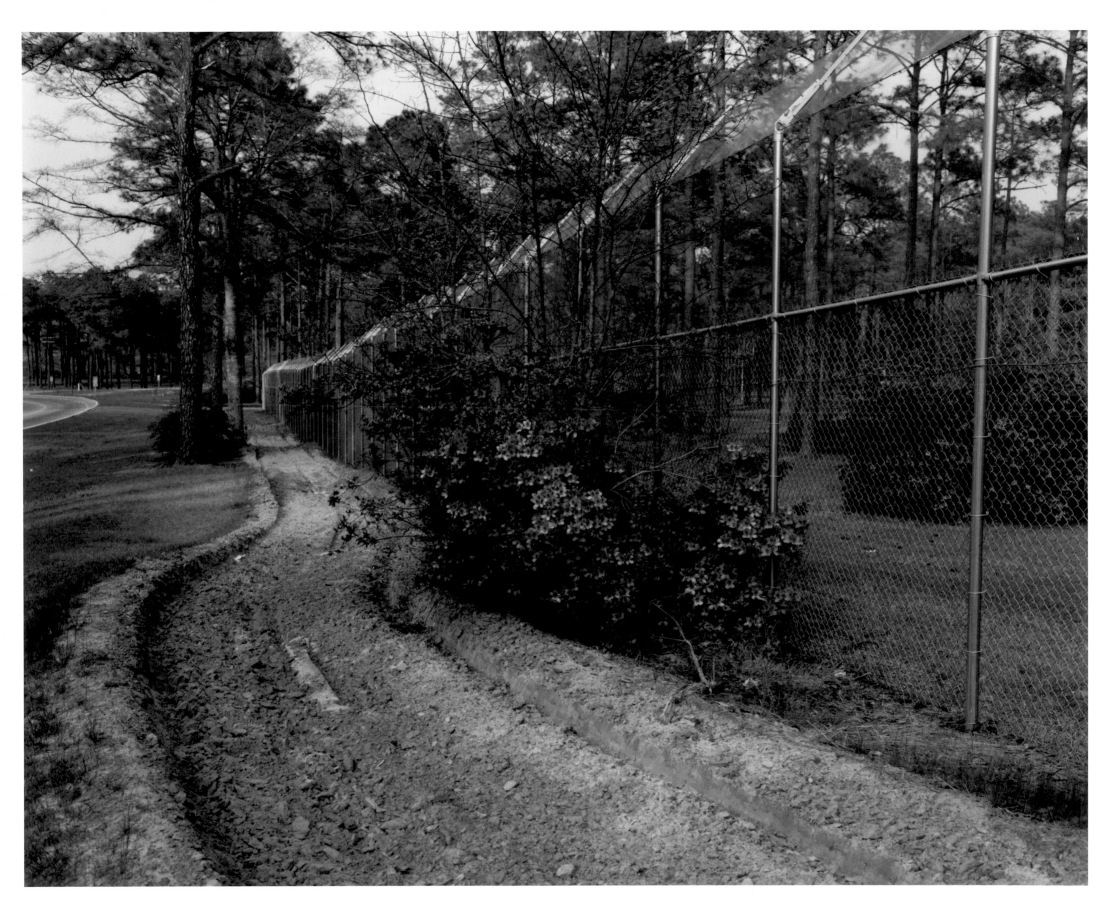

46 Abandoned Union Carbide Lucky Mac uranium mill, Gas Hills, Fremont County, Wyoming

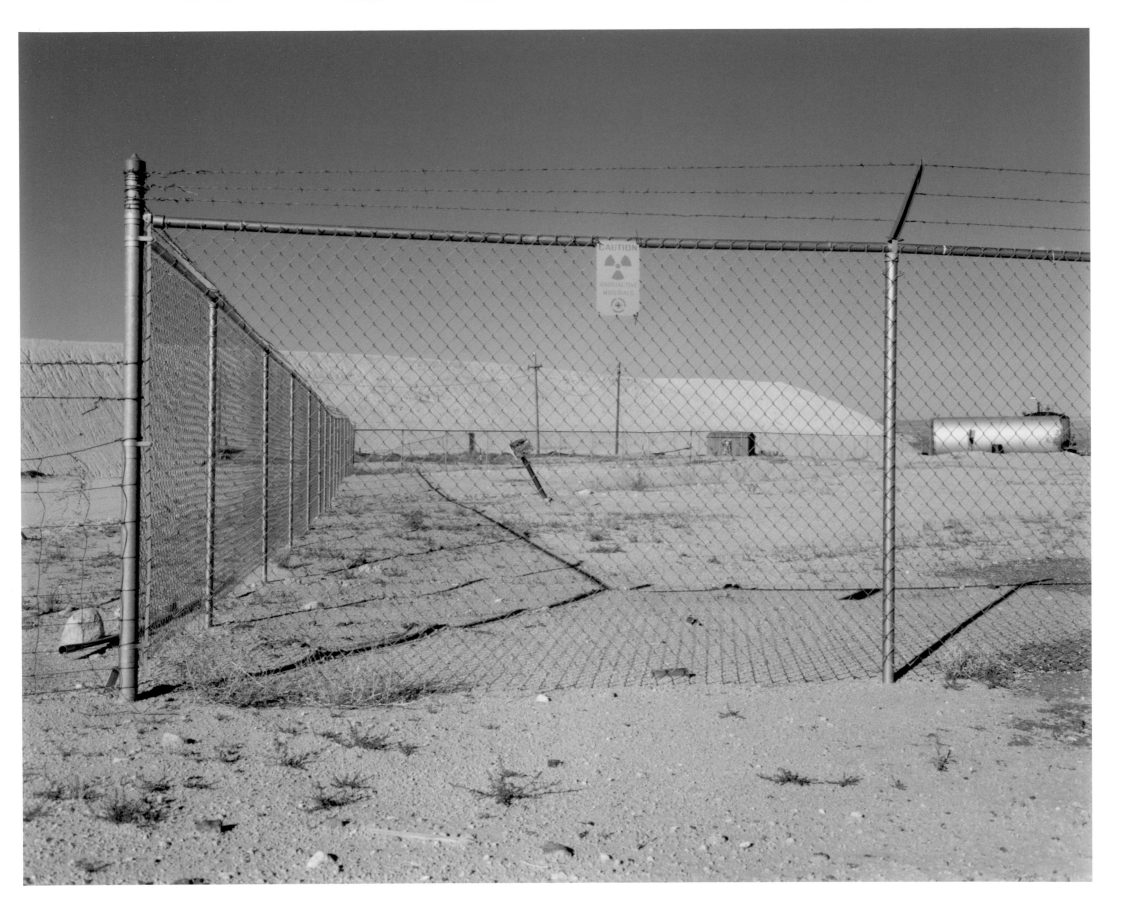

47 Abandoned Union Carbide Lucky Mac uranium mine, Gas Hills, Fremont County, Wyoming

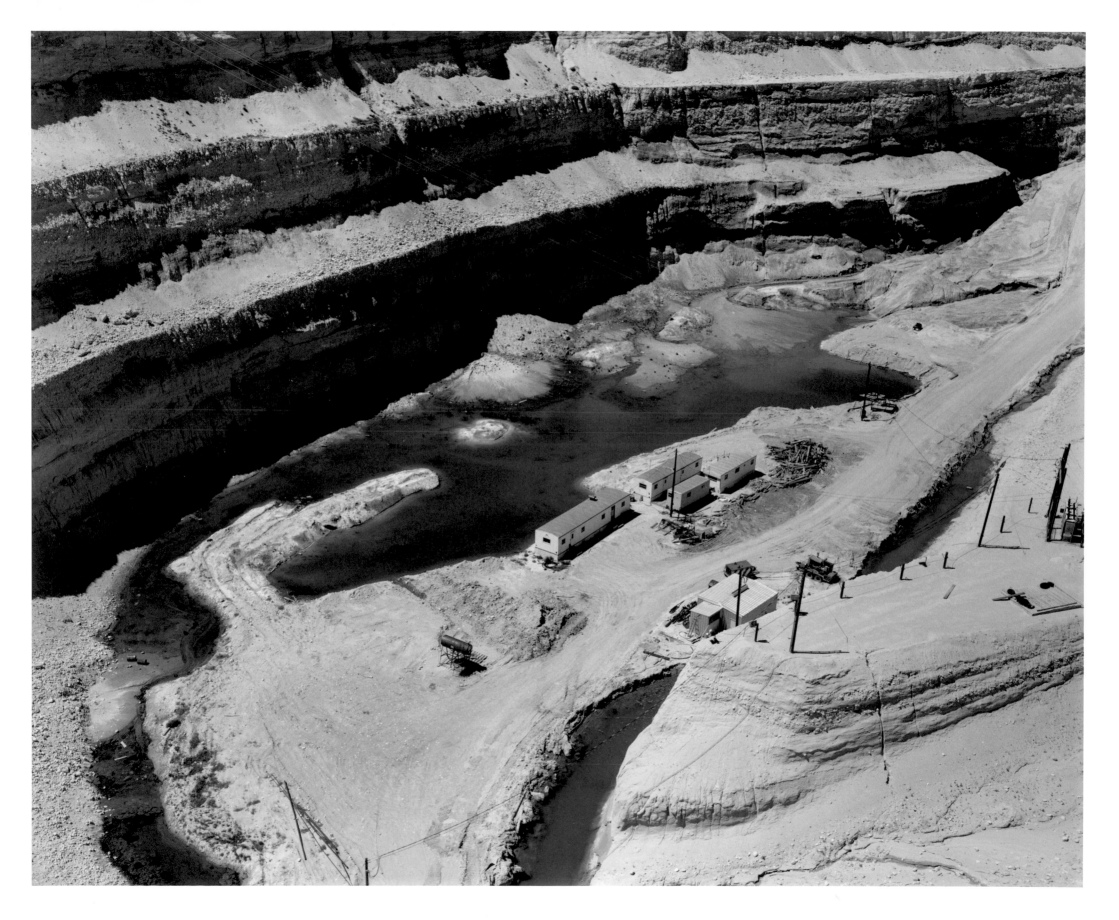

Times Beach Superfund site and the Meramec River, Times Beach, Missouri

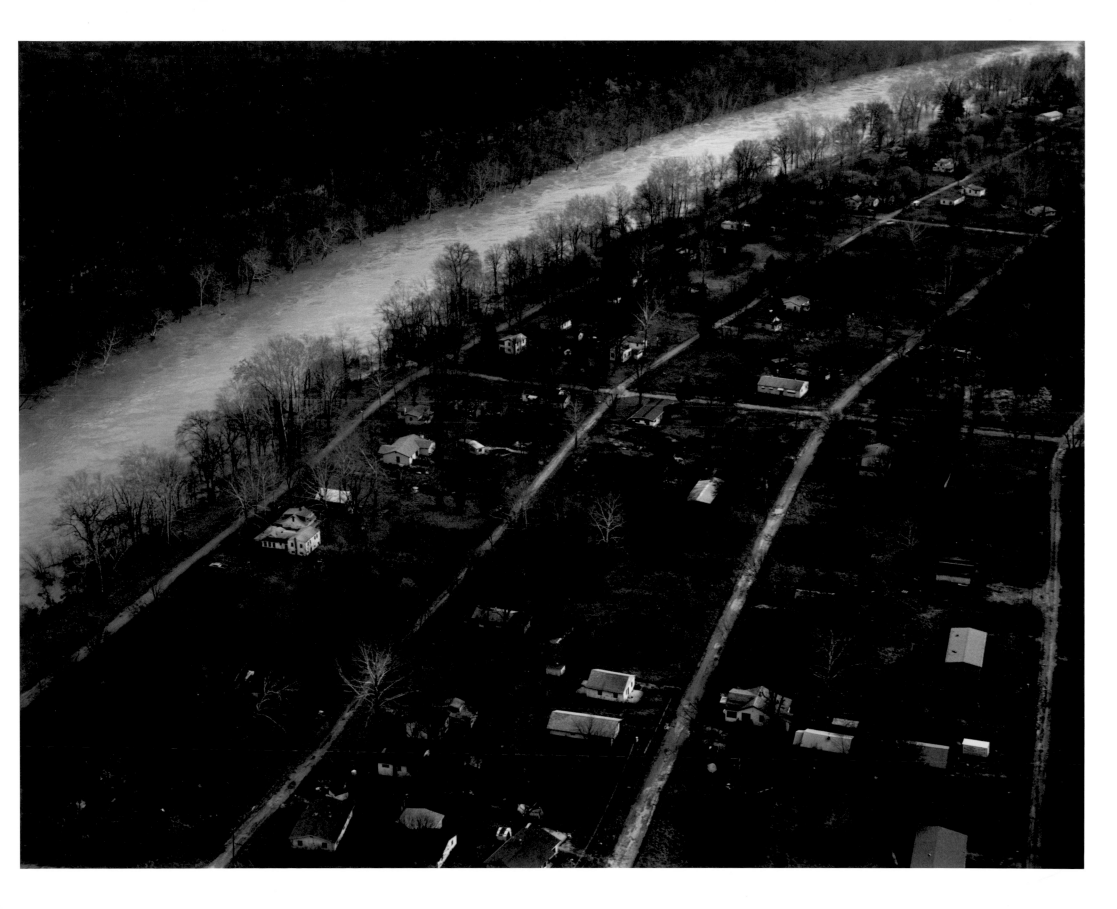

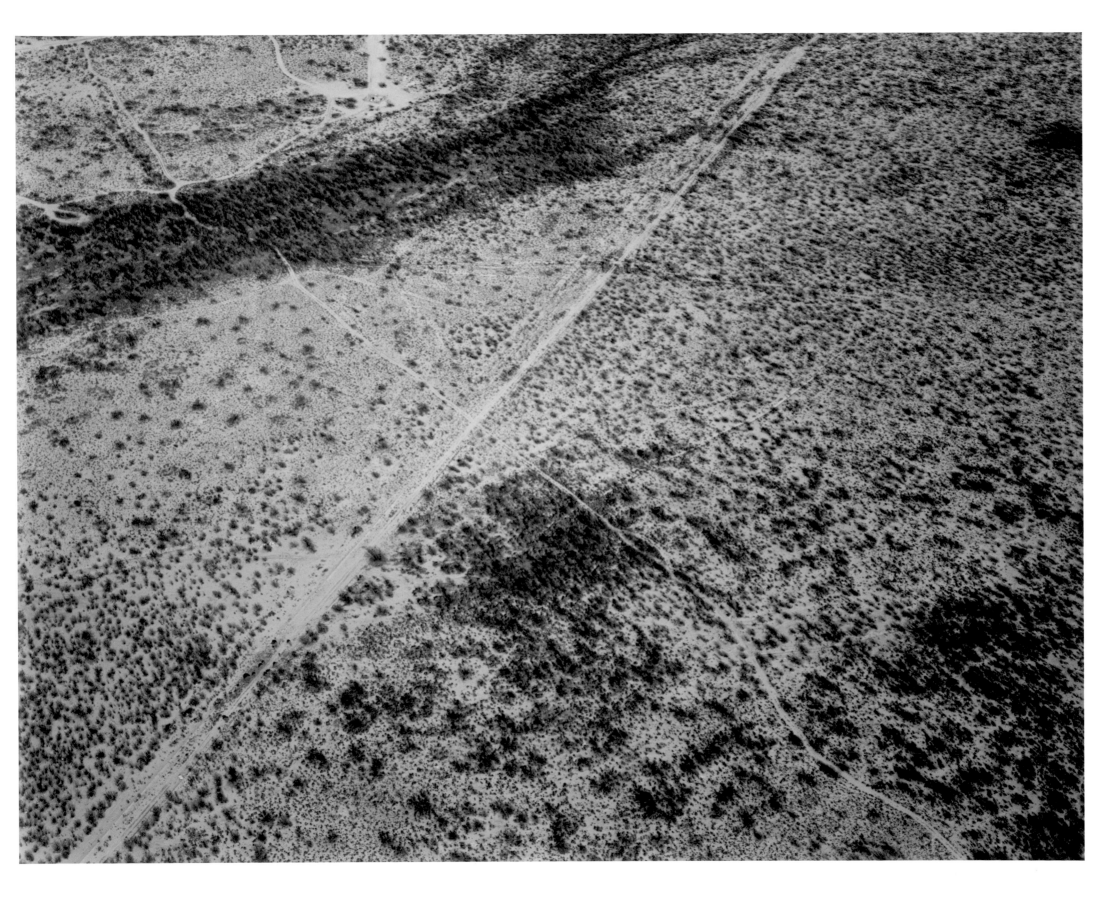

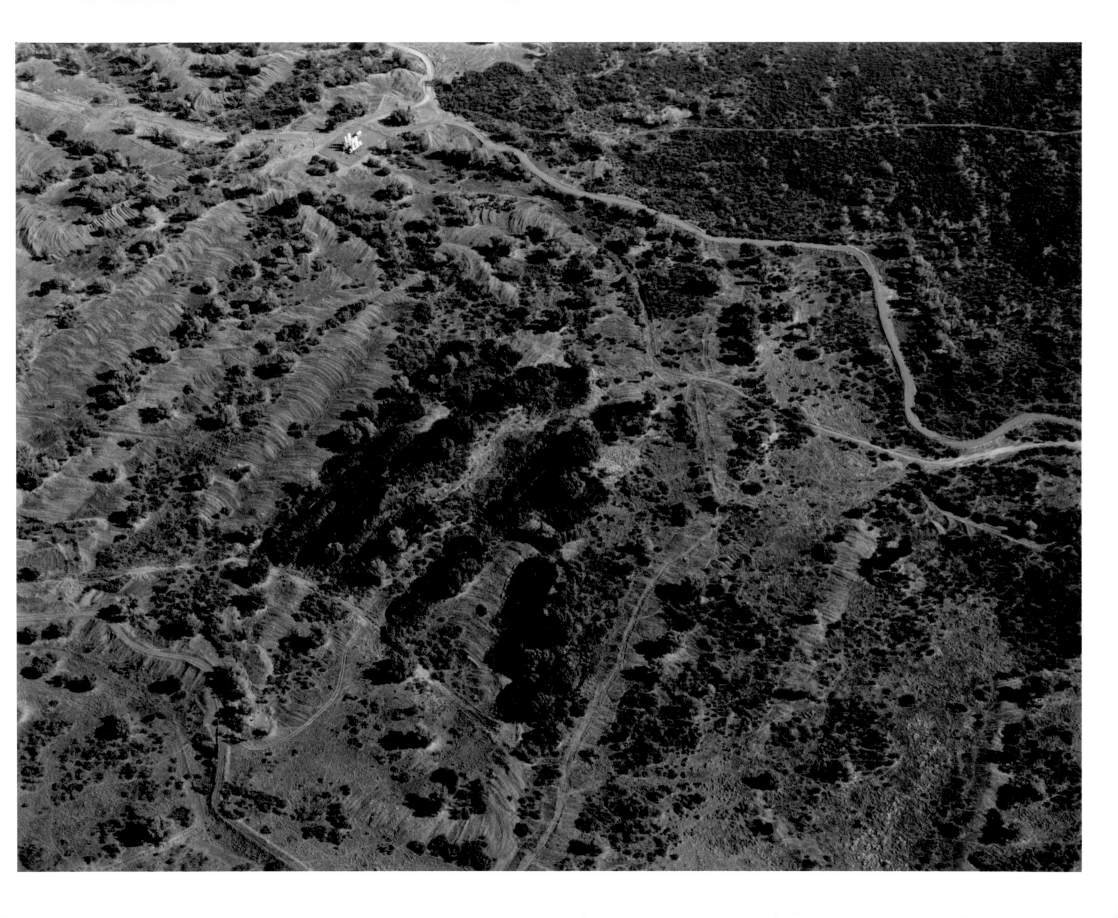

51 Waste slag and irrigated cropland along the Jordan River, Sharon Steel Corp. Superfund site, Midvale, Utah

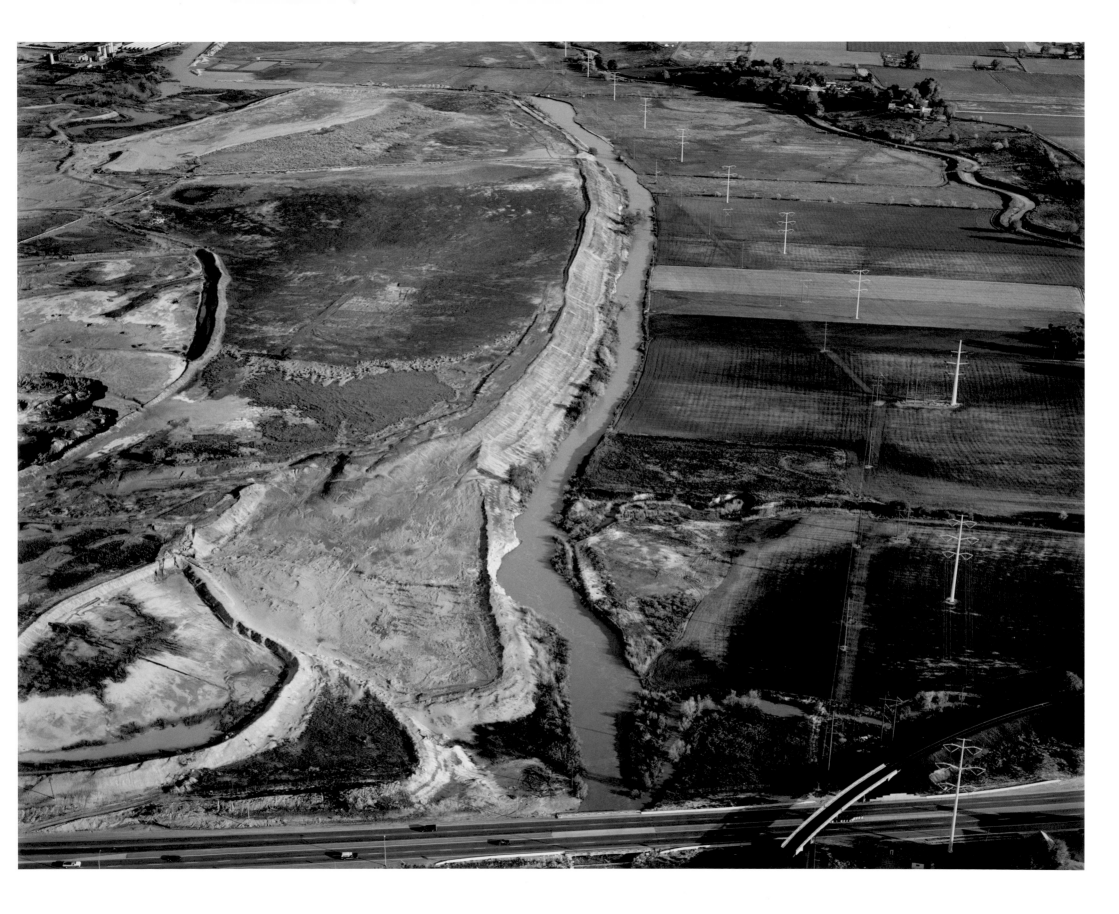

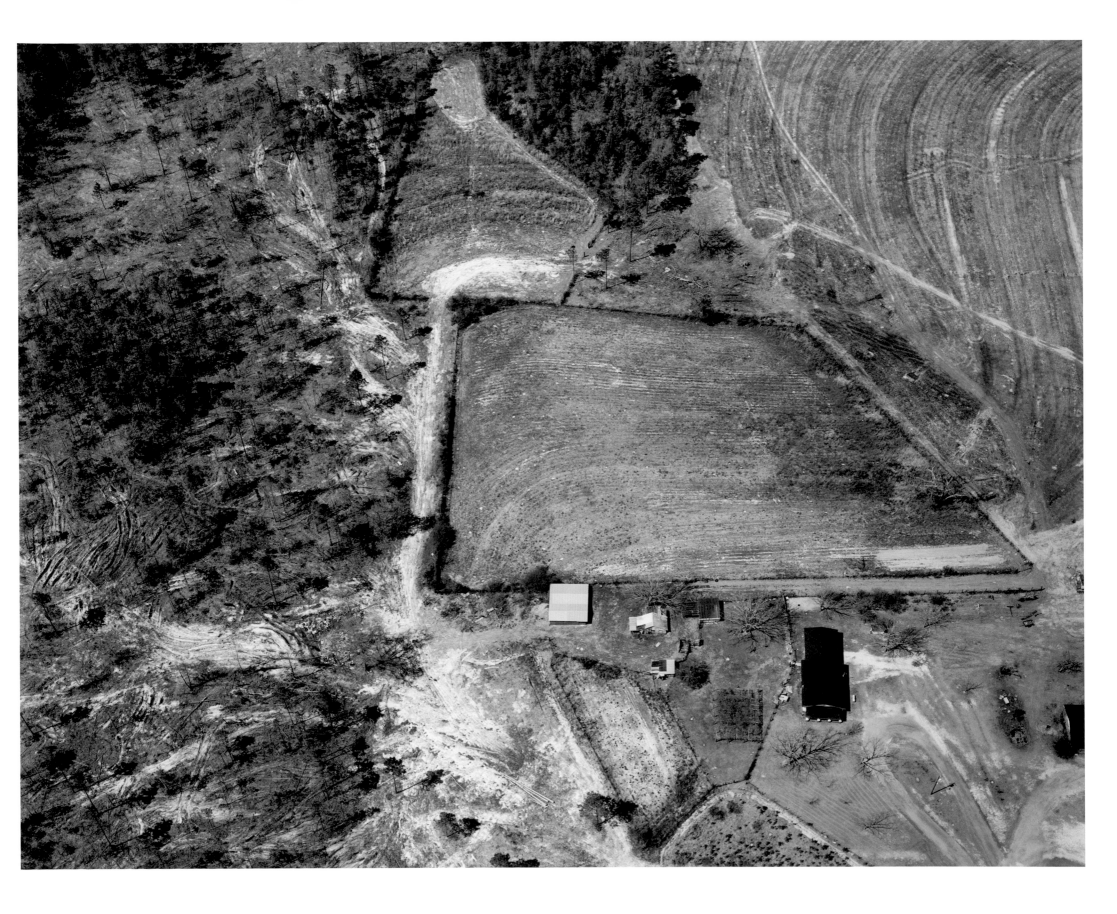

Baxter/Union Pacific Tie Treating Superfund site and the Laramie River, Laramie, Wyoming

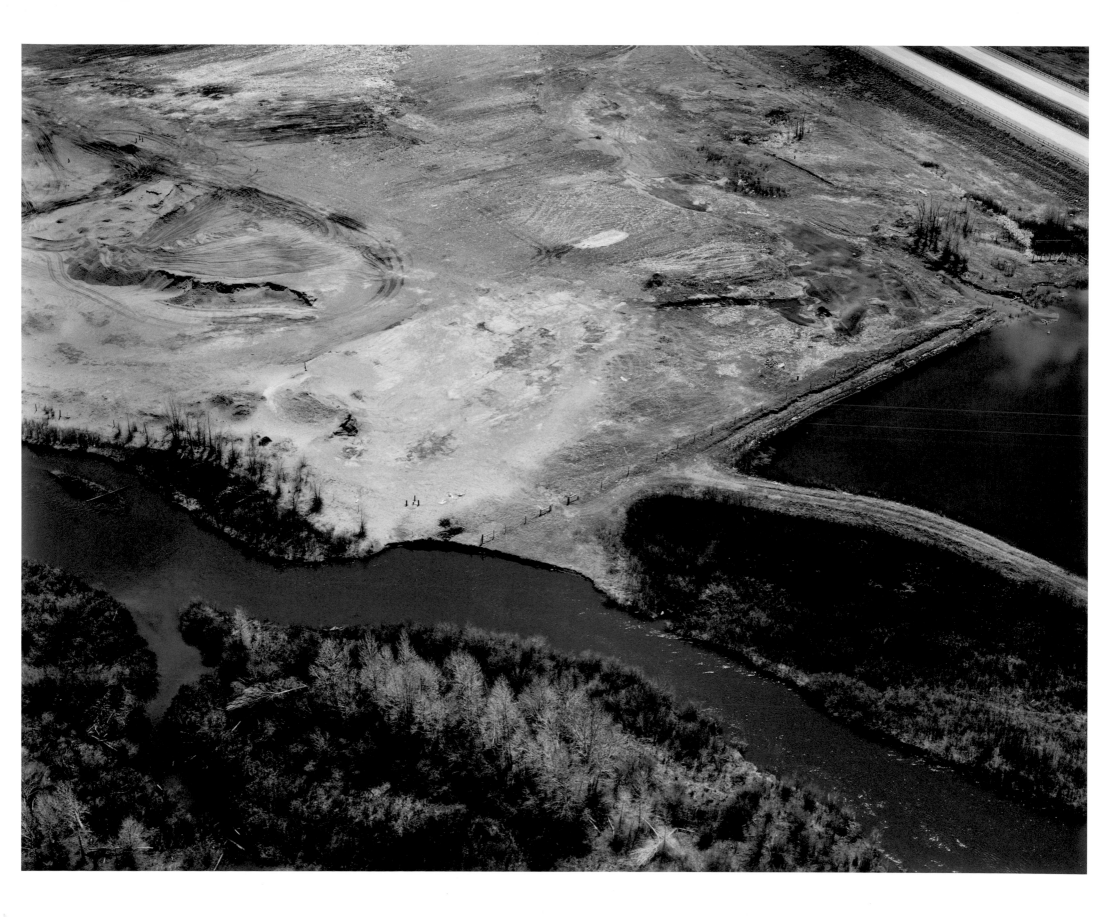

California Gulch Superfund site, Leadville, Colorado

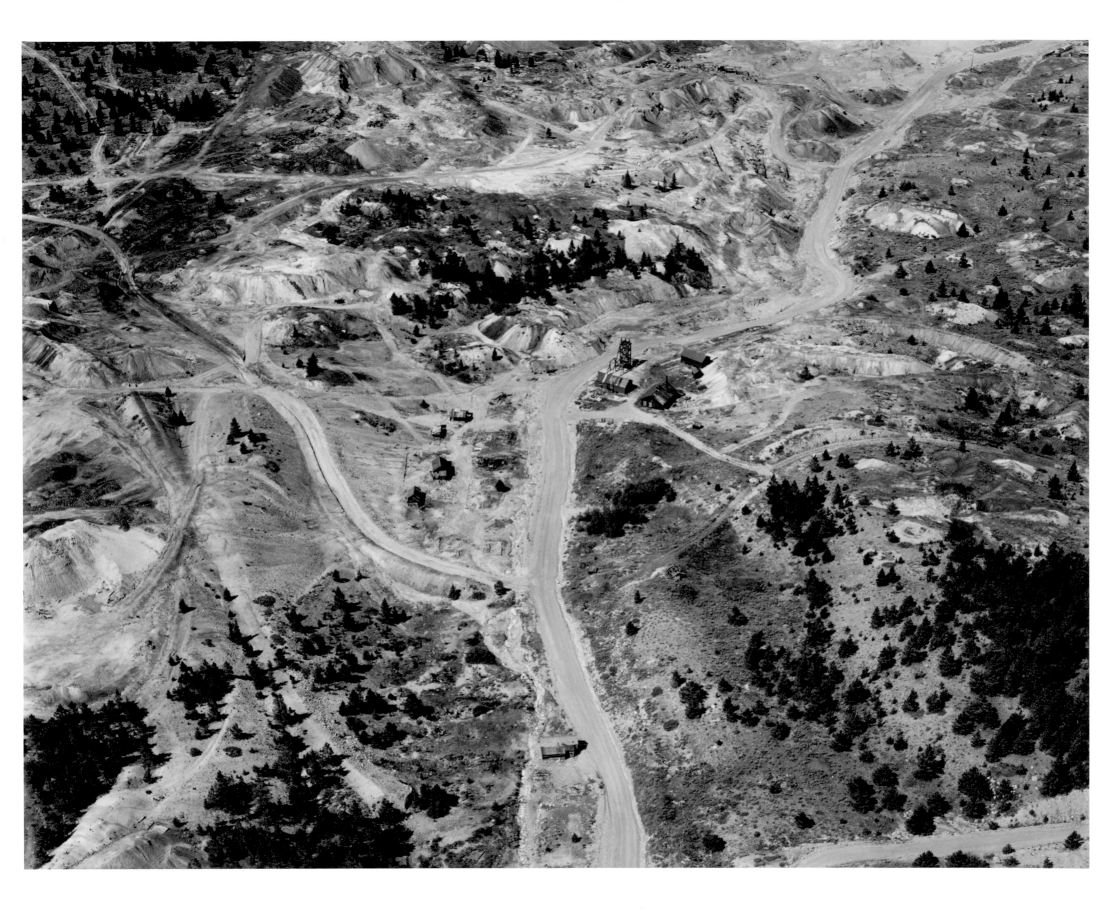

Sikes Disposal Pits Superfund site and the San Jacinto River, Crosby, Texas

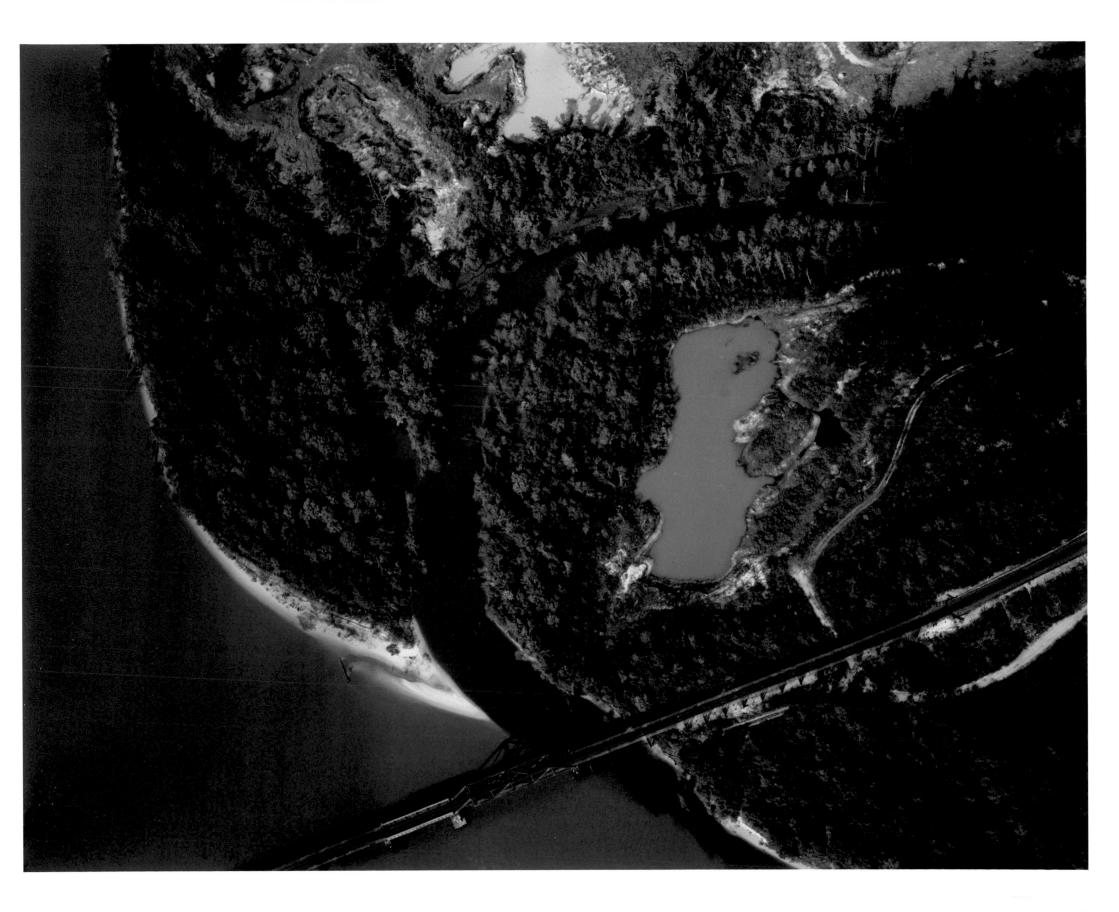

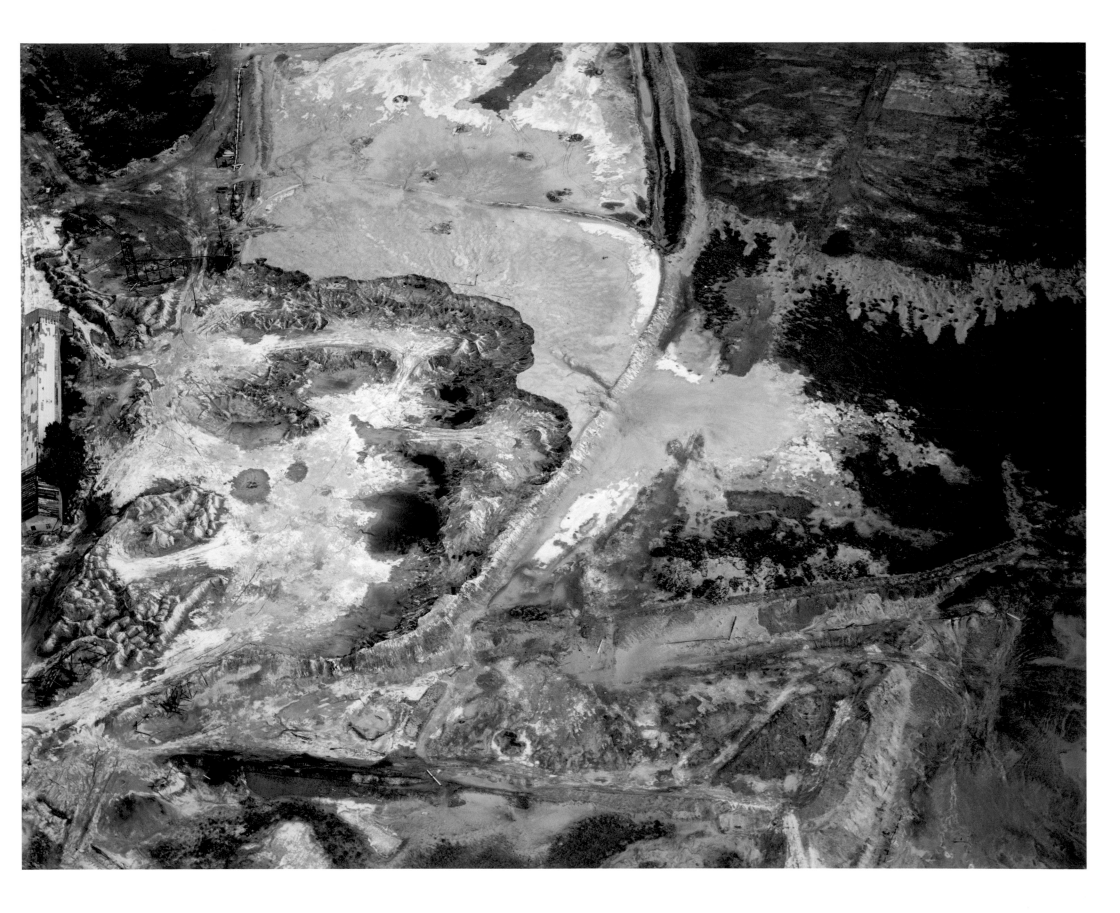

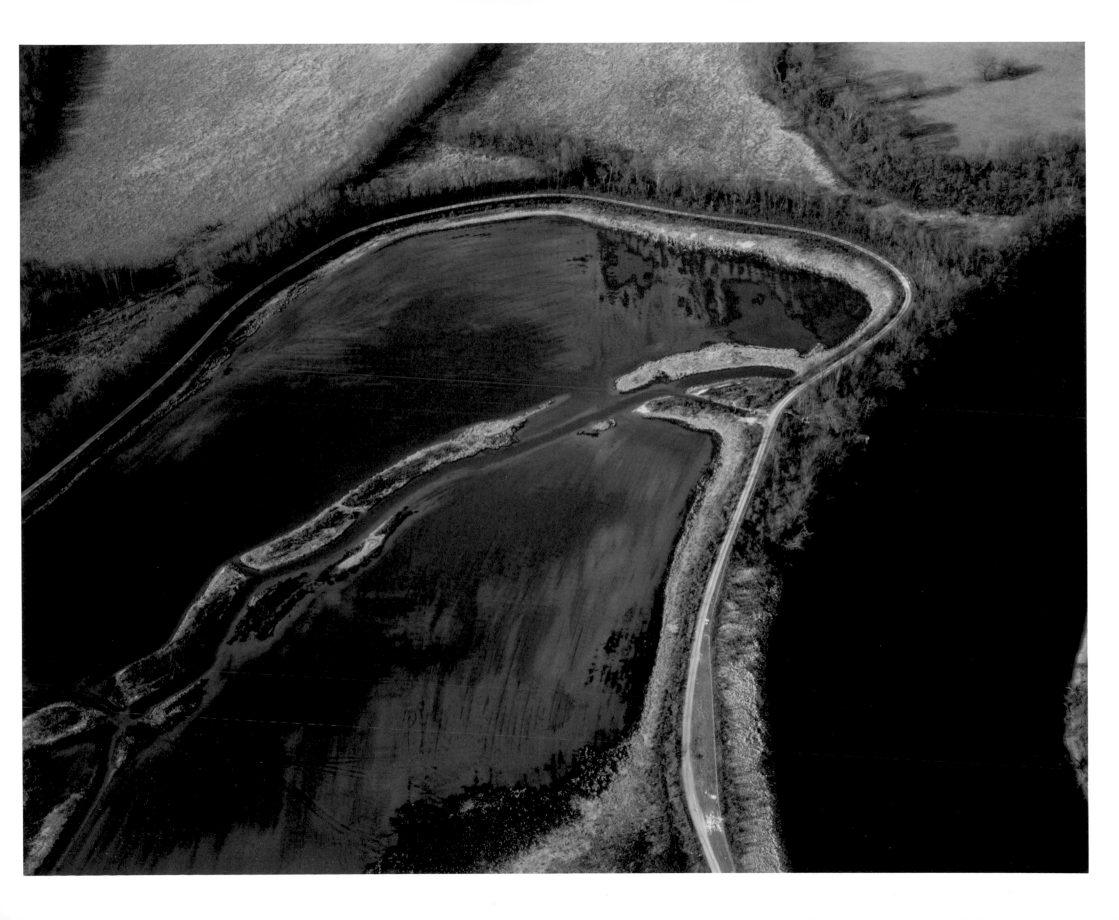

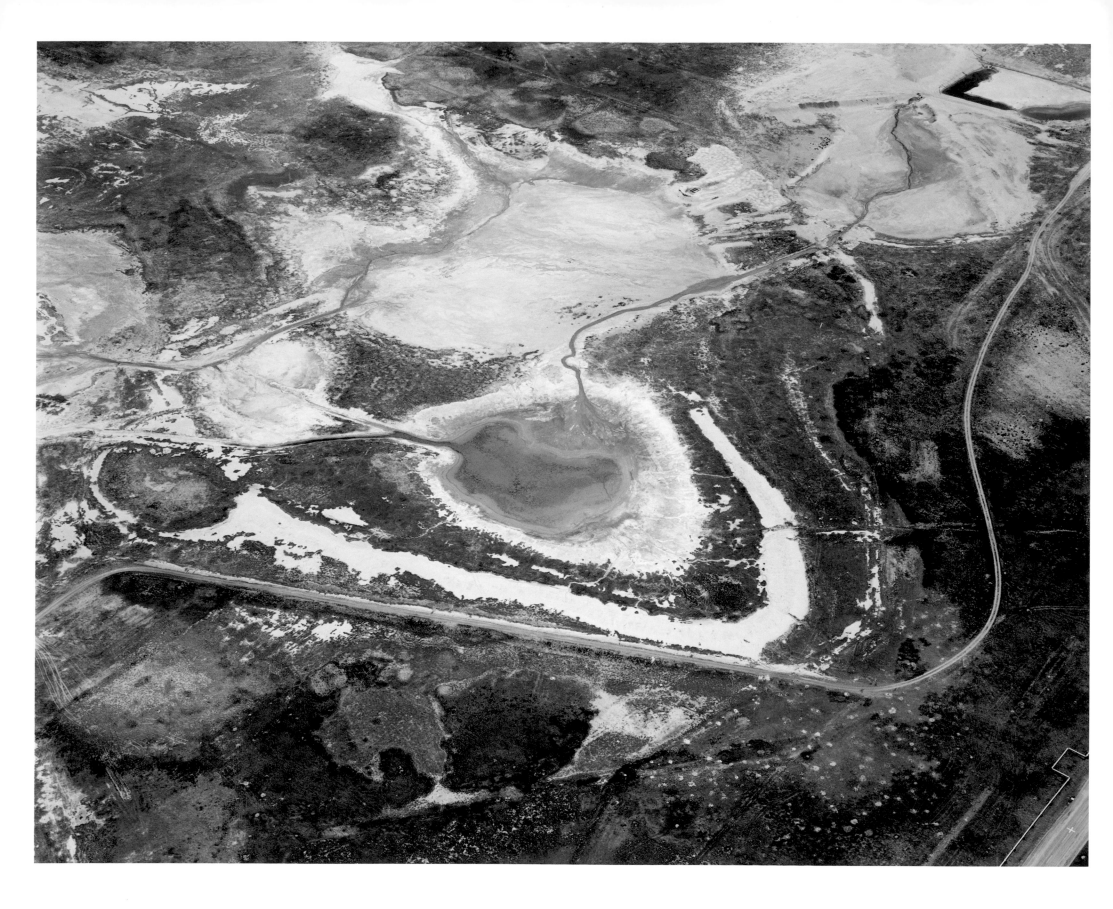

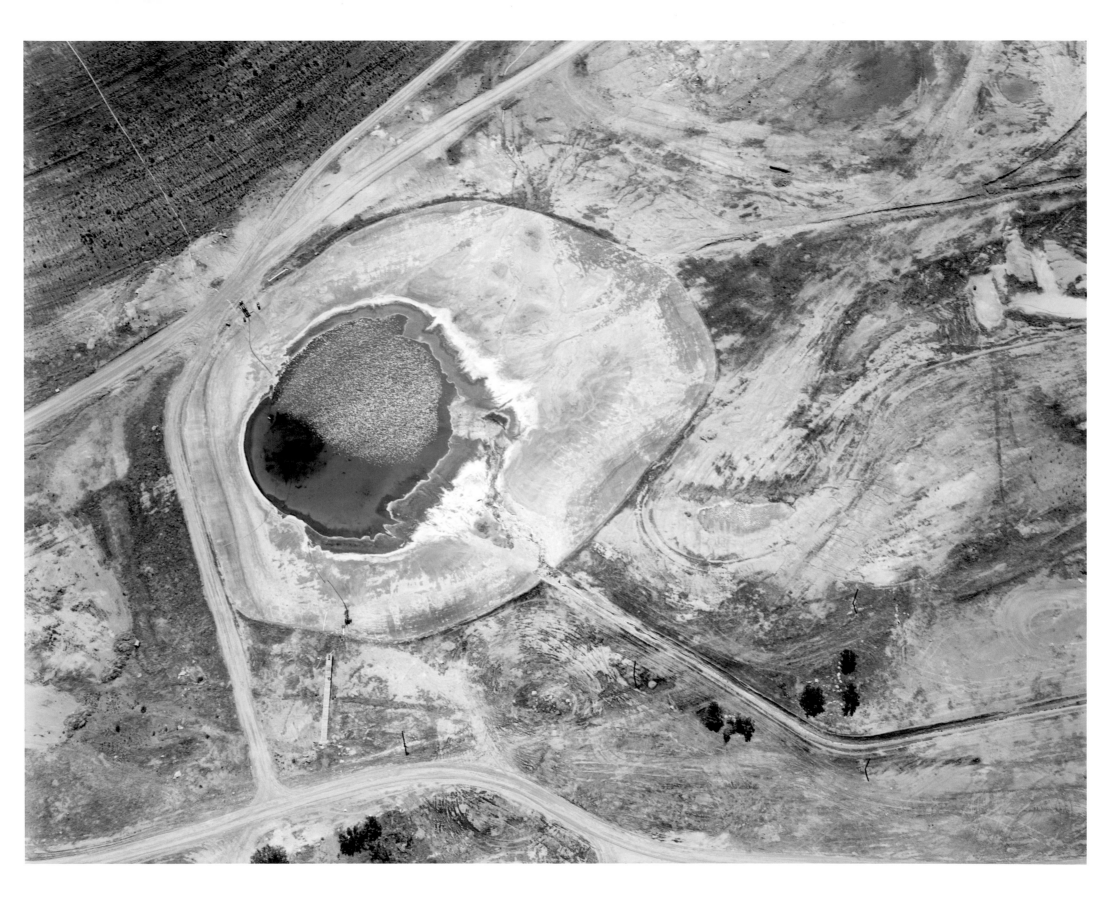

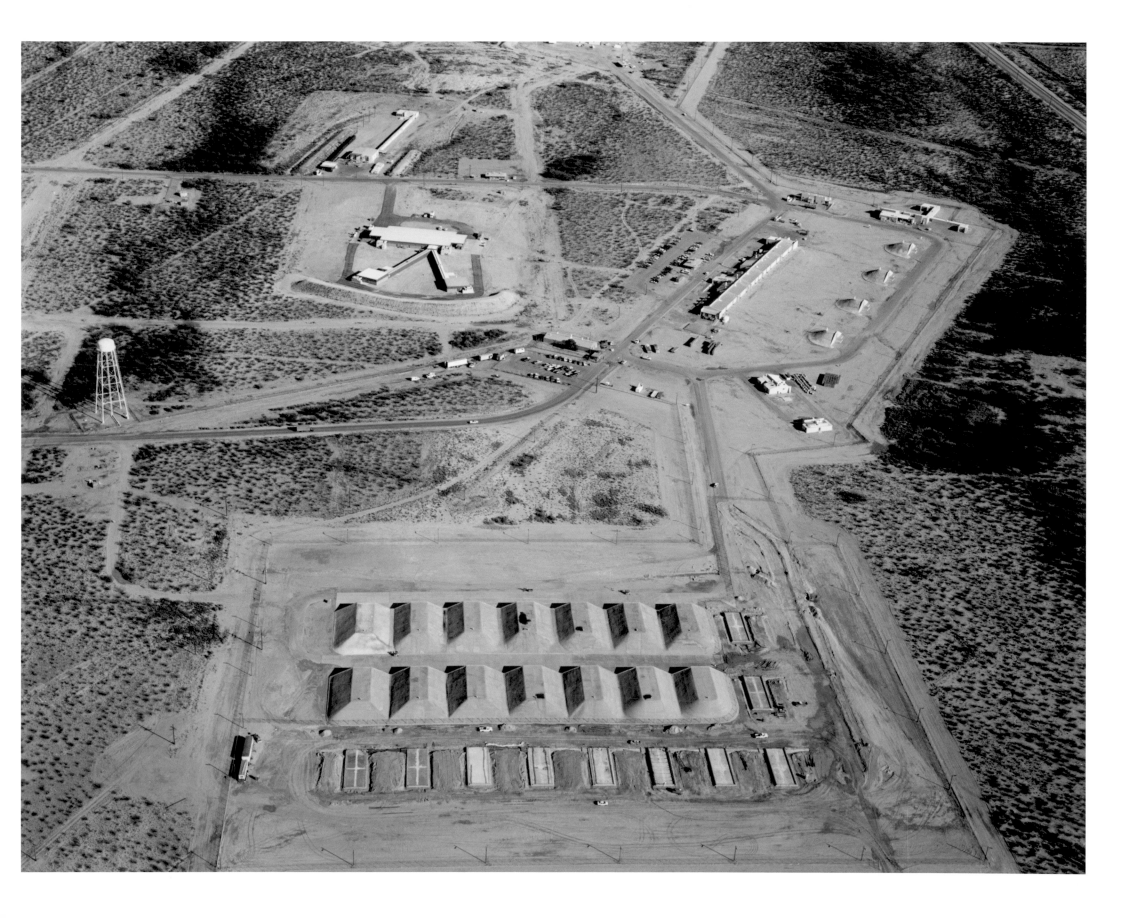

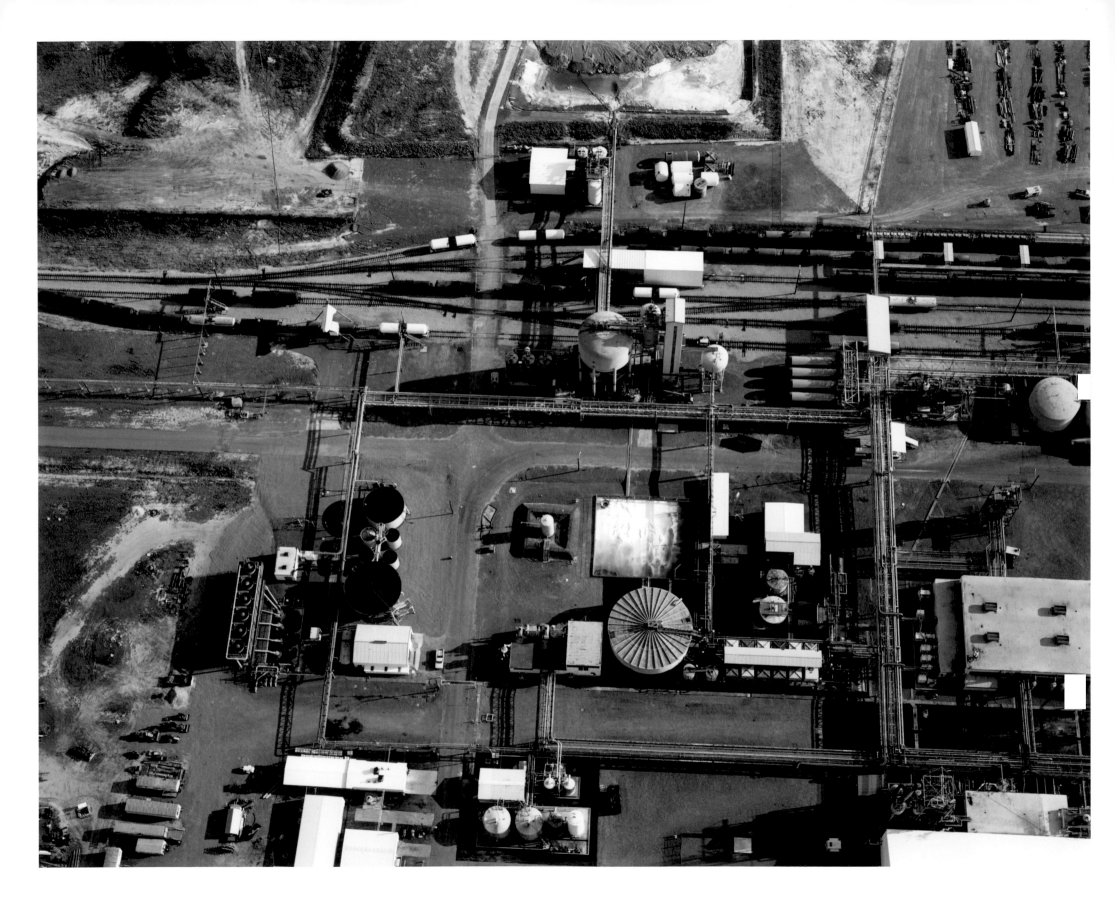

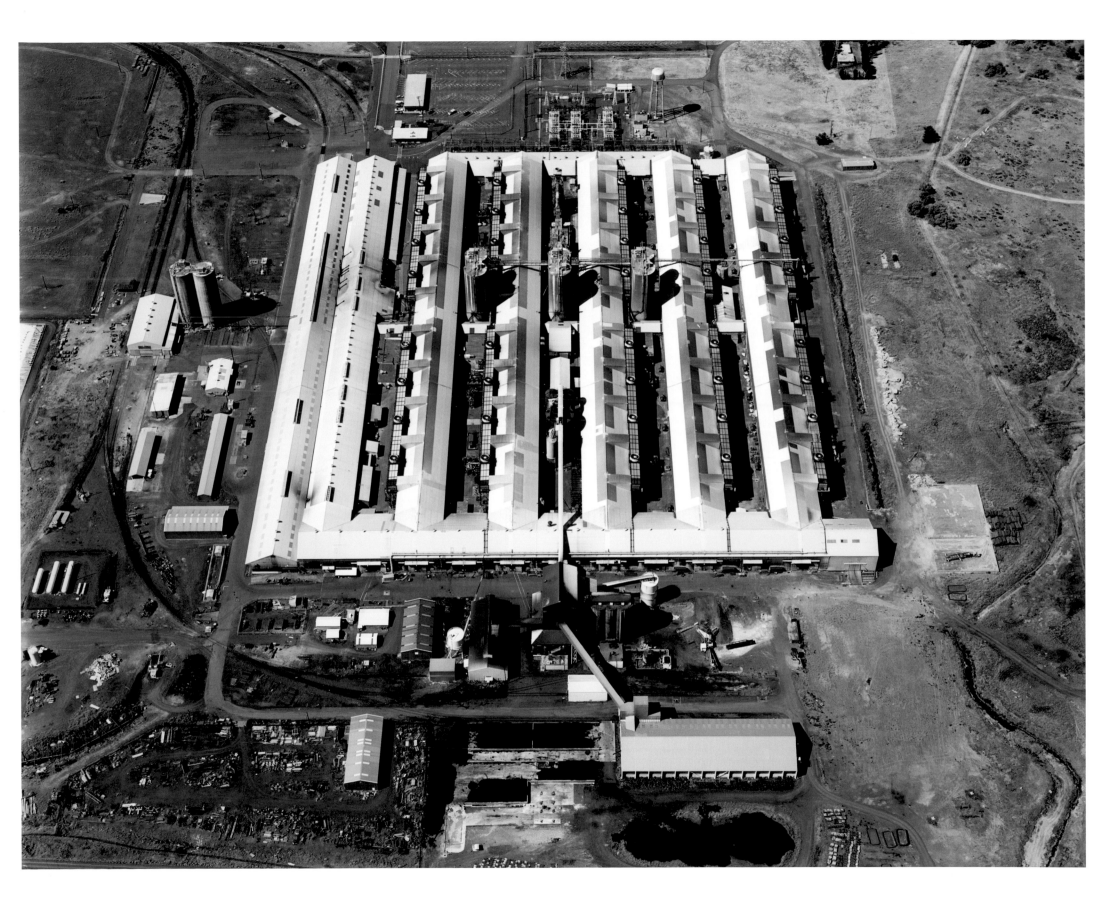

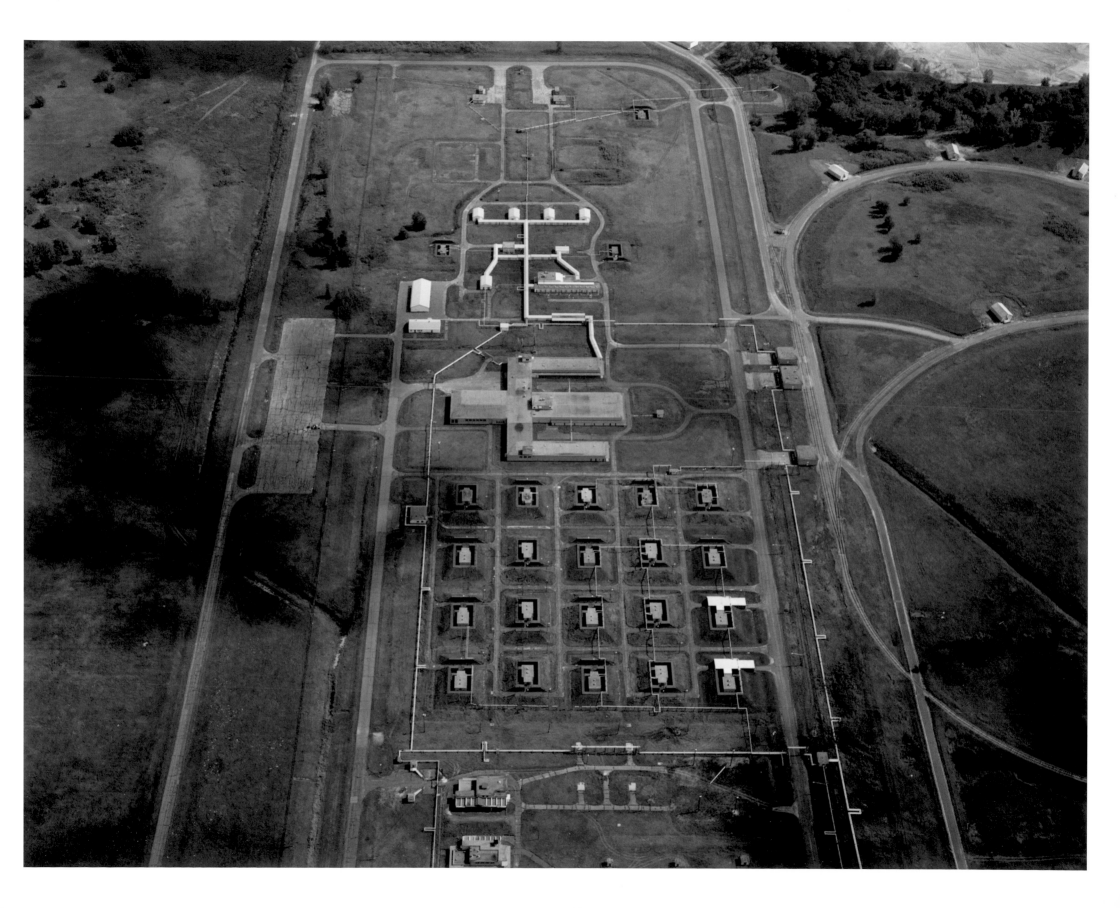

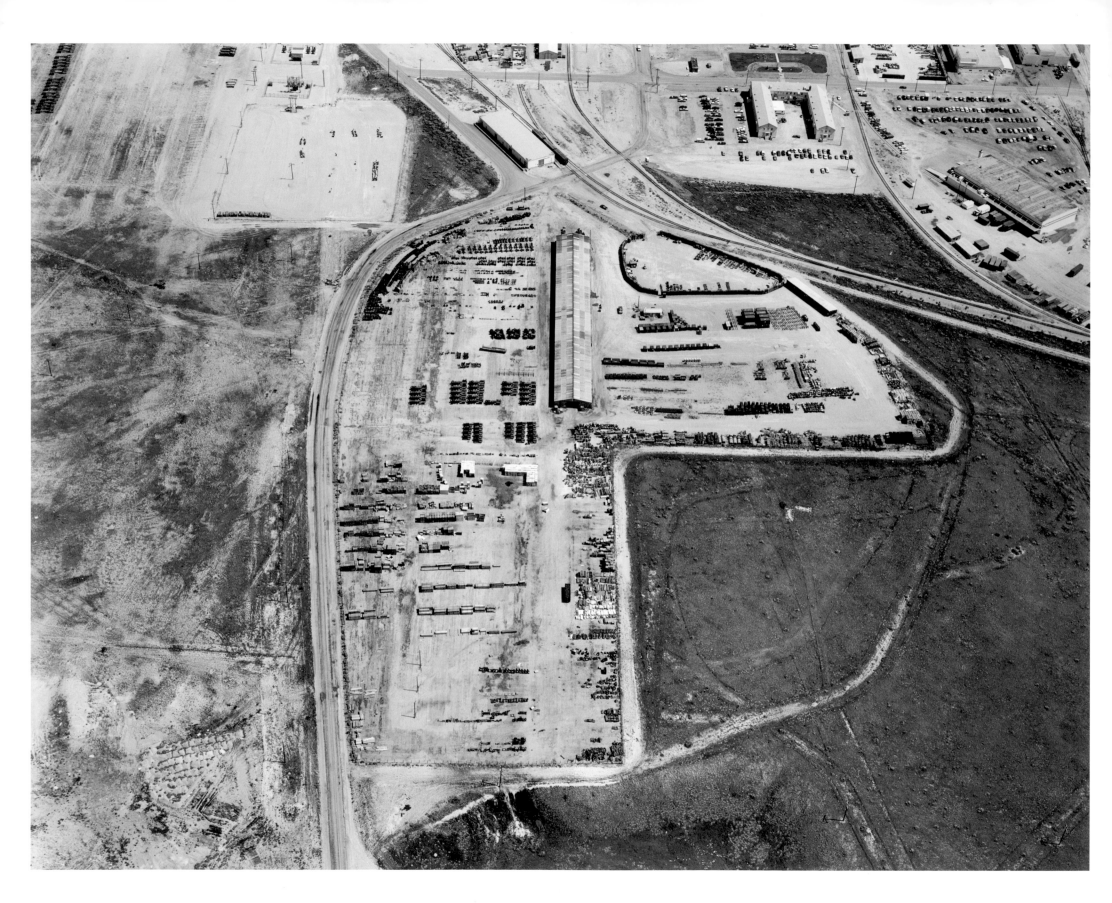

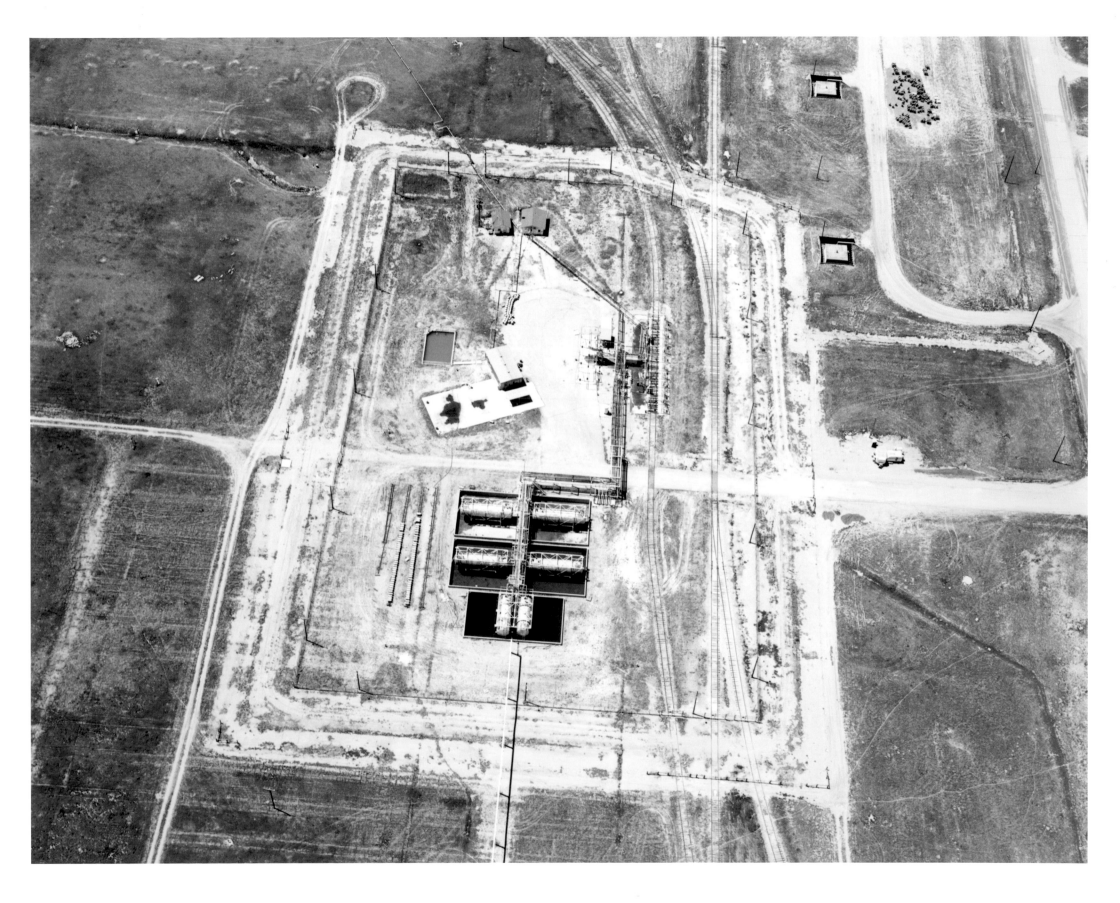

Tooele Army Depot Superfund site, Tooele, Utah

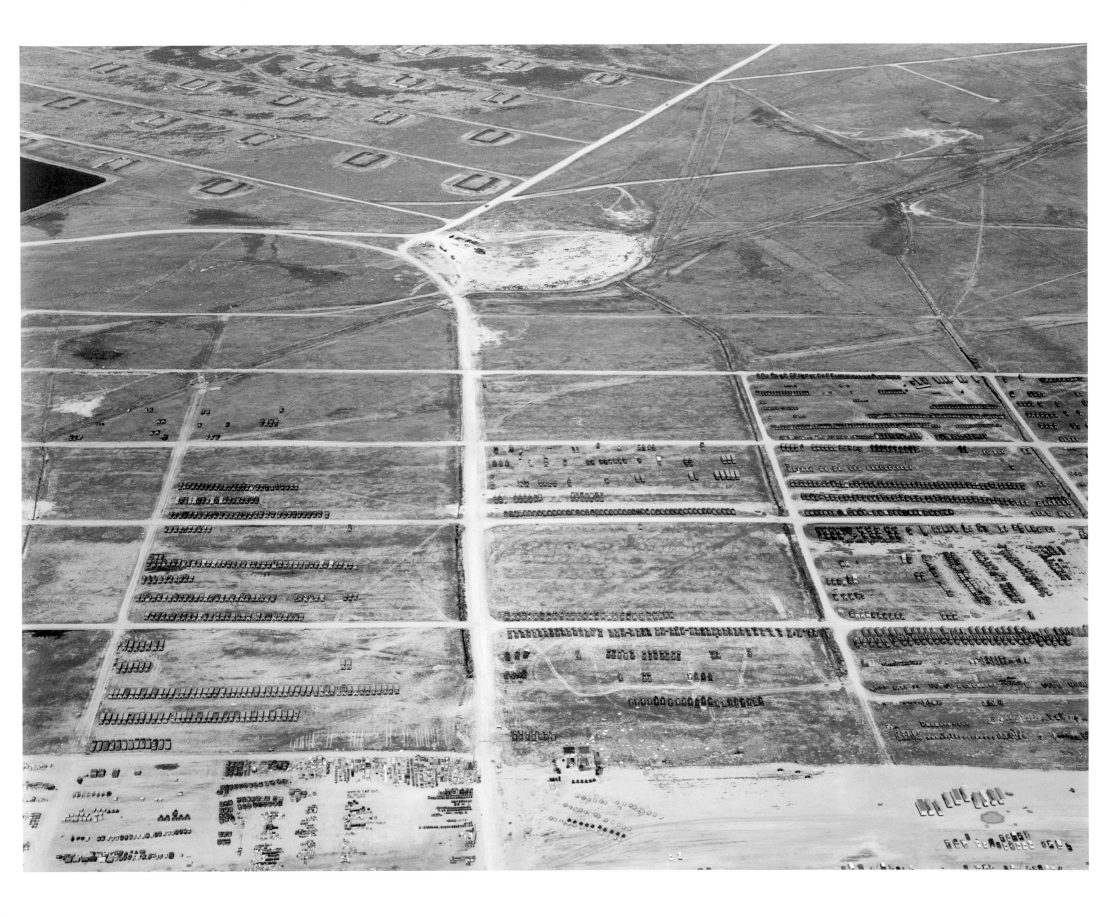

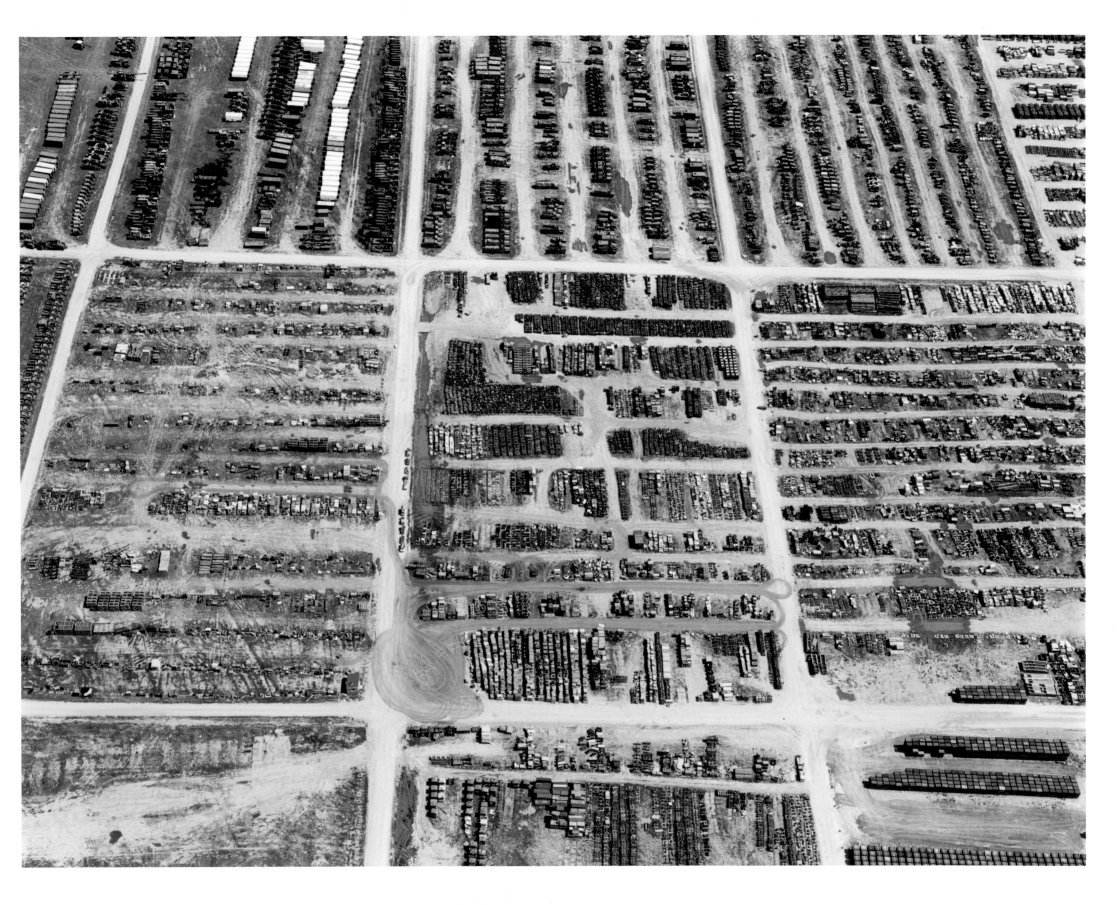

Twilight in the Wilderness 1982-83

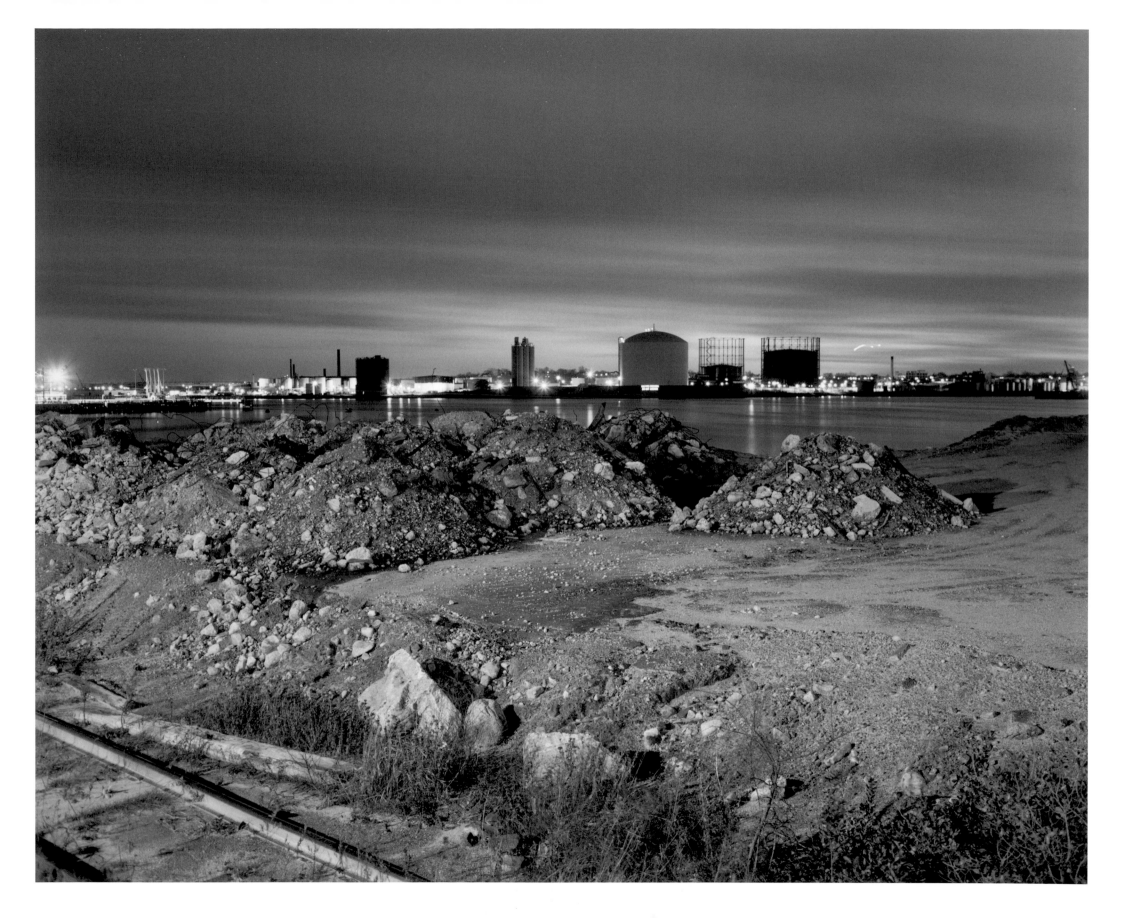

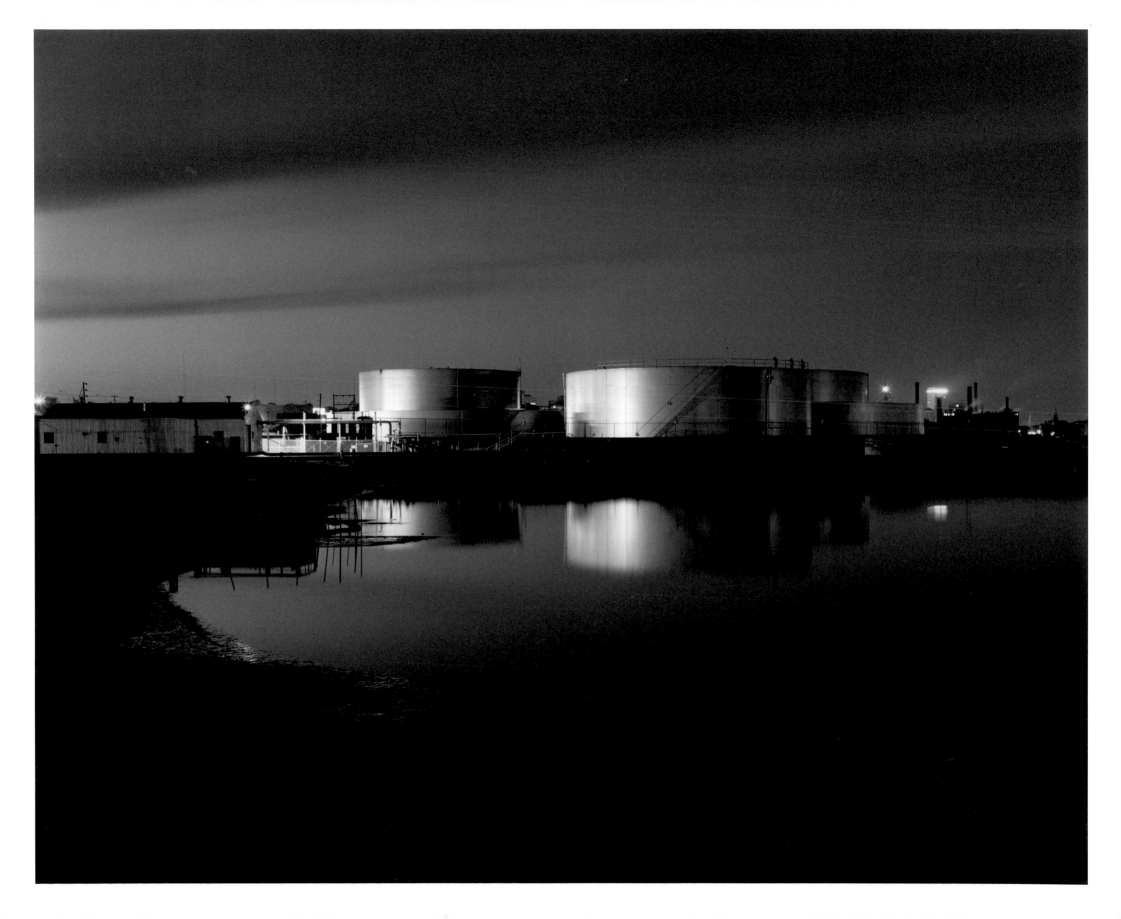

Fading Daylight, Narragansett Bay Texaco Inc., Providence, Rhode Island

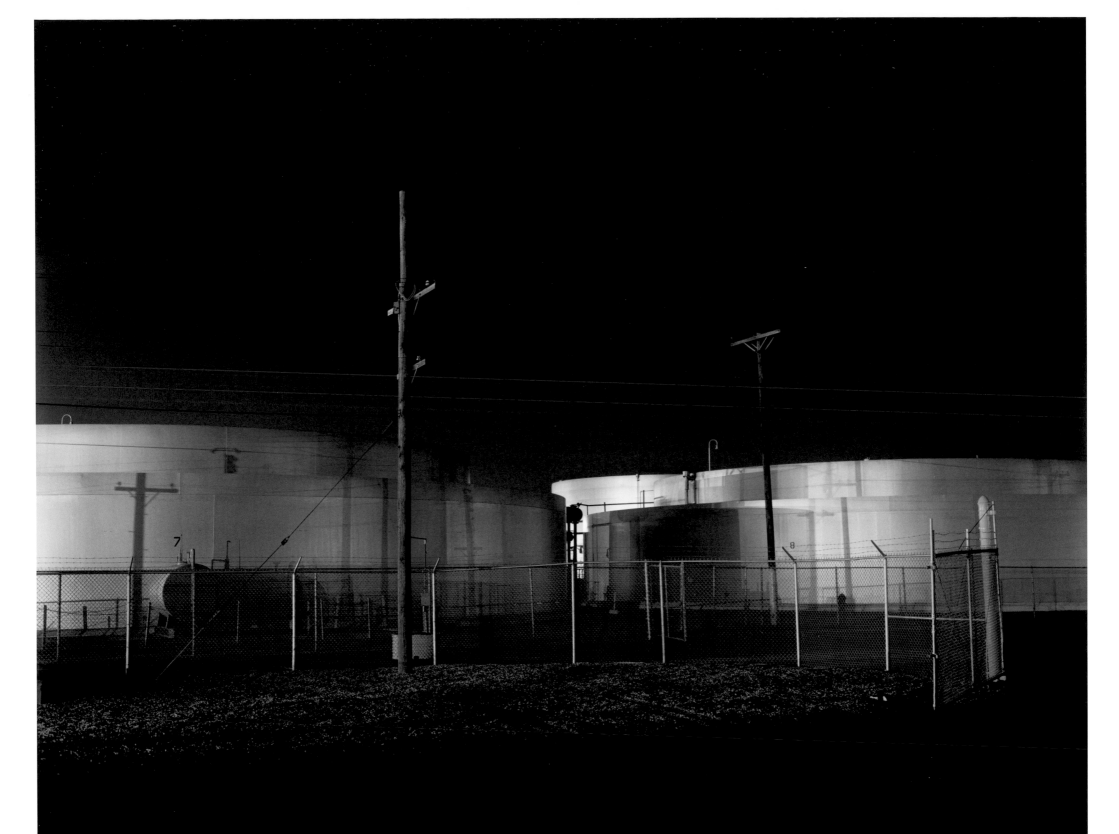

71 Evening, Narragansett Bay Texaco Inc., Providence, Rhode Island

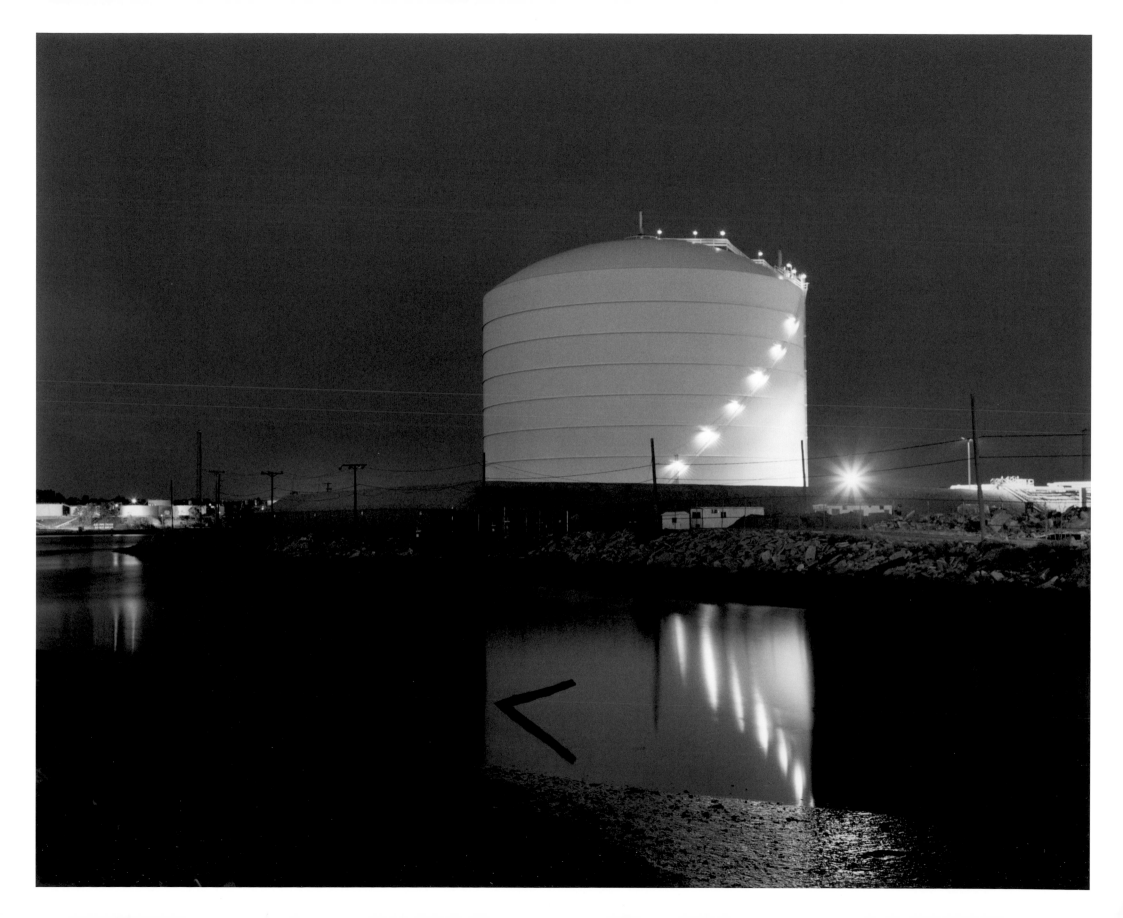

Along the Beach, Rising Moon Texaco Inc., Providence, Rhode Island

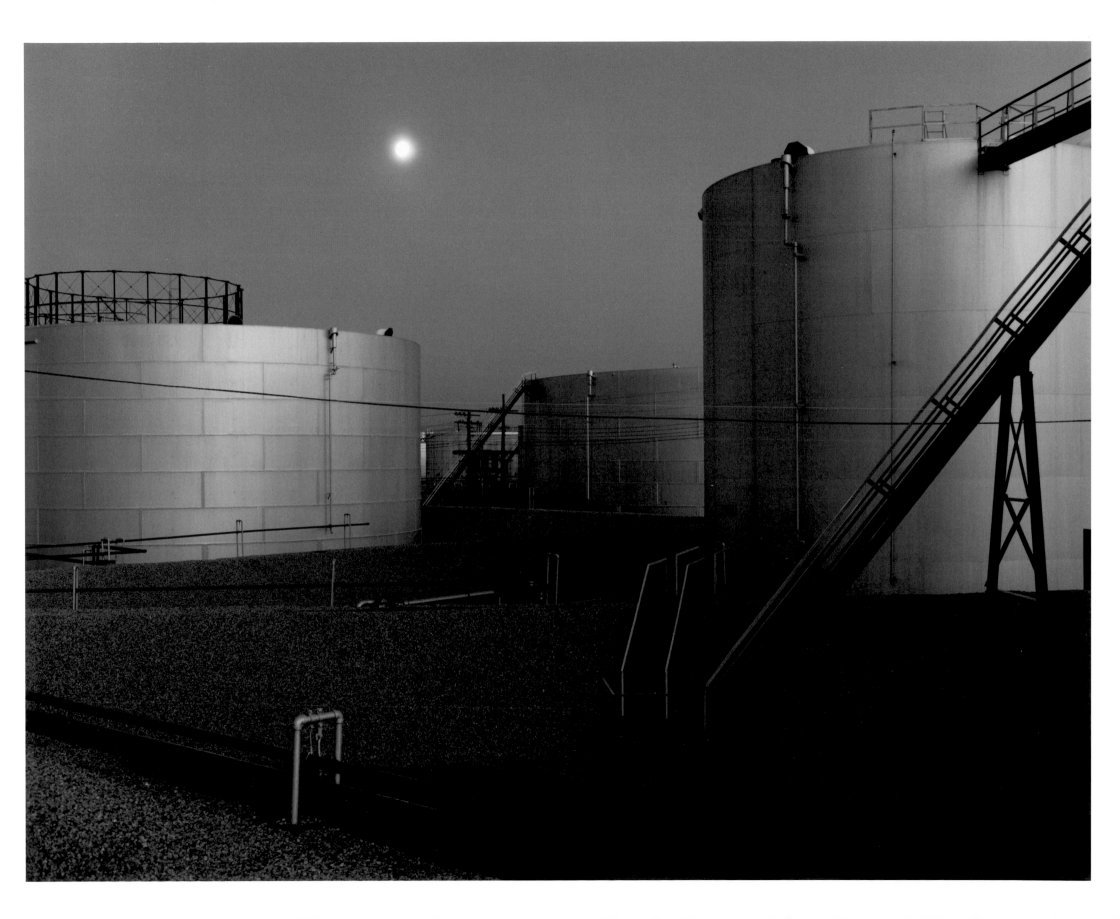

73 Moonrise over Narragansett Bay Texaco Inc., Providence, Rhode Island

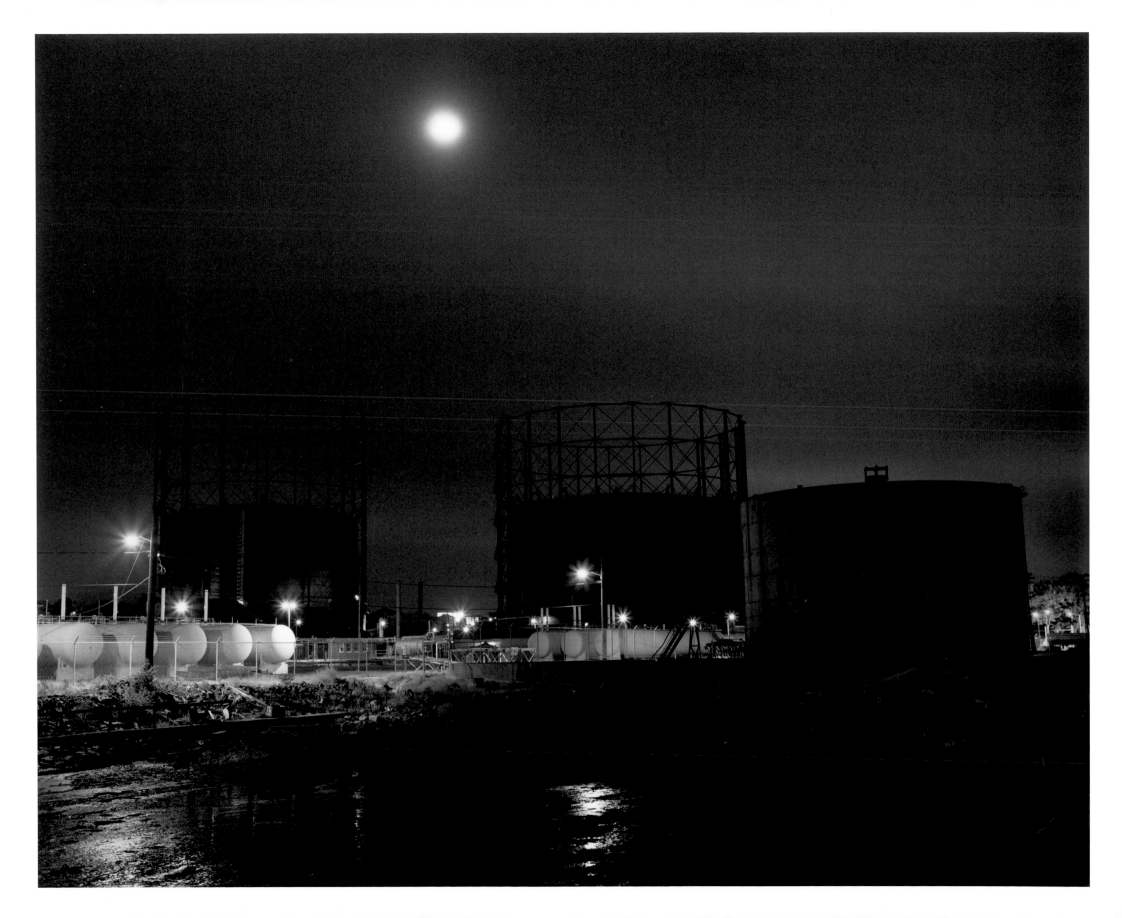

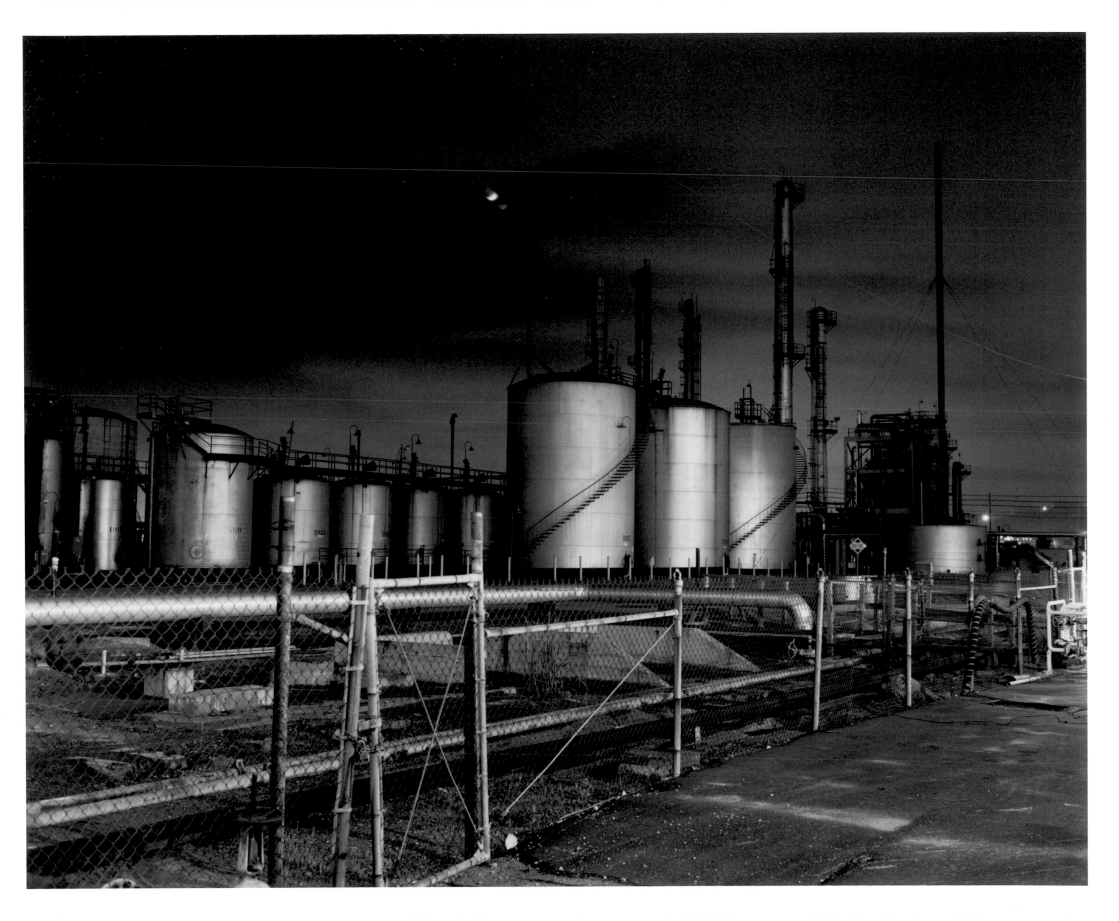

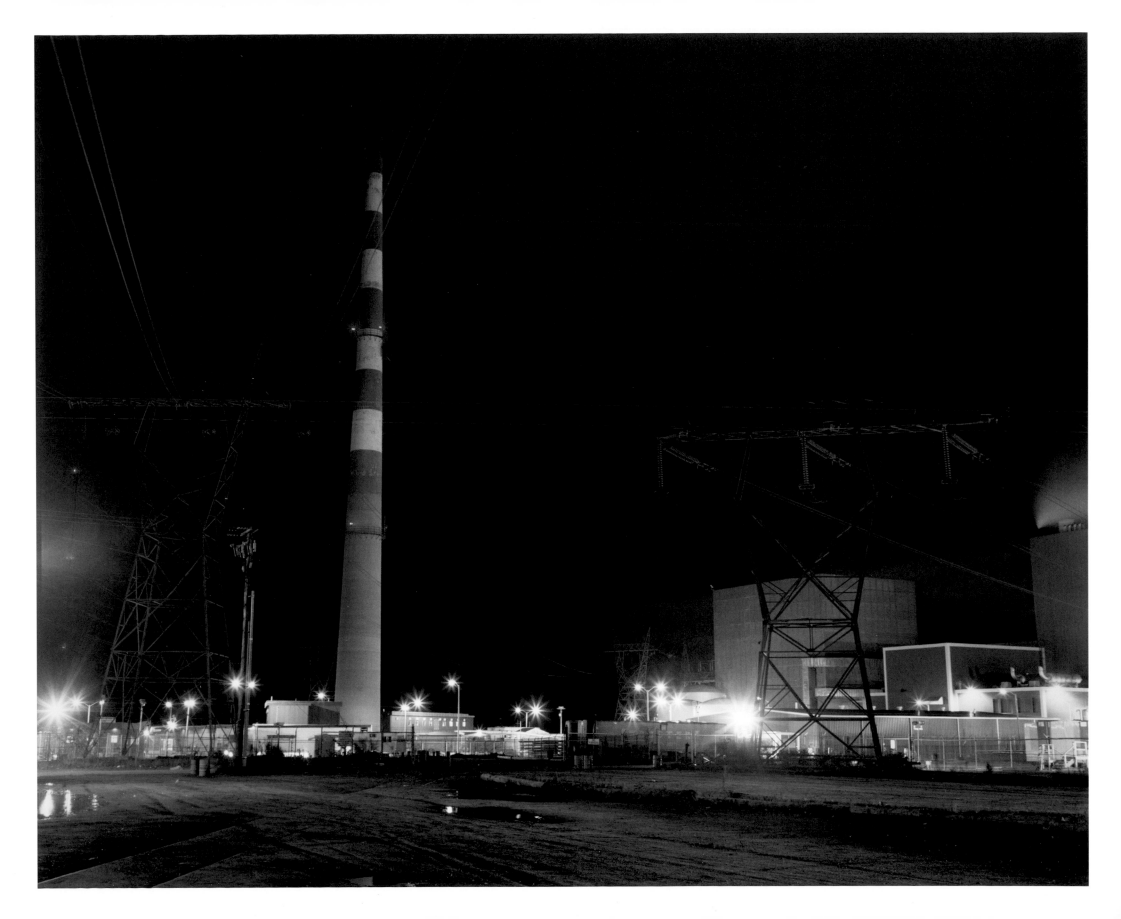

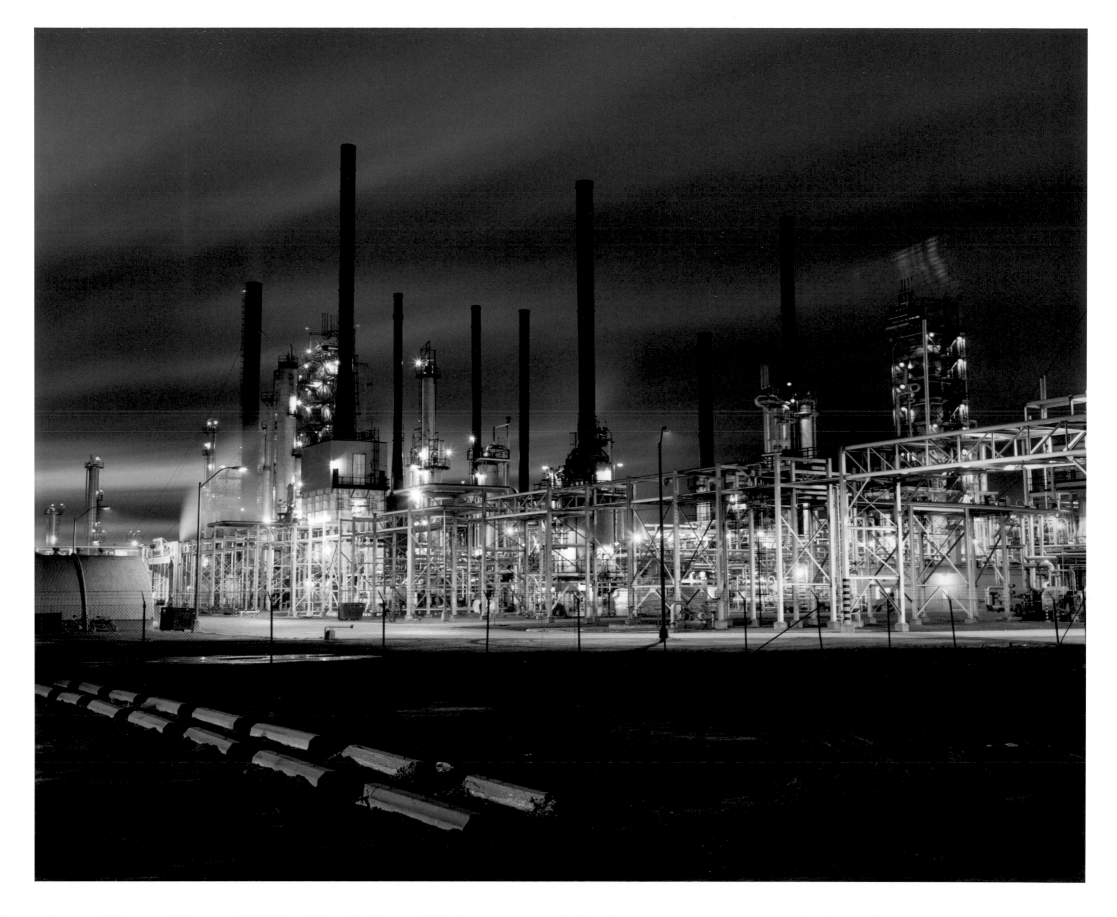

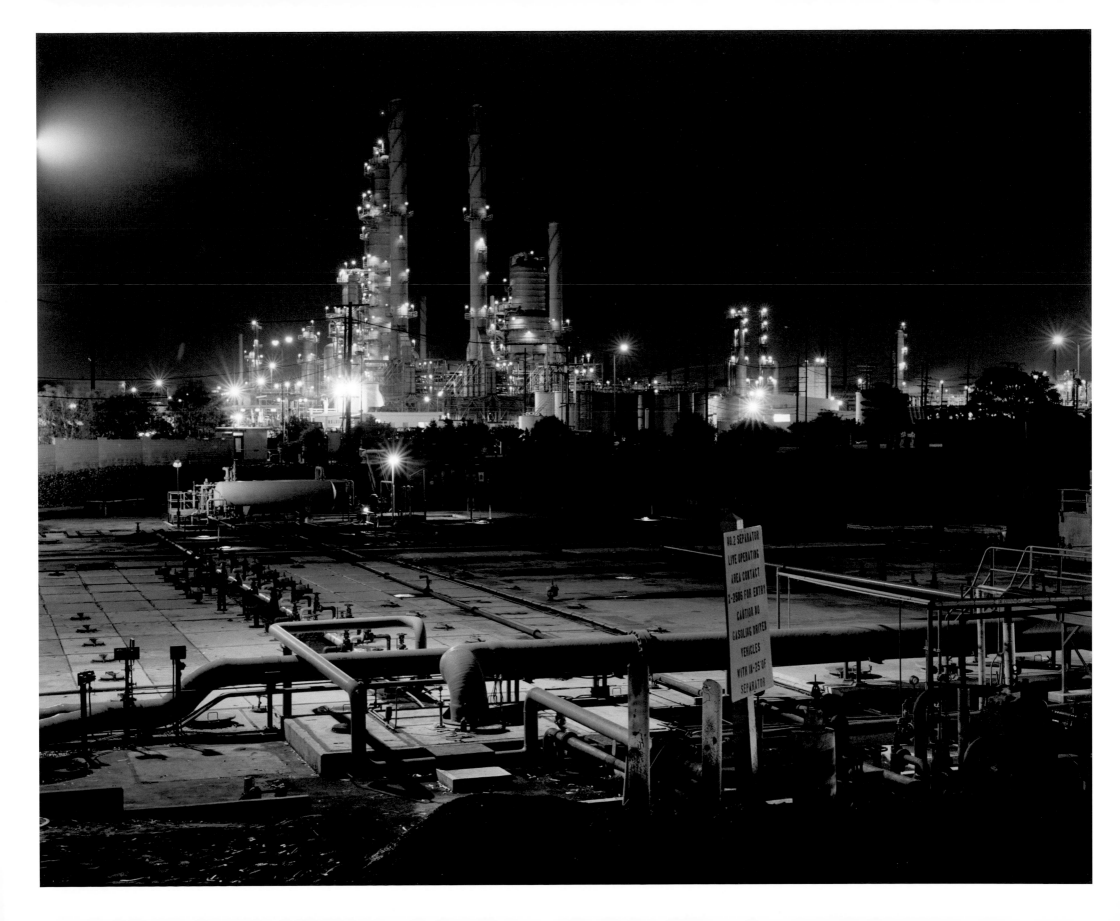

78 View along the Pacific, Evening Standard Oil Company of California, El Segundo, California

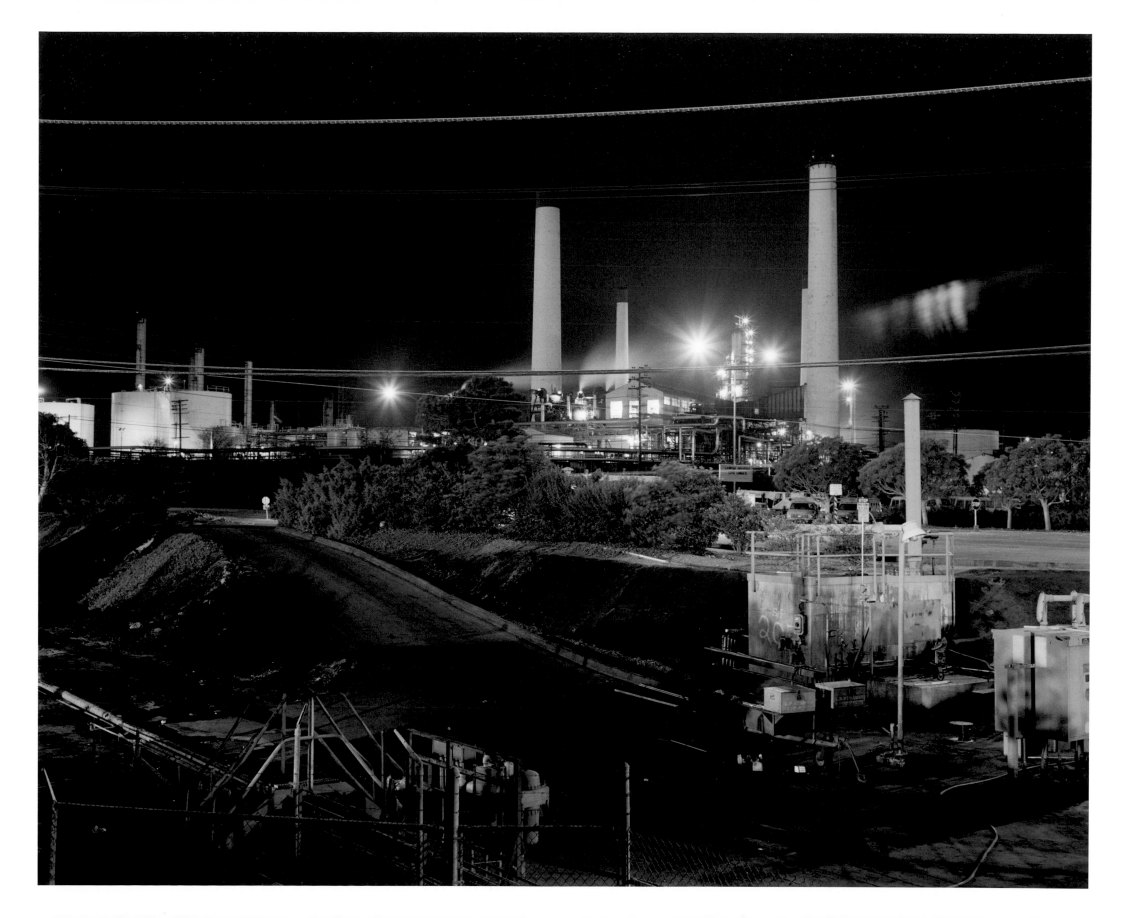

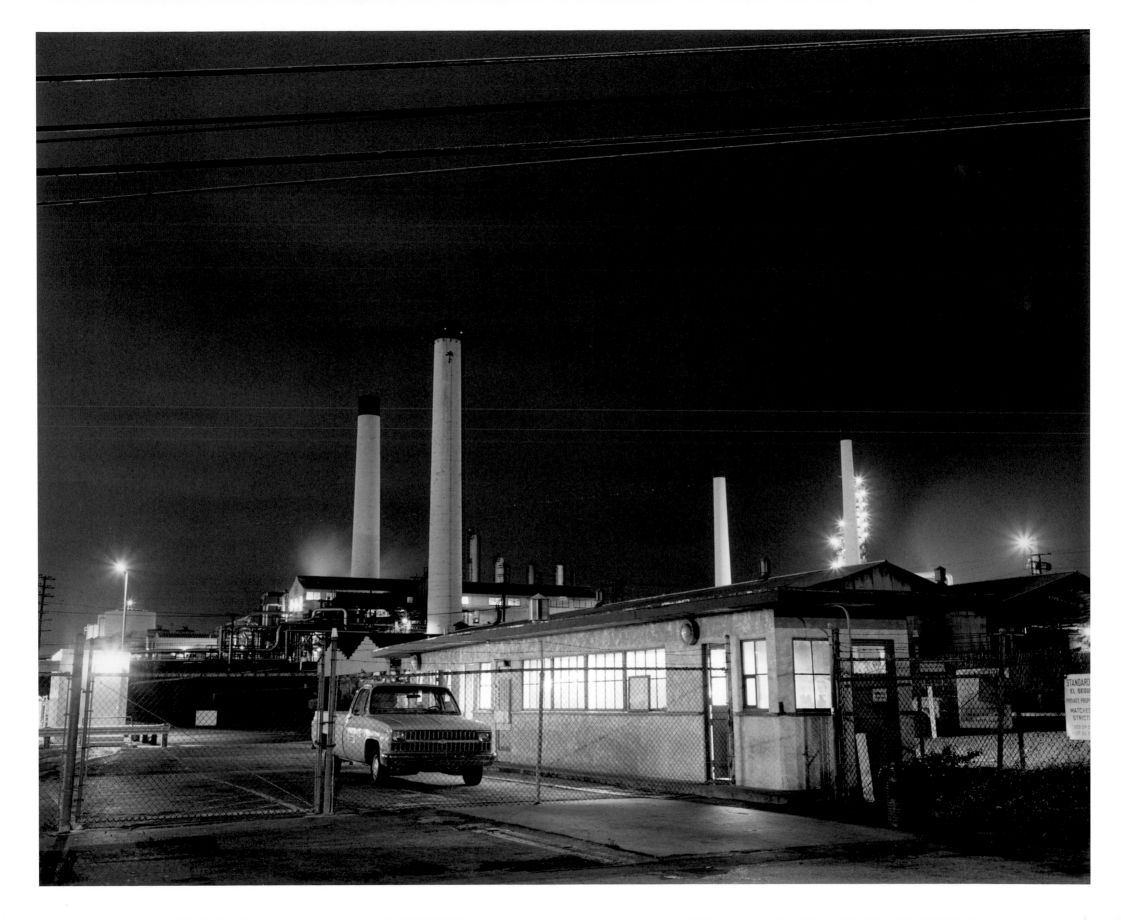

Evening, San Francisco Bay Allied Chemical Corporation, Richmond, California

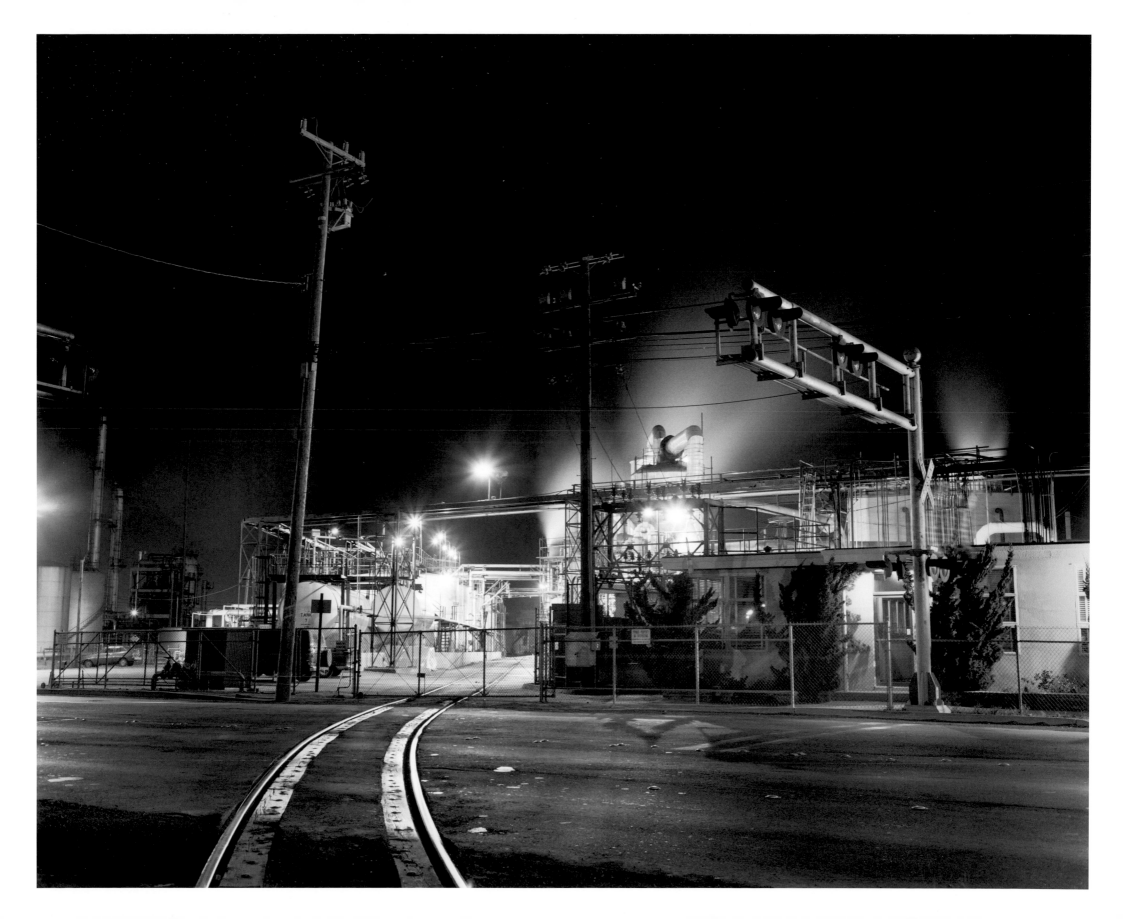

81 Dusk on the Prairie, Montana Montana Power Company, Colstrip, Montana

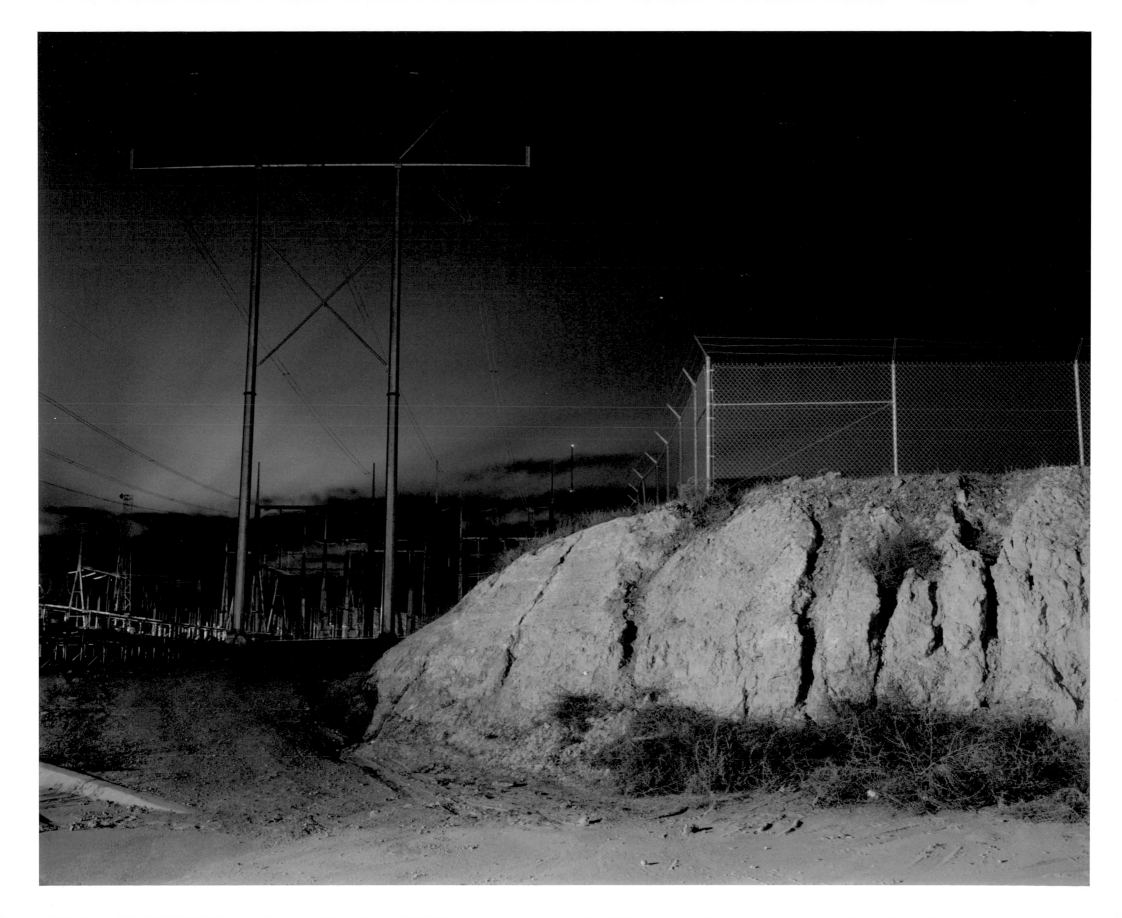

Sunset on the California Coast Union Oil Company of California, Richmond, California

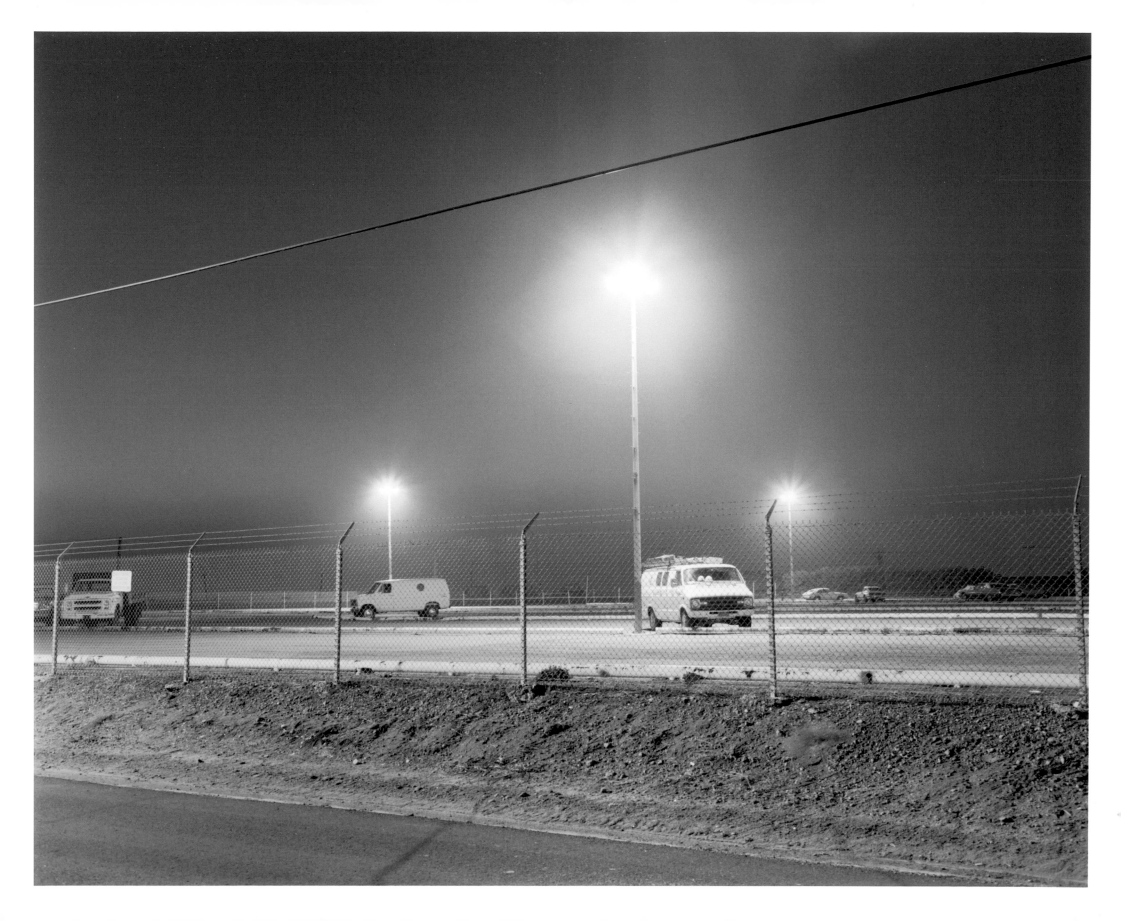

Afterword

David T. Hanson:
The Moral Aesthetic
of Landscape
Photography[1]

Miles Orvell

David T. Hanson's photographs offer a range of imagery and an abundance of visual pleasures—from deadpan records of the vernacular landscape to sublime yet troubling aerial vistas; behind all of his work, however, is a tough edge of irony and intelligence that compels us to look again at what's there before our eyes. As a landscape photographer, Hanson stands in a long tradition going back to the 1860s, and he has inherited the various practices of photographers who have pictured the earth in ways that have been widely diverse and even contradictory, from Carleton Watkins to Robert Adams. He has inherited as well the vision of the great landscape painters, from Thomas Cole in the 1830s to Charles Sheeler in the 1930s. Inheritance is not imitation, however, and Hanson's work is unique among contemporary photographers in synthesizing a historic vision with a revelation of the future that is informed by a strong and factual sense of environmental change. The result is a body of work that compels our attention on three levels—aesthetic, historic, and moral. If Hanson is, for our time, a moral witness to the ravages of unchecked industrial development, he is also a photographer of astonishing beauty, and he poses the challenge to the contemporary viewer of how to reconcile these two responses.

In titling this volume *Wilderness to Wasteland*, Hanson posits a short history of the American landscape—a history that begins in wildness and ends in despoliation. As the title suggests, Hanson's chief interest for many years has been the environment, and Hanson was one of the earliest ecological landscape photographers to use color. Although we think of environmental art as a product of the late-20th century, its roots go back to the 19th century and can be seen most notably in the work of painter Thomas Cole, who establishes the essential background for an understanding of much contemporary landscape art.

i

Born in England, Cole settled in the United States in the 1830s, where he responded immediately to the majesty of the Hudson River Valley, seeing it as a place of splendid seasonal beauty, wild cataracts, open vistas, abundant trees, and space for the farmer's cultivation. Moreover, it was a place that embodied a benign future for American democracy, promising "peace, security, happiness."[2] But

Cole soon observed a changing landscape in the Hudson Valley, reflecting a radically changing social economy that was allowing the unchecked entrepreneurial spirit to exploit natural assets like lumber that one might have assumed were to be held as a sustaining common resource.[3] (Around the same time, Ralph Waldo Emerson, in "Hamatreya" and "Nature," would note acerbically some of these same changes around Concord, Massachusetts; Emerson pretended amazement that the farmers there could think they "owned" the land with full title, land that was there to serve the poet's eye and spirit.) In his 1836 "Essay on American Scenery," Cole lamented the quick passing of the beautiful landscapes he had treasured—and painted: "the ravages of the axe are daily increasing—the most noble scenes are made desolate, and oftentimes with a wantonness and barbarism scarcely credible in a civilized nation. The wayside is becoming shadeless, and another generation will behold spots, now rife with beauty, desecrated by what is called improvement; which, as yet, generally destroys Nature's beauty without substituting that of Art."[4]

Cole was observing the creation of landscapes of destruction, though he chose not to paint them; instead, he framed his scenes carefully so as to preserve an idealized view of the Hudson River Valley. But he was haunted by visions of ruins in other forms, and he brought them into several of his paintings in the late 1830s, including *The Course of Empire* series, which depicted a history of civilization that would lead from *The Savage State* of wilderness to the idyllic *Pastoral State* to *The Consummation of Empire* to the *Destruction* of pomp and power to a final condition of *Desolation* in which the once-mighty architecture of imperial power is reduced to ruin, overtaken by nature. The United States did not have any such ruins—as Europe of course did—but Cole's allegory was picturing a possible future that might befall the growing nation, as the forces of exploitation turned the beauty of wilderness into "wealth," the product of a political economy that favored the dollar over everything else.

Missing in Cole's vision for America was what we have come to call a "middle landscape," one in which there might be a balance between forces of development and the preservation of a sustainable environment. The idealized depiction of such a moment found expression most famously in George Inness's *The Lackawanna Valley* (1855), whose integration of technology into nature—a

locomotive chugs along happily into the middle ground of a bucolic landscape—became an icon of American culture, discussed most notably by Leo Marx in *The Machine in the Garden*. But by and large the middle landscape is a dream that could not be realized in a nation whose values were over-whelmingly on the side of "free enterprise," which assumed that it was the American's "Manifest Destiny" to remove the Native American and get on with the important business of appropriating and exploiting the Indian's former lands.

That process—the systematic exploitation of natural resources—was in fact depicted by pho-tographers in the 19th century, though in ways that seem at odds with the middle landscape idyll that Inness had painted, and this too forms an important context for understanding Hanson's effort. One of the earliest photographers to portray the industrialization of the Western regions was Carleton Watkins, who—not long after commencing his photographic practice—pictured the Guadalupe Quicksilver Mine in California in 1858. We associate Watkins most readily with his spectacular views of Yosemite, views that brought him recognition internationally and that helped create the legislative impetus to set aside Yosemite as protected national land. Yet Watkins used his camera with equal enthusiasm to depict mining and industrial sites—Big River Lumber Mill (1863); Albion Mill (1863); New Almaden, Santa Clara (1863); Selby Lead and Silver Smelting Works, San Francisco (1867); and Golden Gate Mining Claim (1891). The Malakoff Diggins photographs (North Bloomfield, 1869–1871), most notably, are spectacular images that record the destruction of the natural landscape by the use of powerful water jets in a massive hydraulic mining operation. But Watkins was typically working for the owners of these industrial sites, who were seeking to represent their properties in ways that would attract investors. The photographer saw no contradiction between the preservation of the wil-derness in Yosemite and the useful extraction of minerals for commercial profit.

The years after the Civil War, beginning in 1866 with Clarence King's California state geological survey, would see parties of scientists and artists traveling through the Western territories (Watkins himself worked with King in California) recording geological features and potential mining resources; and the response to the landscape often combined an awe at its sublimity and strangeness with a

descriptive keenness for its potential mineral resources.[5] The fruitful compatibility of these two attitudes—the aesthetic and the commercial—was assumed for the most part in a mainstream view that was shared by Watkins and others, including William Henry Jackson. In two photographs taken at the turn of the last century—*C. & N.W. Ry. [Chicago & North Western Railway], steel viaduct over Des Moines River, Iowa* (1895) and *Steel viaduct over Des Moines River, Iowa, C. & N.W. Ry.* (1900)—Jackson celebrates the massive presence of the steel railroad bridge, with the train traveling over its long length, overwhelming the surrounding landscape and thus inverting the Inness pastoral formula. Yet Jackson's photographs were celebrations of the railroad, consistent with commercial development of the land and with a public that was comfortable with the machine in the garden. The course of empire—despite Cole's warning—was taking its way across the Western territories.

ii

In fact, the national religion of the United States from the late-19th century through the 1950s was based on the machine—encompassing railroads, automobiles, airplanes, the manufacturing of household goods of all kinds, the construction of the biggest factories and the tallest buildings in the world, and the extraction of minerals, oil, and coal from the earth to build the greatest industrial civilization ever known. Hoover Dam, Ford's River Rouge plant, the Empire State Building, Henry Dreyfuss's streamlined Twentieth Century Limited locomotive—these were the icons of the early-20th century, and they were celebrated in the photography of Margaret Bourke-White, Lewis Hine, Charles Sheeler, and many others. Meanwhile, Paul Strand was photographing machinery close up (a lathe, a drill, the interior of a camera), reveling in the forms and textures of the manufactured object even as he subsumed them into his own abstract aesthetic universe.

The Great Depression of the 1930s saw idle factories and idle workers, but World War II brought a singular purpose to industrial America that was captured by numerous photographers working for the Office of War Information (previously the Farm Security Administration), beginning in 1942. Among them was German-educated Andreas Feininger, whose depiction of US industry for the OWI—and also for *Life* magazine, as staff photographer from 1943 to 1962—resulted in a glorification

of the machine that we have come to call the "technological sublime."[6] Feininger shows us giant shovels stripping coal from hillsides, the immensity of the Shasta Dam, the cyclotron, Signal Hill oil field in Long Beach, littered with derricks, the production of steel in giant blast furnaces, the manufacturing of aircraft engines, the welding of gun turrets, the creation of helicopters and bombers for the war, the manufacturing of airplane and ship propellers, and so on. Working in black and white, Feininger dramatizes the scale of these industrial operations in photographs that emphasize abstract form, patterned repetition, and the essential role of the worker; for these are images that celebrate the skilled work of industry—from managing furnaces to the minute measurements of the tool and die maker.

But Feininger's 1980 collection of this earlier work—*Industrial America 1940–1960*—is a significantly contradictory text. As much as the photographs celebrate strip mining and oil drilling, Feininger laments, in introducing the photographs to a 1980 audience, the consequences to the environment; as much as he applauds the war effort, he measures the cost of the military industrial complex in terms of neglected domestic needs; as much as he acclaims the nuclear age that brought victory to the United States, he bemoans the proliferation of nuclear armaments. In short, Feininger's consciousness in 1980 has changed—180 degrees—from the consciousness of the war years and the heady postwar expansion of the US economy. Precisely those years, from 1960 to 1980, mark the growth of the environmental movement.

As early as the 1960s, an ecological consciousness had begun to enter into American life (Rachel Carson's landmark *Silent Spring* was published in 1962), initiating a change in awareness that would end the decade with Senator Gaylord Nelson's first Earth Day—held in April 1970. That teach-in was a response to the spectacle of thousands of dead birds, fish, dolphins, and seals, covered with oil on the shores of Santa Barbara, California, the result of a blowout on a Union Oil platform six miles offshore.

The destruction of the natural environment was most obvious in something like an oil spill, but it was manifest as well in subtler forms that were being recorded in the 1960s and '70s by Robert Adams. As a Western photographer, Adams was looking at some of the same regions that had first

been surveyed and photographed by Timothy O'Sullivan and William Henry Jackson in the 1870s; and some of his open vistas might remind one of Ansel Adams (no relation), who had established an idiom of sublime black-and-white photography of the wilderness in the 1930s and '40s. But Robert Adams's approach reflected a new sensibility and a new consciousness, depicting the alteration of the natural environment by housing developments and roadways, power lines, trucks, and cars. Adams's world is the everyday world of the contemporary West especially Colorado—and his approach, using black and white, is straightforward and descriptive. What distinguishes Adams's work is a subtle, almost deadpan approach, showing us things that look "normal," but that, on second thought, we realize, are violations of the natural landscape, intrusions into the wilderness, the markings of a heedless culture of settlements—tire tracks, power lines, treeless suburban developments, gas stations lining a highway. In his later volume *Turning Back* (2005), Adams starts in western Washington and Oregon and works his way back to eastern Oregon, observing the clear-cutting of timber that has left the once-forested landscapes bare and scarred.

iii

Drawing on an American landscape tradition that goes back to Thomas Cole and forward to Robert Adams, David Hanson's work reflects a deep attachment to the land at the same time that it expresses a disciplined outrage at what we have done to our natural endowment. The Native American's original settlement of North America beginning some 15,000 years ago, was minimally invasive and, given the limitations of technology, did little damage to the environment. Living off the land, the various tribes were in a variety of ways exploiting the resources of flora and fauna while leaving the land itself intact. And note the distinction: the hunting tribes were living in a balanced equation, killing what they needed and no more; others were raising crops out of the earth, or raising livestock, in a process that might go on, under the right conditions, indefinitely. To mine the land is quite another thing, for it is the removal of resources—whether gold, copper, silver, oil, or coal—that will not be replaced and that leave the land bereft of its value and, even worse, wounded, scarred, poisoned, ruined, for all time.

Even so, one might ask, can we hold the past responsible if historical agents were simply ignorant of the consequences? Consider Garrett Hardin's argument in his classic essay, "The Tragedy of the Commons," which appeared interestingly at the very moment, 1968, when an ecological consciousness was evolving into an ecopolitics in the United States. Hardin wrote, "*the morality of an act is a function of the state of the system at the time it is performed*. Using the commons as a cesspool does not harm the general public under frontier conditions, because there is no public; the same behavior in a metropolis is unbearable."[7] Surely the frontier is a broad enough space that it can accommodate the tailings of Western mining interests and the other waste disposals from industry. Yes, one might respond, up to a point; but now with over 400,000 hazardous waste sites needing cleanup, it seems safe to say we have long since passed that point.

We can look at environmental photographs as objects within an aesthetic discourse, and we can view them also as evidence for an argument. This is not to say, however, that a picture by itself can constitute an argument, for as Hardin also suggests in his essay, any photograph requires an intellectual perspective, an explanation of the total system within which the image exists. We understand the photograph as part of a system of communication that comprises three possible contexts: (1) the image itself, which may or may not be sufficiently legible to confirm an argument about space and causality; (2) the sequence or narrative in which the photograph appears, which creates a meaning beyond the single image; and (3) the caption and/or textual context for the image. In Hanson's work, we have all three of these contextual forces at work, allowing us to read the image beyond the ambiguity that Hardin's argument implies.

If Hanson's images do in effect reveal to us the environmental cost of our American system, they are bearing witness to our condition and to the events that have brought us to it, which may be the highest calling of a photographer in our time. Bearing witness is a moral act and it is also an aesthetic act. It is looking, seeing what's there, and communicating purposefully what has been seen. To understand it, we need Ralph Waldo Emerson, and his fundamental assertion on behalf of "seeing" the land as against "ownership": "Miller owns this field, Locke that, and Manning the woodland

beyond. But none of them owns the landscape. There is a property in the horizon which no man has but he whose eye can integrate all the parts, that is, the poet." Hanson possesses the eye of the poet, in Emerson's sense, an eye that sees by integrating all the parts. But that is not all. What is needed is the power to say no to ownership, the power to articulate the disgrace and scandal of possession and exploitation, and that is what Hanson succeeds in doing for our time in work that is uniquely compelling. We should say that it is not only the corporate exploitation of resources that is problematic; it is also the Federal Government — in its military installations — that has in the name of the public good acted with the prerogatives of private ownership, "protecting" the nation even while it carelessly destroys its resources. The work in this volume, which was made between 1982 and 1987, is no less persuasive today than it was when it was produced. We are, if anything, more able to see the relevance of this record now in the 21st century than in the late-20th century, as we assess the enduring character of our national legacy of toxic waste.

iv

The present volume is divided into four sections, each with its distinctive character and purpose. Hanson begins with a study of a small town in Idaho that was called Midway until 1950, when it received the quintessential mid-20th-century name — Atomic City. The grandiose aspirations embodied in that name were based on the town's proximity to the nearby "National Reactor Testing Station," founded in 1949, now known as the Idaho National Laboratory. It employs around 8,000 people engaged in advanced nuclear energy research. Not far from Atomic City, the world's first Experimental Breeder Reactor produced enough electricity to power four 200-watt lightbulbs in 1951, and experiments continued until it was decommissioned in 1964. Atomic City itself remains a town with one of the smallest populations in the United States (29 in the 2010 census) and it is the ironic contrast between its postwar futuristic space-age name and its modesty as a physical space that Hanson develops in his series.

Photographed during seemingly clear early winter days, the sky a heavenly blue, Atomic City seems to be hanging on to its existence by a thread. Hanson's approach is deadpan, as he photographs

the modest and simply constructed homes head-on, squared within their surroundings. Trailers stand in abandoned isolation or else serve to anchor homesteads of the most rudimentary character. Bare of visible inhabitants, the dreariness of the town seems evident, despite the fact that Atomic City— having its own post office and zip code—exists as an official entity, a node in a network of communications reaching out to the world, a connecting point in a federal bureaucracy. We can't judge the atomic age by Atomic City, Idaho, but we can measure the vicissitudes of place, of ambition, of the postwar moment when, out of a booming economy, anything might happen—or not happen.

The next section of photographs is likewise a study of a single place, Butte, Montana, which bears a nickname that, like Atomic City, embodies a dream of ambition and aspiration: "The Richest Hill on Earth." But Butte's mining history goes back to the end of the 19th century, when the area first became known for its rich deposits of gold, silver, and copper. Hanson's photographs encompass neighborhoods some of whose names carry the ethnic history and origins of the workers—Corktown (County Cork, Ireland); Dublin Gulch (another Irish area); Walkerville (settled by miners from Cornwall, England); and Centerville. Though historically dominated by mining operations, these suburban enclaves of Butte don't compose a company town in the traditional sense; such towns have a long tradition in the United States, going back to the early-19th century, and some company towns aspired to offer a variety of amenities for the workers, even to establish a kind of model community of sorts. No such amenities or pretensions exist here: these houses function as bedrooms for the workforce, and nothing more. Hanson's photographs of the Butte area reveal the close conjunction of housing and industry in this landscape, where dwellings seem to have been dropped randomly on the hillsides, their chief virtue (and liability) being their proximity to the workplace.

The richest hill may still be producing profits, but the period of major extractions has, by Hanson's time, ended, and Butte has entered the postindustrial era, where it is left with a history which it is preserving as the basis of its new industry—tourism. One of the iconic signs of that history are the headframes scattered on the hillsides—structures that were planted over mine shafts as part of the machinery for hauling minerals up from the earth. Of less interest to tourists is the legacy

of tailings and the runoff of toxic waste in and around the Silver Bow Creek. Hanson closes his series with images of pollution that are essential to the total picture yet are marginalized in the "official" history of the place. If this is, or was, the "richest hill on earth," it may also be among the most polluted, the entire landscape an emblem of opportunism.[8]

Hanson's framing of these hillsides creates a kind of order out of the disorder on the ground, and the presence of the giant headframes (also known as gallows frames) in the background or against the sky in several photographs serves as a further organizing principle. In others, the vertical telephone poles and power lines randomly project lines across the space of the picture. And in yet others, Hanson's irony is quietly implicit—in the decrepit trailer with its street sign outside ("200 S Main"), an address one might otherwise associate with the benign order of small town America; and in the "U.S. Property. No Trespassing" sign that hangs outside a locked door, though the sign itself seems affixed to an interior wall covered with wallpaper; as to the door itself, it features a broadly vulnerable glass panel with a plywood sheet behind it.

The next series, "Wilderness to Wasteland," embodies the core narrative of Hanson's work, which depicts the fate of America in terms of the transformation of once-pristine landscapes into Superfund sites. Significantly, this set of images offers us a double perspective, moving from ground views in the first part to aerial views in part two. The ground perspective is familiar, at least to the extent that we are used to standing on the earth when we look at things; the aerial perspective is what no one would normally see. Where "The Richest Hill on Earth" and "Atomic City" were focused studies of specific locales, allowing the photographer to reflect on the nuances of place, "Wilderness to Wasteland" has a broader scope: Hanson has gathered for the first part of the series ground photographs taken in Montana, Wyoming, Texas, Florida, South Carolina, Arizona, and seven from California. In fact, this section is a national narrative, and the fact that the images are drawn from a variety of states is part of the argument—specific places, under the pressure of economic changes, are fungible: what happens in Wyoming is what's happening in Texas or California or Florida.

Using these representative places, Hanson constructs in the first part of the series a deliberate

history that takes us, as the title suggests, through the stages of civilization—Cole's *Course of Empire*—passing from wilderness to wasteland. The first progression contrasts the beauty of nature against the signs of human incursion in this landscape. Thus Hanson begins with a stunning image of Montana's big sky, a 19th-century tableau, with a rivulet in the foreground taking the eye to a middle ground of trees and beyond to a distant mountain range. The title—"Forest fire recovery area and the Upper Gallatin River"—suggests that nature is here repairing itself from damages that were either natural or man-made, the result perhaps of a carelessly set fire. The stream that takes the eye into the landscape is replaced, in the second photograph, by the rude functionality of a mine road (Arizona) leading us from the foreground to the deep space of the picture; and it is followed by a view of distant mountains in San Bernardino County, California, but now the foreground is filled with a dense pattern of tire tracks—the tracings of off-road vehicles and motorcycles. And that sign of our invasion of the wilderness is followed by the more decisive sign of human habitation—the construction of new housing in Rancho Cucamonga, California, which Hanson pictures as a striking incongruity: a giant wooden framed structure—future housing development—set in a bare field against a spectacular mountain range, complete with Constable clouds. In the next image, a road through the mountains takes us to a distant vanishing point, but in the foreground, along a rain gutter, are the all too visible signs of plastic litter. Human intervention in this beautiful, austere landscape is far more visible in the next photograph, a view of rolling brown hills outside Los Angeles, marked by steel towers with connecting power lines. The progression then moves to images of roadways and arroyos, stained with chemical waste.

A new progression of ground images offers us closer views of the landscape, beginning with a photograph of a Texas cemetery, bare and dusty, with a steel water tank (since removed) gracing the burial grounds; it is followed by a cluster of houses in Barstow, California, with telephone poles jutting into the blue sky above. Pushing beyond the familiar to scenes that are somewhat more arcane, Hanson shows us the junkyard landscape of a "Ding Shop," and the detritus of roadside America as one might find it anywhere—steel fencing, vegetation, chemical tanks. That sequence of landscape

junk is followed by the abstract form of a "Country Disco" building, which happens to be located next to the Pantex nuclear weapons plant where final assembly of weapons is completed; that image is followed by one of "Brown's Mobile Home Park," with the main office a visibly modest and ramshackle building, patched together by any and every thing, including an American flag curtain.[9] Hanson's eye for the ironies of the vernacular landscape is sharp. A different irony is evident in the succession of images, from the disorder of private space to a stunningly ordered view of public space—a park-like setting, with a fence bordered with blooming azaleas. The title tells us this is the "Federal Prison, Marianna, Florida," and we notice the top portion of the cyclone fence is unscalable. Hanson closes this succession of ground views with a neatly fenced (with barbed wire) abandoned uranium mill in Wyoming, space that appears to be simply a dry and bare desert but that conceals within it the dangers of radiation. Beginning with wilderness, Hanson ends the series with a trompe l'oeil wilderness—hiding the death that we have planted there for centuries to come.

The second part of "Wilderness to Wasteland" is a set of aerial views of Superfund sites in the United States, encompassing places in Wyoming, California, Alabama, Arizona, Colorado, Texas, Georgia, Montana, Missouri, Oregon, Minnesota, and Utah. Superfund sites are those designated by criteria established in 1980 by the Comprehensive Environmental Response, Compensation, and Liability Act (CERCLA), with sites requiring immediate response distinguished from sites needing long-term attention, as recorded on the National Priorities List. The money to clean up these sites was to come from a tax on responsible industries (e.g., oil) as well as from general funds of the US government. There are two problems with this otherwise encouraging response by the federal government to the problem of pollution: first, collecting the needed funds from the responsible industries; second, collecting funds from US Congressional allocations. In short, Superfund efforts have been super-under-funded, with the result that perhaps a quarter of the listed sites have actually received needed attention. Hanson had previously, in the series *Waste Land*, treated Superfund sites within the context of Environmental Protection Agency summary reports and maps. That series, which is part of the volume, *Waste Land: Meditations on a Ravaged Landscape* (Aperture, 1997),

featured a succession of constructed triptychs, one for each site, in which a central aerial photograph was flanked on one side by a modified US Geological Survey Map and on the other side by a statement describing the site by the Environmental Protection Agency.

Here, the treatment is less documentary and more narrative, with an implied argument in the sequence of images: from the air we can get an overview not possible from the ground, we can see the contrast between cultivated landscape and destroyed landscape (Midvale, Utah), we can see the polluted waterways that trace their dark shapes through chemical landscapes (Laramie, Wyoming; Crosby, Texas; Augusta, Georgia), and we can see as well land that appears from the air to be unspoiled but that harbors underneath its surface the waste of industrial pollution (Rancho Cordova, California; Tucson, Arizona). And finally, we can see sites that appear to be functioning as airports or arsenals or army depots but that were, when photographed in 1985–86, identified as Superfund sites by virtue of the contamination from activities on the site that have poisoned the underground aquifer.

Looking at the earth from the air, Hanson can not only describe what is otherwise invisible; he can also create patterns of perception—juxtapositions of nature and artifice, of line against curve, of textured surfaces—exploiting the aesthetic of aerial photography as a unique mode of technological vision. At the same time, aerial photography, with its origins in military surveillance, reveals information on the ground that is of strategic importance. In this case, the photographer is surveying the war against the environment, taking a privileged view from the skies that shows us without the possibility of contradiction the harm and violence inflicted upon the landscape. Many photographers, especially after World War II, have used aerial perspectives to expose a range of issues in land use—from agriculture, to natural disaster, to nuclear testing, to suburban development. Using a 4-by-5 Linhof Aero Technika camera, Hanson's focus on Superfund sites gives his work a concentration that compels our attention to this most vexing of industrial legacies. For we realize that the laws of economic development have permitted private corporations to extract natural resources for private profit, but at an extraordinarily high cost to the public. Rather, let's say an impossible cost, since the superfunds will never, literally never, be able to cover the cost of restoring the landscape and making it safe for future

generations. In effect, the government has sold our birthright, our land, for virtually nothing, allowing privilege without responsibility.

The final set of images, "Twilight in the Wilderness," depicts industrial sites that appear to be fully operational—oil refineries, chemical plants, nuclear power plants. These are the gleaming technologies that produce the power and manufacturing wealth of the United States, and the scale of their facilities is awe-inspiring. Shooting with a Plaubel 6-by-7 camera on a tripod and using Kodak color negative film, Hanson's approach to these sites is deliberately provocative: taken at twilight or at night and using available light with long exposure time (from several seconds to several minutes), the photographs glow with an unearthly luminescence, in subtle shades of green, blue, purple, and orange. The clean lines of the giant oil tanks, steel towers, power lines, smoke stacks, refining machinery, silhouetted against gorgeous colored backgrounds, make these images seem like celebrations of the aesthetics of machinery. One thinks of the Precisionist artists of the 1920s and '30s, who evolved an aesthetic of lines and curves based on machine forms; and of Charles Sheeler especially, whose industrial landscapes were rendered with a similarly austere composition that emphasized the sheer size of the industrial machinery. And like Sheeler, Hanson excludes human beings from his depictions of the technological sublime.[10]

Hanson's "Twilight in the Wilderness" series has an ambiguity that likewise calls to mind Sheeler's industrial landscapes—a tension between the aesthetic celebration of industrial form and an ironic contextualization of the image that derives from the artist's title. In Sheeler's case, he calls his two most ambitious paintings *American Landscape* (1930) and *Classic Landscape* (1931), suggesting that these entirely new machine landscapes—no trees, no sheep, no pastures, not a trace of 19th-century pastoral—have come to define the new America. Hanson's titles similarly evoke the past, though in his case it is a past one associates with mid-19th-century pictorial representation, especially paintings by the Luminists.

In fact, Hanson supplies two titles for each image in his "Twilight in the Wilderness" series—a poetic first title and a parenthetical title that is factually descriptive—e.g., "Moonrise over Narragansett

Bay [Texaco, Inc., Providence, Rhode Island]," 1982; "Twilight along Long Island Sound [Millstone Nuclear Power Plant, Waterford, Connecticut]," 1982; "Dusk on the Prairie, Montana [Montana Power Company, Colstrip, Montana]," 1982. It is the ironic self-consciousness of these purposely poetic titles that makes the point, for Hanson is not proclaiming himself heir to Emerson's world-creating poet's eye. Rather, in his initial "poetic" titles, he is evoking an absence: what is not there is nature as we might otherwise like to have it, or as we did briefly have it—until the violent incursions of the industrial age. In evoking the Luminist sensibility of a John Kensett or Martin Johnson Heade—glowing somber colors, reflected shapes in the water, crepuscular moments, vaguely threatening atmosphere—Hanson is likewise offering a meditation on history and on the mutations of culture. Seeing these photographs, one thinks of the 19th-century response to nature, and one thinks of what is before us now—an industrial landscape that conceals beneath the aesthetic surface the power to devastate our environment.

Hanson's photographs thus take their place in an aesthetic tradition that traces its source to Thomas Cole, to Emerson, and to the Luminists. In evoking that tradition with pitiless irony, Hanson is demonstrating the power of photography to give us a clear sight of what is there before us and what we have to deal with. Hanson's art, however, is not only to show us what is there, but to evoke absences, gaps, things hidden from view: the toxic residue of industrial processes, the blasted dreams of nuclear power, the mineral wealth that has been extracted and has left in its wake a world of waste, the lost sensibility that allowed us to see God in nature and not just the best investment a capitalist could make. Hanson is not a Luddite. No one using the technology of the camera as artfully as he does could be so called; but he is reminding us in his photographs that the workings of technology have come at a cost, and that we (as opposed to the corporations) are paying that cost. Hanson enacts for us a moral aesthetic, compelling us to pay attention to two things at once: even as he responds to the ravages of the industrial landscape by creating photographs that capture our pleasure as pictures, he is framing his response within a larger critique of the industrial history of the United States, challenging us to look and to understand at the same time. In some ways, this

approach is analogous to the way that religious art in the Christian tradition has functioned since the Middle Ages in the portrayal of the suffering of Christ: Christ's pain is pictured vividly enough to evoke a horrified response on the part of the viewer, yet the work as a whole—whether painting, altarpiece, or sculpture—has an aesthetic character that attracts our eye and compels our attention. In this sense, the moral aesthetic of Hanson's landscape photography rests on a foundation in Western art going back hundreds of years. Hanson's originality is to ground his critique of the industrial order in an aesthetic response to landscape that stares unflinchingly at our contemporary condition and requires us to take stock of who we are and what we are: our shocked awareness brings us knowledge, and our knowledge is our responsibility.

1. I'm grateful to David T. Hanson for providing information about his photographic technique and about the sites pictured in this volume.

2. Cole, quoted in notes for *The Oxbow*, by Oswaldo Rodriguez Roque, in John K. Howat, *American Paradise: The World of the Hudson River School* (New York: Metropolitan Museum of Art, 1987), p. 127.

3. See Angela Miller, who quotes the Englishman Basil Hall's observing, with dismay, the slashing and burning practices of the nascent lumber industry around this time. Angela Miller, "The Fate of Wilderness in American Landscape Art: The Dilemma of 'Nature's Nation,'" in Alan C. Braddock and Christoph Irmscher, eds., *A Keener Perception: Ecocritical Studies in American Art History* (Tuscaloosa: University of Alabama Press, 2009), p. 94.

4. Cole, Thomas, "Essay on American Scenery," *American Monthly Magazine 1*, (January 1836), p. 12.

5. King's own description of the Great Basin in 1866 depicts a landscape of ruin, but the destruction is part of a natural process, not the result of man-made intervention: "The bare hills are cut out with sharp gorges, and over their stone skeletons, scanty earth clings in folds, like shrunken flesh; they are the emaciated corpses of once noble ranges now lifeless, outstretched as in a long sleep." Quoted in Joel Snyder, "Territorial Photography," W. J. T. Mitchell, ed., *Landscape and Power*, Second Edition (Chicago: University of Chicago Press, 1994, 2002), p. 198.

6. See David Nye, *American Technological Sublime* (Cambridge: MIT, 1996).

7. Garrett Hardin, "The Tragedy of the Commons," *Science* (December 13, 1968), pp. 10-11.

8. In 1928 Ryan and Percy Rockefeller, owners of Butte's Anaconda Copper, manipulated the stock and reaped a fortune from buying low and selling high; small investors suffered huge losses, and the episode is considered a contributing cause of the stock market crash that precipitated the Great Depression. Mining interests generally were not paragons of national interest: ten years earlier, in New Mexico, the Phelps Dodge mining company had kidnapped 1,300 striking mine workers and put them on a train, without food or water, going 200 miles south. This act, known as the Bisbee Deportation, was accomplished with the help of the local sheriff and 2,000 deputies.

9. My thanks to David T. Hanson, who supplied some of these details in an email to the author, July 21, 2015.

10. There is a tiny human figure in Sheeler's *American Landscape* (1930).

List of Plates

Frontispiece: Yankee Doodle tailings pond, Montana Resources' open-pit copper mine, Silver Bow Creek/Butte Area Superfund site, Butte, Montana, 1986

1 View toward East Butte, Atomic City, Idaho, 1986

2 East edge of Atomic City, Idaho, 1986

3 Looking east toward Middle Butte, Atomic City, Idaho, 1986

4 Rising moon, Atomic City, Idaho, 1986

5 Off Main Street, Atomic City, Idaho, 1986

6 Edge of Atomic City, Idaho, 1986

7 Off Main Street, Atomic City, Idaho, 1986

8 Off Main Street, Atomic City, Idaho, 1986

9 Fackrell's Texaco Store & Bar, Atomic City, Idaho, 1986

10 1st West Street, Atomic City, Idaho, 1986

11 Main Street, Atomic City, Idaho, 1986

12 Looking north toward the Sawtooth Mountains, Atomic City, Idaho, 1986

13 Mt. Con Mine waste pile and remains of Corktown, Butte, Montana, 1985

14 Mt. Con Mine and Centerville, Butte, Montana, 1985

15 Kelley Mine and remains of Dublin Gulch, Butte, Montana, 1987

16 Steward Mine, Original Mine and Dublin Gulch, Butte, Montana, 1985

17 Mt. Con Mine and North Main Street, Centerville, Butte, Montana, 1985

18 Corktown and Kelley Mine, Butte, Montana, 1985

19 Corktown and Mt. Con Mine, Butte, Montana, 1985

20 North Main Street and Lexington Mine, Walkerville, Butte, Montana, 1987

21 Wyoming Street and Steward Mine, Dublin Gulch, Butte, Montana, 1985

22 Corktown, Butte, Montana, 1985

23 Main Street, Butte, Montana, 1987

24 U.S. Property, confiscated home, Butte, Montana, 1987

25 Butte, Anaconda and Pacific Railway yard along Silver Bow Creek, Butte, Montana, 1985

26 Slag and mine waste along Silver Bow Creek, Butte, Montana, 1987

27 Slag and mine waste along Silver Bow Creek, Butte, Montana, 1987

Acknowledgments

This book represents the collaborative efforts of some remarkable people. Joyce Carol Oates kindly agreed to write the foreword. Miles Orvell contributed the major essay and generously served as informal editor of the project. Ned Gray worked with me to make the exhibition prints. Mark Holborn provided valuable assistance with the picture editing and sequencing, and Molly Balikov helped edit the texts. Katy Homans designed and typeset the book, Robert Hennessey made the digital scans and color separations, and Danny Frank supervised the printing at Meridian Printing. I am honored to have their contributions to this publication, and I am truly grateful to each of them.

This publication was made possible with support from the Chicago Community Foundation, the David T. Hanson Foundation, and an anonymous donor. Many of the photographs in this volume were made with the assistance of a John Simon Guggenheim Memorial Foundation Fellowship and a National Endowment for the Arts Visual Artist's Fellowship. I gratefully acknowledge this support.

I am also indebted to many friends and colleagues for their assistance during the making of this book. I would especially like to acknowledge Edwin Dobb, Rick Donhauser, Lisa Dority, Brigitte Fletcher, Vesna Glavina, Shepley Hansen, Heidi Lehman, Karin Matchett, Burton Milward, Stacy Miyagawa, Mark Paul Petrick, Manjushree Thapa, and Ken West. They have my deepest thanks for their generosity.

—David T. Hanson

Project editor: Miles Orvell

Picture editor: Mark Holborn

Designed and typeset by Katy Homans

Digital scans and color separations by Robert J. Hennessey

Printing by Meridian Printing, East Greenwich, Rhode Island, under the supervision of Danny Frank

Binding by The Riverside Group

Published by Taverner Press

P.O. Box 2352, Fairfield, Iowa 52556

www.tavernerpress.com

Distributed by D.A.P./Distributed Art Publishers, Inc.

155 Sixth Avenue, Second Floor, New York, NY 10013

Telephone 212-627-1999, facsimile 212-627-9484

www.artbook.com

ISBN 978-0-692-49372-4

Library of Congress Control Number 2015913025

Frontispiece: *Yankee Doodle tailings pond, Montana Resources' open-pit copper mine, Silver Bow Creek/Butte Area Superfund site, Butte, Montana*, 1986

Front cover: *Interstate 15 near Barstow, California*, 1985

Back cover: *Sunset on the California Coast [Union Oil Company of California, Richmond, California]*, 1983